VIDEOGRAPHY

Videography

Video Media as Art and Culture

SEAN CUBITT

St. Martin's Press New York

First published in the United States of America in 1993

Printed in Hong Kong

ISBN 0–312–10295–X (cloth)
ISBN 0–312–10296–8 (pbk.)

Library of Congress Cataloging-in-Publication Data
Cubitt, Sean, 1953–
Videography : video media as art and culture / Sean Cubitt.
p. cm.
Includes bibliographical references and index.
ISBN 0–312–10295–X. — ISBN 0–312–10296–8 (pbk.)
1. Video recordings. 2. Video art. 3. Mass media. 4. Popular
culture. I. Title.
PN1992.935.C85 1993
302.23'4—dc20 93–25196
 CIP

To Alison Ripley

Contents

Acknowledgements

The time it takes to view a tape and the time it takes to read aren't the same. The first video art I ever saw was 07734, upside down on a pocket calculator LCD display. I'm still thinking about it.

My first book (Cubitt 1991) was an attempt to clarify in my own mind the terms under which it might be possible to think about video. In the current work, I have extended this by trying to find out how to write about it. Videography is writing about video: this book is an expedition through some different schools of analysis in pursuit of a way or ways of making useful, apposite, adequate commentaries on video practice, and thereby to contribute to video culture. The term 'commentary' may suggest a deconstructive turn to this endeavour, and some might see in that a gesture of defeat, an Alexandrian palimpsest of comments upon commentaries. The contrary has been my intention: I have wanted to make a work of writing which can serve a useful purpose in helping and encouraging the growth of interest in new media practices. Then, perhaps, both this writing and the video work to which it refers can work in consort to contribute to the critique of what is described here as an emergent hegemony. This critique I understand as the heart of the cultural democracy which this writing is intended to serve, the purpose of both practices being to disrupt the dominant through diversity, and so to provide the circumstances for further diversification. Perhaps because of this critical role, the works referred to will often be difficult for the reader to find. I have appended a list of the major distributors of video media in the English-speaking world so that, if these titles are unavailable, you can find others.

This book could not have been written without the help of my colleagues at Liverpool John Moores University (previously Liverpool Polytechnic), to whom many, many thanks: Sean Brierly, Paul Caplan, Julia Hallam, Karen Lury, Phil Markey, Margaret Marshment, Adrian Mellor, Bob Millington, Nickianne Moody, Sean

Nixon. I owe a debt too to my students at Liverpool, and students and colleagues at Central St Martins School of Art, The Slade School of Fine Art, The Open University, Moviola, Film and Video Umbrella, Variant, New Visions Festival, the Museum of Modern Art (Oxford), Mersey Film and Video and London Video Access. Particular thanks to Eddie Berg, Bryan Biggs, Steven Bode, Peter Callas, Michael Chanan, David Connearn, Penelope Curtis, Robbie Devcic, Malcolm Dickson, Anna Douglas, Jon Dovey, Stefan Dowsing, Kate Elwes, Terry Flaxton, Lynne Fredlund, Clive Gillman, Judith Goddard, Peter Harvey, Lisa Haskell, Chrissie Iles, Mike Mazière, Chris Meigh-Andrews, John Morgan, Ian Morton, John Roberts, Simon Robertshaw, Marty St James, Mike Stubbs, Dave Williams, Anne Wilson, Colin Window and John Wyver. Special thanks to my editor, Simon Frith, to my copy-editor, Keith Povey, and to Frances Arnold. My love and gratitude to Alison, to whom this book is dedicated.

SEAN CUBITT

Introduction: Video Media

Why video *media*? Video, after all, is a familiar enough medium in its own right. We know, or feel we know, what it is: a recording medium using magnetic tape to distribute synchronised sound and image. But then, the word 'video' is also used to distinguish between types of camera: film cameras using the more traditional photochemical strip, and video cameras using electronics, either tubes or now, more frequently, silicon chips, to convert light and sound into electrical impulses. Filmmakers, long used to video viewfinders, now often turn to video editing, transferring filmed images to magnetic recording media in post-production. Or, even more recently, they are turning to laser disc transfers, allowing greater speed in finding, comparing and selecting alternative versions of a shot. Magnetic and laser media share a base in digital technology. Film is an analogue medium, providing with every frame an imitation of whatever was before the lens when the aperture was opened. But digital media, instead of storing representations (little photographs), store their visual and audio information as blips of electricity, little 'on' and 'off' signals, little ones and zeros. You can look at a piece of film against the light and see what is recorded, but you can't with magnetic tape, or magnetic or laser discs.

This storage by means of bits of information takes us a step away from film and towards another family of media whose core is the computer. Unlike film, video media do not rely exclusively on the camera. Admittedly, some films are made by working directly on the image and sound areas of the film strip: Norman MacLaren's animation work with the National Film Board of Canada is only the best known representative of the tradition. But even then, there's a guaranteed physical presence of the film in the process of its own making. By this I mean that the film strip has always actually been where the work of marking/exposing it took place; there has been some physical contact between it and some kind of

outside reality (the light through the lens, the hands of the artisan). Video isn't like that.

I often find myself using the analogy of the guitar and the piano. Film is like the guitar: you select your note with your left hand as well as sounding it with your right. But the piano player doesn't select the note in the way a guitarist or violinist does, or sound it the same way: her hands never actually touch the string that vibrates. It's not that there is any less skill involved, or that equally wonderful music cannot be made on each instrument; it is simply that they are different, albeit related. Video is like the piano: it is at that slightly greater distance from the physical world when you actually try to 'play' it. The analogy won't bear much extension: the point is that video doesn't need a camera as it has many sources from which it can derive its visual and auditory effects: from MIDI interfaces, touchscreens, light-pencils, alphanumeric keyboards, libraries of text, sound and image stored as tape, disc, laser and magnetic media, computer programmes and, of course, from all the traditional media. Video media are plural, then, in terms of their origination, the places in which they are produced.

When we talk about watching a video, a similar confusion arises. Are we talking about a feature film, or a timeshifted TV programme, a leisure tape on gardening or fitness, a corporate or community information tape, a video artwork, a surveillance tape from a closed-circuit TV system, or a home movie? What sort of medium would each of these have originated on? Moreover, video is, and has been almost since its birth, an umbrella term for a bewildering variety of formats. The domestic ones and some of the professional formats are well known, others less so: VHS, S-VHS and VHS-C, V 2000, Betamax, U-matic, Hi-band, Beta SP, Video-8 and Hi-8, MII, MAC and D-MAC, and so on. But now that people can work directly on computers to generate their imagery and sound, are you sure that the music or titles at least, if not much more, on your favourite tapes haven't been derived from magnetic or laser media, such as floppy discs, CD-I, Laservision? Public playback incorporates another family of media, including arcade screens with moving environments, video walls, projection, stereo screens in mask-and-glove systems. And what of the changes they have gone through to reach the familiar low-resolution screen – with relatively few points of light or 'pixels' per square inch – of the domestic television? An ordinary piece of work may have drawn in

materials originally recorded in print, lithograph, cylinder or disc sound recording, and any one of the myriad formats of film in use now and in the past, still and moving. But to reach video playback at home or in the workplace, it will have transferred those original sounds and images, perhaps several times, adapting and modifying them with each shift. It would be wise to be as aware of these processes of transfer as it is to be wise to the ways that cameras are used to select from the events of the world those moments, and those aspects of those moments, which someone has deemed significant in post-production as well as production itself.

Video playback is a handy centre to begin our enquiry, since it is there, most clearly, that the processes of production, of textuality and of reading all meet. Contemporary Hollywood feature film production is quite cognisant of the importance of video markets to the long-term profitability of its films. Some films are made with that eventual home specifically in mind. In cinema, the shape of the image is described as its aspect ratio, the ratio between the vertical and horizontal dimensions. The standard TV screen matches none of the standard aspect ratios of cinema, which means that too much or too little of the original frame is transferred to the TV screen, most obviously in the telecine transfer of CinemaScope films, in which a sizeable proportion of the image area is lost unless a letterbox format is employed, leaving much of the TV image area unused. A film like Coppola's *One From the Heart* (1983) was shot in the old Academy Standard aspect ratio specifically to ease the transfer to the small screen. Contemporary films shot in wide screen formats such as CinemaScope are often composed in such a way that action in any one sequence occurs in a specific area of the frame, again easing the processes of transfer to the narrow confines of existing broadcast TV ratios. Editing procedures, likewise, often produce a cinema ('release') version and a TV version, cut to match the demands of family viewing, leaving out the sweatier sex and flamboyant violence that would offend network schedulers and their advertising clients or the constraints of British video censorship laws.

The music business, too, has reformulated its marketing strategies to match the demands of video. No new recording contract is complete without provision for a promotional video, and acts can increasingly expect to up their earnings both through broadcast airtime on specialist programmes or dedicated channels like MTV,

and by means of the sell-through market, where video albums and EPs take an increasingly prominent share of the market. It's a common complaint that pop acts must be visually attractive as well as musically, now that the industry has to rely so strongly on visual impact via video. Of course, this visual aspect of pop has a long history (cf. Goodwin 1992), certainly as far back as the music halls, where stars like Marie Lloyd were as famous for their performances as their singing. But pop video has altered, if not intensified, this visual relationship with the stars. The visual appeal, especially of stars working in the teenage market, is more than a marketing tool: it is an intrinsic part of the product, where 'product' is defined as what can be sold to the public. The public now buys videos as well as audio recordings, in a way that it could not previously buy a performance to take home. At the same time, simple documentary records of performances tend to sell less well than productions designed for repeated viewing, using the panoply of devices that have become familiar as music video: elaborate *mise-en-scène*, rapid cutting, special effects and storylines (even if they take the form of fractured narratives largely subordinated to the performance image and musical repertoire of the artist). The music business, like film, has begun to adapt to the position of video in the complex of media in which we now live.

Video is a frequent adjunct to scientific and technological work: videos derived from ultra-sound scans of intra-uterine foetal development or from X-ray photography of fractures in engineering components under stress. It is a major tool of education and corporate communications, and is also central to electronic networks such as databases, E-mail, electronic bulletin boards and newsletters. It has a place in policing and the law, where it is used for taking evidence, and in psychotherapy, where it has been developed as a tool for analysis of body-language and group interaction. The home video camera is used for everything a still camera did before, and much still imagery is now produced using magnetic rather than photochemical media, both at home and, in an explosion of use, in commercial photography for advertising, editorial and publicity (cf. Wombell 1991, Ritchin 1990, Bishton, Cameron and Druckery 1991). Amateur video makers showcase remarkable work in conventions and festivals around the world, and they support a major wing of the magazine trade, regularly sharing shelf space with their spiritual neighbours, the computer

and photographic papers, magazines more often than not produced using video technology.

Video is, then, at the heart of the increasingly interlinked webs of previously separate media. I don't want to make any imperial claims for the medium, however: quite the opposite. No matter how a magazine is produced, we consume it more or less in the same way. A film using laser effects, film effects or computer effects is still a film if we consume it in the cinema. Certainly, there are nuances in such texts that will evoke specific responses. Peter Greenaway's *Prospero's Books* (1991) feels different from his *The Cook, The Thief, His Wife and Her Lover* of the previous year, though both had their premièr as theatrical movies and shared some stylistic and thematic tendencies. *Terminator 2* (1991) has more in common with the pioneering optical wizardry of Meliès than it has with thermal imaging of uninsulated housing. But all of these cultural forms share, potentially if not actually, another existence as electronic information prepared for display on a video screen or projector. At the heart of this argument is a feeling that video is neither an autonomous medium, free of all links with other forms of communication, nor entirely dependent on any one of them.

It's for this reason that discussions of video need to be prefaced with a caveat against essentialism. There is no essential form of video, nothing to which one can point as the primal source or goal of video activity. It isn't intrinsically good or bad and, as Roy Armes argues, 'continual technological development makes it increasingly difficult to pin down a fixed identity' (Armes 1988, p.1). At the same time, it is important to note that video cannot be narrowed down to a subset of television, either in practice or theoretically. There is a special relationship between video and broadcast television, one that accounts for the majority of video practice today: video cameras, video editing, video viewing. But that is only one of the relationships into which video enters and, though statistically important, it does not exhaust (and should not be allowed to exhaust) its potentialities, potentialities which are, precisely, the relationships into which it enters.

The phrase 'video media' is chosen specifically to disrupt such a centring of video as single, uniquely this or that, essentially something. By using the plural form, I want to indicate that video works across a plurality of relationships, plundering other media for sources and channels, rarely pursuing an imagined goal of pure

video, video in and of itself. Such a beast, I believe, could not exist. Video, a core element of the multimedia devices and networks into which, increasingly, people in industrial societies are connected, is nevertheless only a part of that world, a single aspect. If, as seems possible, we are to be invited to purchase home office and entertainment machines which will combine the functions currently shared between the computer, the TV, the hi-fi and various domestic and financial technologies – telephony, banking, security, thermostats, shopping, and perhaps newsprint, letter post, facsimile, photocopying and who knows what else – if so, the video monitor will play an even more central role in social life. This multimedia environment is, in more dispersed form, characteristic of our period of history.

In general, this book eschews futurology. Guessing the shape of the future from present trends is fraught with perils. Instead, I want to engage with the state of play now, at the time of writing and in the immediate past. Video media are currently changing the way we interact, perhaps less profoundly than some commentators would have us believe, but nonetheless in significant ways. Whether that will continue, we have no way of knowing. There seems little reason to doubt the medium-term continuance of technological development, or the widening of the gap in levels of access to it between industrialised and developing nations. Nonetheless, decisions are being made today which will affect the eventual shape of the media technologies we can expect to see in that medium-term future, decisions which at present are being made entirely on military and commercial grounds. This book is intended to open up the debate over those developments, to point to alternative routes into the future, and to offer some ways of thinking about our choices that go beyond the assumed triumph of global capitalism. So, rather like the subject which it covers, this book has no pretensions to permanent, intrinsic value. Once its moment is past, it will retain only some small documentary value, whether the avenues described here are followed up or closed off on the way to global standardisation of technologies and products.

There is no video theory in the way that there is a body of knowledge called film theory or, rather differently, television studies. There never will be. Not being really a simple and discrete entity, video prevents the prerequisite for a theoretical approach: that is, deciding upon an object about which you wish to know. Yet

there is a field in which a variety of intersecting activities gather around the video apparatus: the field of culture. The word culture, too, has its complex histories and conflicting definitions, largely because it is itself complex and contradictory. Thought of culturally, video is both a symptom of the societies in which it has emerged and is being used, and a tool in their further development. Materialist philosophy insists that culture, like the societies in which it is inextricably suffused, is at once a product, a site and a source of struggle. Whether we think of that struggle as one over power, truth, meaning, wealth or some other great abstraction, the words culture and struggle are inseparable. What we have gained, what we wish to see happen, we must fight for. So the attempt to understand what video does cannot be a passive, distanced or objective gaze from the sidelines: it must be an active participant in the wider cultural struggle, just as video practice is. Writing about video is writing about some small areas of this wider domain, a strand of cultural studies or media studies rather than an autonomous discipline of its own.

At the same time, video practice offers important challenges to media theory. Like culture as an object of study, video demands a holistic approach, investigating all the determinations focused upon and opportunities latent within a given situation. Like culture, video requires an historical understanding in order to clarify its present functioning. And because it operates in so many domains of social life, it needs to be addressed using all the techniques at our disposal. It was argued above that video is not reliant upon the camera for its images (or the microphone for its sounds). Video is thus freed of its dependence upon the real world which the camera must record, even though the camera is a tool in the hands of an operator, whose ideological formation constrains the breadth and style of images captured. With video, we no longer need to restrict ourselves to issues of representation, in practice or in theory: much video work is simply uninterested in representing the world as it is or might be. That representational job is only one of its functions. In video media, the moving and the still image attain the kind of autonomy from the demands of the everyday world which was attained in Europe by painting at the end of the nineteenth century, and by music with the rise of the symphony at the time of Haydn and Beethoven. Yet the histories of the arts should alert us to the pitfalls of autonomy, the dangers and responsibilities that emerge along

with a new freedom. Considered as a medium or family of media, video needs to be understood in close relation to the development of art.

For this reason, *Videography* is composed of two sections, the first dealing with theory, the second with practice. In the theory section, various approaches to twentieth century media are raided for ideas in relation to sample video practices. Looking at ideas and histories of art, film, television and music allows us to think about video in terms of similarities and differences with each mode of practice. It encourages discussion of the ways in which video practices pick up on and re-echo concerns of practitioners and theorists in these neighbouring domains. The comparison makes it possible to unpack the useful and the impractical elements of theoretical systems, and test them against the demands of video culture. In particular, such comparisons make up the dialectical links of an argument which is intended to play upon the problematic relationship of art and culture.

These two terms resist definition but, in terms of video media: 'art' describes an approach centring on the problem of autonomy, of what happens when a medium is set free – or cast adrift – from a necessary connection with daily life. 'Culture', on the other hand, is the approach which insists that there is an unbreakable bond between the specificity of video practices and the generality of social life. The dialectical relationship between these two contrary approaches is what shapes the arguments of the whole work. Should we try to understand video as somehow separate from the rest of the human universe? Or must we accept its place as a servant of a social and economic formation which subordinates its free development to the demands of the market place? On the art route lies a lonely toil without redeeming social purpose, chasing the purity of absolute freedom. On the culture track lies subjection to an economic system which, on present showing, is hell-bent on the destruction of the planet and most of its population. By looking into this small domain of practice (almost arbitrarily defined by the group of media involved) this book intends to explore the interplay of these two positions as they are worked through in the making of video culture by producers and viewers alike.

In the second part are analyses of specific tapes and uses of tape which seem to bring to the fore this dialectical relation. These analyses are open-ended, in the sense that there can be no defining

conclusion to the debate or to the dialectic in which it situates itself. I have had to rely to a great extent on my own enthusiasms and experiences in writing on video. If it is true that there has come into being a transnationally dominant culture, largely based in the English-speaking world, whose major goal is to maximise profits, then it is unsurprising that that goal be pursued by dominating the marketplace. Large corporations gauge their success less by units sold than by market share (the percentage of total sales which have accrued to them). The purpose of this method of accounting is to minimise the competition in a given market and to exclude, especially, newcomers, who might not only take away sales, but alter the parameters of the market itself. This happened in the 1970s with the break-up of IBM's market dominance as new firms entered the computer area, bringing with them a new style of user-friendly software and a redefinition of computing as a suitable technology for small businesses and leisure. The video market has experienced, as yet, no similar break-up. So the tapes that I have viewed are largely the ones I have sought out, none of them as familiar as the films, DIY and music tapes that dominate the world's rental and sell-through shelves. Some contact addresses are provided at the end of the bibliography to help the reader find these and other tapes that have so far evaded the attentions of network TV and chain store buyers. There will undoubtedly be more work, even by the time this book appears in print, which will demand the redefinition of the arguments in it.

Finally, the combined address to art and culture is intended to delineate the limits to development of video media under current conditions. The works analysed here are as good as those in any medium in the last decade: as emotionally demanding, as rich in texture, as profound in thought. Yet there is a constant feeling of disappointment that seeps through, a sense that should be nurtured and expanded upon. If work of this calibre is not yet enough, what should we be demanding of our culture? We should demand, precisely, what we have not got. What we lack so thoroughly, what is central to any culture yet missing in ours, and what is apparent in the best work written up here, is hope. By denying that we are satisfied with what is on offer in the dominant culture, we keep the doors open for something better. Only blind acceptance of the current state of affairs, even of its best moments, condemns us to unending repetition of the everyday.

Part I

Theory

The tradition of the oppressed teaches us that the 'state of emergency' in which we live is not the exception but the rule. We must attain to a conception of history that is in keeping with this insight. Then we shall clearly realise that it is our task to bring about a real state of emergency.

(Walter Benjamin 1969, p. 257)

1

Videography: The Helical Scan

Video arrives in the material world, a world torn apart by contradictions: between wealth and poverty, knowledge and ignorance, power and oppression. Other huge contradictions fragment and work themselves out in our world, our cultures and our bodies, contradictions explored in these pages. These are the contradictions which divide video, too. The historical sources of the medium are manifold. On the one hand, it has a clear link to the entertainment industries in the person of Bing Crosby, who invested in magnetic recording media in the 1930s in order not to have to travel so extensively for radio and, later, TV appearances. On the other, technologies of radar, closed circuit surveillance cameras, lightweight portable packs and many of the individual devices and techniques needed for standard or enhanced video work were developed initially for the military. Many developments – like macrophotography – were undertaken for commercial purposes. It would be an essentialist error to imagine that these roots define the medium as it is today, but it would also be naïve not to want to trace some of these sources into the practices of our own times. This is not context, in the sense of a field of events surrounding the text which give some clues to its interpretation: it is the very fabric of the video media.

Video media can only be understood as the product, the site and the source of multiple contradictions, lived out in multiple practices, caught up in multiple struggles. To this extent, the study of video must address the structures and processes of the contemporary cultures in which it operates, the more so since 'video' is both a cluster of diverse, even mutually exclusive cultural practices, and at

3

the same time a medium which the most diverse practitioners can still find ways to communicate about to one another. The internal undecidability, the lack of essence in video, its 'lack of being' in the Lacanian phrase, should not be taken as the 'truth' of video: video's internal dialectic is produced out of the circumstances of its invention (or more properly the multiple, ongoing invention of the medium). The complex of media clustered around the monitor/VDU and associated presentation media (video walls, projectors and presenters) is formed in, performs and informs the instability of contemporary social structures. Such contradictions inhabit even – or perhaps especially – the most banal forms of video: practices that least consciously address the characteristics of video as such, and in doing so reveal the more profoundly some of its most pervasive qualities.

The wedding video is a product of supreme invisibility and supreme formalism. Few video practices invite less critical attention to the niceties of lighting and angles, or to the other aesthetic issues that will be raised in this book, yet few forms are as tightly bound by rules. Deriving its shape from the wedding album, and most frequently delivered by the same high street photographers who otherwise would provide the snaps, wedding videos repeat not just the ritualised gestures of the marriage ceremony but the traditional set-ups for the wedding album: arrival of the bride, signing the register, the family group, cutting the cake, and so on. Every shot is precisely and skilfully done, and must be: the aim is to edit in camera (that is, without the use of an edit suite since that would cost too much in time and money, and delay the moment at which the family take delivery and watch the tape, both important factors in an extremely competitive market). At the same time, every tape must appear fresh and personal as if it addressed this event and no other, never to betray the suspected secret: that it is exactly the same as every other wedding video.

The point is, of course, that to the participants, this specific videotape is unique: precisely rendering the behaviour of named and known people, including themselves. A disparity then arises between the formulaic mode of production and the tightly focused referentiality of the viewing situation. Giggling flower girls and page boys are part of the formula, but not perceived as such when they are identified as specific cousins, and when the viewer has been party to the spectacle that the video has recorded. This is a form of

reference that persists in video as in snapshots, a determination in relation to the real in which the videotape itself acts as a bond, a seal binding again the members of the family group: representation as a guarantee of the reality of family union (especially at a time when that union has to alter in the face of alliance).

In short, there is something specific to the viewing situation that determines the meaning of the video, just as much as the video itself determines the kind of viewing that is possible. In this instance there are two key functions: to bring into the family circle people who couldn't attend the event (but who can be trusted to recognise a useful proportion of the people shown there) and to help participants remember. This mnemonic function is, again, shared with photography and perhaps derives from it; video a supplement to the older medium. Like portrait photography, it takes on a double role, promising presence while presenting absence: the image of an auntie is simultaneously a reminder of her presence, but is conditional on her actual absence, a dialectic fundamental to representational technologies. But this particular dialectic is only available to someone who recognises the auntie. For them, the wedding video is an index, a way of pointing to the real auntie at a real moment in time. What is unusual, though, and what draws us back into a wider dialectic, is that taken as a whole the wedding video (formal product that it is, and record of a formal occasion) takes on simultaneously the character of a universal event. It's clear enough what is meant when people say that a wedding draws its participants into a continuity with everyone who has ever married. But the video too, especially by reiterating the formulae established for representing the event, takes on a quasi-linguistic form, a form which universalises the event by referring it to all other wedding videos. Even the unique this-ness of the event and the record of it are shared with the equally unique this-nesses of every other wedding, every other wedding video.

At the same time, the experience of watching someone else's wedding tape is a bizarre one, especially when you know absolutely no-one shown there. Certainly the formulae are more apparent, but less readily expected is the intensity of interest with which it's possible to watch total strangers enacting an otherwise familiar spectacle. The sense comes over you of looking in on something rather private, something to which you are uninvited, that excludes you. And that sense of exclusion, I believe, derives from a reversal of

the dialectic: moving from an expectation of the universal to a realisation of the particular. What at first looks like a simple commodity, interchangeable with any other wedding tape, begins instead to look like a precious pledge of the particularity and specialness of these strangers' lives, a particularity so specific it overrides our culturally sanctioned pleasures in watching screened images.

These two factors are in play in watching a wedding video: universality (always, under capitalism, marked with the sign of the commodity) and particularity (likewise marked by the construction of individualism). Wedding videos are not unique in this: much the same might be argued of the classic realist text described by *Screen* theory in the 1970s. But the latter is an intellectual construct invented after the event to describe the similarities between an otherwise disparate family of texts, whereas the wedding video's claim to universality is based on the repetition of the same narrative elements in the same order in every variant. It is as if the logic of classical realism – obliteration of the processes of production, transparency of the medium, construction of an ideally coherent subject position from which the text is comprehensible – are all brought to a head in the wedding tape. The wedding tape carries out in meticulous detail the determining characteristics of classical realism. No-one questions the videomaker's intentions, so formalised is it; no-one notices the materiality of the image mediating between the event and its representation. And the viewer's position, even looking guiltily in on someone else's tape, could scarcely be more definite and hemmed in, more surrounded by ritual responses and respect for the authenticity of the experience on screen: few other media experiences so completely rule out the possibility of criticism. It is perhaps this traffic between the universal and the individual in realism and in wedding tapes that has taken the place of religion: that gives us a sense of where we fit into the scheme of things.

The formula reminds us of our place in an order which, socially and historically specific though it is, we still want to believe is somehow natural. At the moment of marriage, one of the few moments of Western life that is still surrounded by a commonly shared ritual, we have evolved, in the few years since cheap, portable video cameras became available, a form of representation as rule-governed as Spenser's epithalamia. That formal representation

guarantees the interlinking of the particular and the universal, the single instance and the grand order of things. So deeply ensconced is this belief that we no longer notice the suddenness with which the video has become part of the wedding ritual. Instead, the new medium has acquired, in this usage, something of that religious aura which stops us criticising wedding ceremonies, for both seem to guarantee us an official place in the world. It is then only surprising that we greet an image of ourselves participating in the wedding not with pleasurable recognition, but with shock and embarrassment.

The sight of oneself on tape is not grounds for identification: what you see is not the 'ego ideal' of psychoanalytic identification in the cinema (cf. Mulvey 1975). This flattened representation is a stranger, perhaps most of all (to use the psychoanalytic lexicon) it is a picture of the ego, by which is meant the conscious public front representing someone formally to the world, especially on a formal occasion. We feel an instant need to comment on the image, to explain our actions and deportment, to apologise for or to historicise the picture on the screen or the voice on the soundtrack. The role of words here is to act as supplementary material, to fill in the gaps, to make up for the alienated image, the difference between it as object and you as subject. That difference between (re)presentation and presence is an expression of a split we all feel anyway, but which is poignantly and powerfully apparent in this kind of video. That split is the difference between how we experience ourselves and how others see us, a split which we internalise at a deep level when we learn as children that we must accept social roles and social laws that will govern our conduct. One of the key functions of language is to try endlessly to plug this gap, babbling on and on in an attempt to complete and make whole the internally-fragmented psyche. That's why the sight of your own image calls forth so much explanation.

If I am right, then it is not all that surprising that probably the next most familiar form of video practice is the record of some kind of family disaster: immortalised in the UK in the network show *You've Been Framed*. One shot in particular never fails to evoke riotous hilarity: the 'knock-out' shot which, in various scenarios, ends up with the camera being struck on the lens. If the wedding video shot of your public persona evokes speech, this shot evokes its opposite: the inarticulacy of laughter. Freud suggests that laughter is a form of release in which unpleasant tensions find a way of suddenly and pleasurably letting rip. I'd suggest that this laughter

is down to a startled release of the tense differential between person
and representation. The ball that hits you on the nose is sufficient
proof that there is a continuity between what others see and what
you experience: that the gap between image and reality isn't a final
one.In that moment of shock – and indeed of pain – comes a
momentary reassemblage of the dispersed fragments of the psyche
back into one unified whole. The pleasure of that reunification far
outweighs the displeasure of being 'struck'. This shot cannot really
be seen as an addition to the rhetoric of television camerawork: it is
strictly a video shot. I'm grateful to Tony Bywood for pointing out
the use of a similar perspective (tricked by use of telephoto lenses) in
cricket coverage to show the impact of the ball on the stumps. But
there the fateful contact between apparatus and referent doesn't
take place: without that contact, there's no guarantee of the presence
of the camera to the reality it records, no confirmation of the
continuity between observer and observed, self as object and as
subject.

 You've Been Framed is a hugely successful programme format,
exported on a global scale and recruiting tapes from every continent.
Most viewers have spotted the emergence of the rigged sequence:
shots set up to appeal to the programme editors, typically of cute
kids or pets suffering sudden indignities. But most viewers would
overlook that peccadillo, and prefer to accept the polite fiction that
all these tapes are amateur products, and that therefore they come
with a kind of implicit authenticity. Our preferred belief is that all
the tapes are the fortuitous record of genuine events.

 Though we may – as ordinary punters, not just as academics –
have a sneaking suspicion that television in general is taking over the
world, and that what we see on the screen is a reality entirely
manufactured for soundbites and photo-opportunities, still we want
to believe that reality continues to exist. The marks of reality as
opposed to the pseudo world of politicians and celebrities are the
hand-held camera, the break-up of sound and/or image, the
presence of a burnt-in viewfinder date on the image track, shots
made without benefit of lighting or microphone rigs, the presence of
plain-looking people, and perhaps most of all the record of
accidents, of the kind of pratfalls that wouldn't be funny if they
were set up for an actor and crew. The attraction of *You've Been
Framed* is the lure of the contingent in a TV world which otherwise
seems entirely managed and manipulated. The spectacle we are

offered – for it is, in formal terms, as much a spectacle as a song-and-dance routine or set-piece shoot-out – makes a fetish of the accidental. It gathers all our attention around a micro-narrative whose ending is always a sudden release of laughter brought on by a sudden fall from grace.

One of the clues as to the authenticity of amateur clips on the show (as opposed to those set up solely to get on to it) is that they tend to reduplicate formulaic set-ups deriving from the family album or the home movie tradition: holiday snaps, prize pets, family occasions. And since their protagonists often know they are being taped, their actions, gestures, vocabulary, tone of voice tend, as in our previous example from the wedding tape, to be staged especially for the camcorder. And it's this staginess that, I think, is the first level of humour: the deflation of posing. The complicity of actor and recorder is severed by some chance event, the administration of the moment defeated, and the predominance of reality over representation reasserted in such a way as to re-establish the unity of the two, despite our fears that they might be utterly estranged. In other words, the power of these sequences derives from their being the antithesis of television. Their poignancy, and the sense of disappointment that accompanies them, derives no doubt from the realisation that TV is quite capable of subsuming its antithesis within itself.

This achievement, heralded by Baudrillard in his defeatist critique of Enzensberger (Baudrillard 1972, pp. 200–28), is much overstated however. A case will have to be made sooner rather than later that television is losing its pre-eminence as the dominant medium of our time. Certainly the sets are still there and still turned on, but we have changed our relationships with them. We are to be found less often glued to the box, more often rifling through rival media (magazines in particular have boomed during the 1980s and early 1990s) or using leisure time in a wider variety of forms: the unholy pairing of cooking and keep-fit, of gaining and losing weight observed by Barbara Ehrenreich as the emergent pleasures of the 1990s, the rise of heritage centres, PCs and computer games as rivals for our attention. And the development of rental and sell-through markets as well as the rapid upswing in camcorder sales since the introduction of compact formats have their part in this change. Perhaps no future medium will ever have the hegemonic position of film and, subsequently, TV in the twentieth century. In video, and in the

exemplary subsumption of home video into *You've Been Framed*, we may be witnessing not the total power of television to replicate itself at the expense of rivals, but the worm in the bud, the first emergence of the low-power media, the fragmentation of dominance, that will supersede TV itself. TV may contain its antithesis, but it may also contain there the seeds of its own downfall. For TV, far more than film, has attempted (and in some nations still tries) to be a mass medium. Single-channel or duopoly systems, or systems whose major competitors compete only in trying to reach the same mass audience, are doomed to blandness, ironing out difference or marginalising it. So when difference does emerge, it is a sign less of the power of TV than of the break-up of its old hegemony.

Of course, much of what is different on television is pitched at the wealthy. Innovation is usually fostered only in relation to minority audiences, and the only one that can pay its way is the upper class. The system has a great deal of strength yet. But TV doesn't diversify because it likes to demonstrate its strength: it diversifies because it is afraid of losing its audience to competitors in broadcasting, and also to other media and other pastimes within the strict limits of the leisure market. The end of TV domination, at least in the form that we have known it, is well within the bounds of possibility. We need, then to understand video in terms of TV, but not exclusively. Perhaps, indeed, it will be found that studying video gives us a new perspective on the powers and nature of television. TV is – and this is the first lesson – not a monolith but a leaky vessel, one into which all manner of strange and unassimilable things may enter, even those that threaten to change it completely.

A particularly informative example is the tape *Zygosis* completed by Gorilla Tapes in 1992 with part funding from Britain's Channel 4 television. The tape is structured around a brief critical biography of anti-Nazi photomontagist John Heartfield, comparing his work with subsequent political and pressure group campaigns and with the film montage of Eisenstein. At the same time, it exemplifies the power of the technique by its own editing style, and by building composite images using computer edits and effects. The tape is a late example of scratch video, pioneered by Gorilla in the early 1980s. Like its predecessors, *Zygosis* is likely to be heralded as a text in which the free play of signifiers has superseded the attachment between sign and referent, language and reality. But this is not how the tape works, and it is important to understand how it does

operate, and why, if we are to make sense of the difficult relation between the video image and the world. The purpose of *Zygosis*, like the Heartfield montages which it describes, is to intervene in the processes of mass media in such a way as to destabilise the flow of manipulated and administered images. To do so, photomontage and scratch video alike typically take a public, posed event – Nuremburg rally, presidential address, electoral photo-opportunity – and supplement it with a surrealistic commentary. Montage, to be clear about it, is not a process of uncovering, but one of commentary: the kind of commentary described above as characteristic of seeing oneself on tape. There is a supplement to be added to the event, a supplement which the event has tried to exclude by filling the image as much as possible with controlled and controlling signifiers. No-one is supposed to disrupt a showcase event like a rally or a press conference; any such incident is immediately described in terms of mob rule and gangsterism (terrorists of image manipulation).

However, the supplement offered by scratch/photomontage begins by disrupting the claim of such public occasions to speak for themselves. Commentary, especially this disruptive, almost childlike pleasure in disorganisation and mess, denies that the event stands by or for itself. The dignity of statesmen derives from lack of interruption, and the sense that they speak with authority: that they are the authors and origins of their speech. But montage steals that sense of original authority away. At the same time, though, the images used to disarm the rock-solid, self-sufficient pomposity of the good and the great, though surrealist perhaps, aren't random. The visual gags of *Zygosis* are each carefully timed to the sound-track, or cross-refer us to external knowledge we might have of Hitler's painterly ambitions, perhaps, or of the links between montage and advertising techniques. What we get is then not just a scattering of the terms of the discourse that formed the subject of the initial photo/tape: we also get a counterdiscourse established, one that picks a different way through the reading of the first text, not just disrupting it but entering into a dialogue with it. So it's not just 'art'; it is also political.

As the sight gags of *You've Been Framed* work against the grain of television's immaculate and seamless flow, montage and/or scratch work against the wholeness, the integrity of the achieved image, especially as that is produced in the marketing strategies of the political image maker. The first act of the spin doctor is to produce

an image of someone you can trust or, more correctly, to create out of someone an image you can trust. Montage's first step is to remove the possibility of trust in images by denying the transparency of the image and insisting on its construction. The specific technique used is the introduction of a further layer of signification between viewer and viewed, a layer built out of self-proclaiming edits or collaged imagery. But its second act, and it is this that slips out of the postmodernising agenda, is to make of distrust a political strategy, making out of the permeability, the fragility of the whole, trust-worthy politician the grounds for *political* action. Deflating leaders, making them subject to (rather than objects of) the viewers' interests, is a profoundly democratic use of the medium (or, in this case, media). And it has been broadcast on Channel 4. So while it is true that, to some extent, it will be marginalised and contained within the overall flow of TV, it is still the case that *Zygosis* can make some difference there.

This difference is central to my arguments here and in the conception of *Videography* as a whole. The gap between the viewer and the viewed, between image and commentary, is at the heart of the video relation; writing ('graphy') about video is one form of that relation. The need to speak or to add visual commentary, to supplement the image, arises from a recognition that neither the image in itself nor your own subjectivity in itself is whole, complete, unified, pure. Broadcast television makes up for this lack in itself by ceaseless renewal, never stopping long enough to allow recognition of its paucity. Video recording already disrupts that sense of TV's presence to itself, and in doing so damages the parallel psychic activity of the viewer. For the success of TV lies in the homology between its endless pursuit of fulfilment and that of the viewing subject, who is also incomplete and also seeks for full self-presence down the endless chain of experiences and activities in which s/he engages. The vision of oneself on tape brings this homology to a crisis, since in making manifest the incompletion of television (it hasn't included you just by representing you) it infers your own fragmentation too (what of me is left after I've been represented?).

By analogy, then, it is possible to argue that photomontage, by intervening in the travel of the image from source to viewer, not only sets up a counter discourse to that offered by the figured politicians, but also a counter discourse of subjectivity. Not content with enforcing awareness of the constructed nature of the image, it

devotes itself to making clear a message, the kind of clear statement of ideology which dominant culture avoids, preferring the silences of understatement and common sense. *Zygosis* works politically by making the processes of communication themselves apparent, including the role of the viewer as active participant in meaning-production. In place of the passive receiver of the transparencies of common sense, media messages are made the centre of a network of power relations. If Hitler can be made to skateboard, or Reagan to condemn his own administration: if, in short, leaders can be shown to be unable to control themselves when they are represented, then it is clear that when we do feel like believing them or similar people, it is often because no-one has challenged their control over their images. Video enables a contest over that control, while at the same time inferring that we have a stake in it too.

Montage, especially as practised in *Zygosis*, is a direct action on the material of the mass media. It is an error to conceive of the media as dependent for their existence on either ideology or language, at least in the simplest sense. Television is perfectly real, perfectly material. There is nothing immaterial about the sounds and images that emanate from the box in the corner. That under certain circumstances they may appear as merely mediators between two moments of the real doesn't alter the fact that they are themselves real. On the other hand, the linguistically-inspired semiotic criticism that has proved so productive in the last 20 years needs to be curbed in its ambition to see the world well lost in favour of a textuality without end. Montage and scratch, far from demonstrating the entirely self-consuming, self-obsessed intertextuality of video as 'mere' commentary on television, disrupt this illusory plenitude of texts that seem to have no need of a world in which they are read. Video is like language less because it is a 'langue', a systematic organisation of rules of difference, and more because it is composed of 'paroles', of instances of usage in which their construction, their textuality and their reception are all in play. This is as much as to say that, by dint of their materiality, the media, especially video and especially the practice of montage, share with anything else that is material the property of simultaneously working and being worked upon by everything else with which they come into contact.

Ironically, what is at stake in the arguments over postmodernism and television is not the reality effect – the supposed power of TV to

create a illusion of reality – but the new belief in the fictiveness of television. Semiotics has been drawn into an idealist map of the world in which the tenets of literary criticism are applied in blanket fashion to all cultural artefacts, a critical artifice which is founded on the primacy of text over production of reading. This sense of fictiveness evacuates from television texts their materiality, grounded in their production and use, to replace it with a rhetorical analysis focusing exclusively on discursive strategy to the exclusion of discourse's material conditions. The 'knock-out' shot in *You've Been Framed* is important here because it is disruptive of our by now generalised understanding of the fictiveness of television. Like Dr Johnson disproving Berkeley by kicking stones, the image of the camera struck by the pro-filmic, of the resistance of the real to being only camera-fodder, gives us a momentary and enjoyable release from the vertigo of TV as rhetoric, the postmodern television which has no exterior. Here, it does. No text is pure, though the new strategy of fictionalising TV in postmodern commentaries pursue this exclusion of reality as a route towards a foreclosed, self-fulfilling purity of the image. This idealising tendency is a deeply fatalistic one, replacing TV as bogie man (the core of an older effects theory) with the TV as infinite text, capable of absorbing every blow struck against it; this is TV ascribed the attributes of an endlessly wise, endlessly forgiving father (is this the secret of the 'No matter what you've done, you're our son' school of TV melodrama?).

In the struggle between language and reality, we are told, language is winning hands down. But, as applied to television, this depends on a series of steps, each of which bears analysing: (a) TV is a language; (b) TV rhetoric completely covers over reality; (c) TV is supplementary to reality, and has no reality of its own; (d) TV can be entirely defined as a textual practice. TV is not a language, it is a complex of many languages – musical, literary, graphic, photo-graphic, animated, and so on – some of which are mutually incompatible. It is for this reason, along with others, that TV cannot completely blanket out reality, and is in fact drawn back to the scene of its supposed murder of reality in images like the 'knock-out' shot. At the same time, TV is neither an alternative nor a surrogate for reality because it doesn't replace anything: it is merely additional. Video media – camcorders, VCRs, computer games played on the TV screen – reinforce the growing materialisa-tion of TV, its movement from mere channel of other interests

towards the status of social fact. And in this context it must be stressed yet again that pure textuality does not allow of a genuine understanding of the medium: what is needed is an understanding of the material processes of viewing. TV has no existence of its own: it must be used. This again is video's mission in reinterpreting TV as its historical role changes.

For things do change, including the nature and role of the media generally and also of specific media. The role of television has, in this sense, altered since the arrival of video, just as video as altered perpetually since its inception as electronic recording and playback. At the same time, though, if the argument concerning the homology between the medium and its viewing is correct, then we must also be looking at a shifting role for subjectivity, at least within the viewing situation. I have long nurtured a suspicion that Freud came to discover the unconscious when he did because it was only then, in the death throes of the Habsburg Empire, a particularly momentous modernising shift from feudal to bureaucratic society, that modern subjectivity (which had come into being more gradually throughout the rest of Europe as it was thrown into crisis) became a startlingly new subject for scientific knowledge. Is it possible that, despite Freud's theories to the contrary, the unconscious only came into being as a product of the evolution of capitalism? That the formation that brings with it scientific rationalism, the Protestant work ethic and the industrial workplace also is responsible for the specific formation of the psyche forged in those conditions? If so, we should begin the business of unearthing the history of unconsciousness, and in particular the investigation of the vagaries suffered in the split between language and reality.

The self is the site of this Freudian struggle, a self which has become less a citadel of sweet reason and more a kind of crossroads through which pass impulses, signs, caveats, anathemata and ukases, a caravanserai of treachery, temptation and intrigue where nothing is what it seems and no-one is ever at home. According to Foucault, there was at one time a harmonious synonymy of words and things. Up to the end of the sixteenth century, he tells us, 'The nature of things, their coexistence, the way in which they are linked together and communicate is nothing other than their resemblance. And that resemblance is visible only in the network of signs that crosses the world from one end to the other' (Foucault 1970, p. 29). At that stage, language was held to work because it, like the world,

was made of signs. So there was a straightforward continuity between the world and the perceiving, thinking subject. When, in the intellectual revolutions of the seventeenth century and after, the fault line between the two was established where it still is – between the mind and the body – the subject itself was irrevocably split. In the act of discriminating between word and world, the world began not at the epidermis but internally. The body became a place for symptoms, a thing to be read and interpreted, and ultimately, by Freud's time, a fellow creature, more or less distant, sending garbled messages in the form of dreams and parapraxes.

My utopian self wants to believe that video is a precursor of media forms on which this partition can be overcome. Video boasts its materiality, its physicality, and is perhaps best understood in terms of sound which is far more closely associated than vision, in our time, with the corporeal. Here we can begin to think of the mission of video less in terms of representation or even signification; indeed less, in general, in terms of its relation to a higher and more authentic reality, and more in terms of a direct interplay with the needs of a disrupted psyche torn unhappily between a reified language and a downcast world, between a mind condemned to cerebration and a body doomed to darkness. The physical world has become mysterious to us, while our mental processes have been ever further removed from the sensuous processes of the body. In *Chroniques de ma vie* (1935), Stravinsky writes: 'the phenomenon of music is given to us with the sole purpose of establishing an order in things, including, and particularly, the coordination between man and time' (cited in Griffiths 1978, pp. 66–8). It is at this level of physicality that video must operate: dealing in the mismatch between the linguistic and the real, the mental and the physical in terms of the almost (and sometimes actually) tactile experience of sound and vision, time and space.

It is for this reason that the theory chapters of this book derive much of their direction from the history of art and from music theory, only in that framework turning to more traditional concerns of media studies. It is not that there are two distinct phenomena, culture and art, which are utterly distinct from one another, but rather that each term collects about it a sense of how similar (or even the same) phenomena can be approached. In particular, coming in from the discursive field of art history allows a far broader historical canvas, one in which it is easier to distinguish the typical character-

istics of video in our time. It recognises, too, the historical dialectics which have produced art as a separate walk of life. Culture, on the other hand, cuts short the tendency of art criticism to ignore or marginalise the broad cross-currents that inform and shape every human practice.

Much of art history is still engaged in discourses of connoisseurship and of taste, the former an elite set of skills in iconography and the reading of the medium-specific qualities of paint, stone, wood and their associated techniques, the latter a Kantian hangover, claiming universality for a mode of experience which is simultaneously understood as a rare and precious gift of nature. Where cultural studies have already impinged on the discourse, for example in the work associated with T. J. Clark (for example, 1984) and Griselda Pollock (for example, 1988), it still returns to the centrality of the text, and to questions of what constitutes an adequate reading of art works. Cultural approaches, however, see the text only as a particular moment of its circulation, a circulation whose other moments include its production, the institutions surrounding both its making and its exchange, its marketing and promotion, and, crucially, its historical and contemporary reception by audiences. It's in this domain of reception that disciplinary cultural studies has made perhaps its most significant contributions to date to our understanding of how culture works. In the debates with the sophisticated theories of subject formation developed in the 1970s and 1980s, ethnographic cultural studies have urged a move away from even complex versions of effects theories, towards an understanding of the social and cultural formations within which they are received. Two jobs remain to be done: to undertake qualitative work on the reception of art objects (a task more difficult than it seems, given ethnography's long tradition of 'us' analysing 'them'), and to commence a reworking of the psychoanalytic in a form which addresses what appears to me the beginnings of an historical shift away from individualism towards the social. Freud undertook his work in a period dominated by individuality, especially among his bourgeois patients. What we now need is something that addresses the production of a social unconscious: not Jung's more than a little racist 'collective unconscious', but the kind of unconscious develped in common by relatively small groups, sharing as part of their community a sense of what's funny, embarrassing, fearful, exciting or moving. The mutual interaction of cultural studies and art

historical approaches in this work is intended in some way to contribute towards the conditions of possiblity of such developments.

Most domestic video recorders use a helical scan system to record and read back from the tape. In order to reduce the speed of tape through the machine, alternate vision tracks are laid by two heads on a single revolving drum set at an angle to the travel of the tape, so laying tracks diagonally across the tape surface. In most systems, these two heads are set at an angle to one another to minimise interference between adjacent tracks. A second head lays and reads the sound and control (synchronisation) tracks along the edges of the tape. The helical scan system seems to offer some sort of complex metaphor for the relationship I wanted to find between the art and culture approaches. Video media and their cultural practices can only become democratic, or keep open the possibility of democracy, if they continue to understand that they are profoundly dialectical. Videography, as the business of writing about video, must engage this strange double helix of analysis if it is to decipher our magnetic futures.

2

Video, Modernity and Modernism

A woman picks an apple. She picks it again. She puts it back on its branch, then there are two of her, mirrored across the video screen. Each picks and replaces apples, out of phase. The colour bleaches out of the image, from rich greens to harsh, grainy black and white, until the image becomes a kind of Rorschach blob, an illegible, symmetrical tangle in which we read off our desires. A woman like this woman but not her, another, similar woman, beckons from a gate, and fades away, reappearing further down a lane, beckoning. In modified form, these images will recirculate through the 18 minutes of Catherine Elwes's *Autumn* (1991), part of an ongoing project on the seasons. The only thing that is obvious is that this is not television. It is not transparent; you cannot read straight through it to a lived reality because something intervenes between you and the woman in the orchard, something that you wouldn't notice on TV.

A sense of distance emerges, one which Elwes, in unpublished notes on her work, associates with the use of computer graphics as they oscillate between their familiarity, in popular forms like title graphics and music video, and the unfamiliarity of their use in storytelling forms. The sense of distance, of a gap between the action in front of the camera and the image on the screen, is reinforced by the elliptical storytelling, the use of telling detail, the abrupt leaps from pastoral twitterings to a ringing telephone on the soundtrack. To some extent, this is like one of those children's games that make you suddenly aware that you're looking not at a jungle scene, but at interwoven 'hidden' pictures of animals. It makes you aware of the medium. Such jolts are familiar elements of our cultural landscape,

the sudden switches between illusion and reality, the bathos of gags that depend on asserting the real over the narrative. But we think of them, when we think of them, as belonging to a different kind of experience from the familiar patterns of domestic culture. TV always seems to be a window: this is a self-conscious screen. This isn't television: this is art.

Once upon a time, there was no such thing as 'art'. Though we are accustomed to describe cave-paintings, ritual sculpture and mediaeval cathedrals as art, it is not a term the makers of such things would recognise. For the mediaeval cathedral builders, when the word 'art' arose, it was used in the way that has been preserved in the word 'artisan'. A maker's 'art' was that which could be acquired in a guild, or through an apprenticeship. As such, it is unsurprising that there was little sense of art as a separate entity from everyday life. Though each guild fought tooth and nail to preserve the value of its 'mystery', then a synonym for art, and though there was fierce competition for status between the different guilds, there was no clear hierarchy among them. Silver and goldsmiths, sculptors in wood and stone, makers of glass, dyers, weavers, painters all worked on single great projects, and the hierarchy operated within the guild rather than between different guilds.

Moreover, the classic forms of mediaeval culture were public or divine. They had a purpose, either in the praise of God or the glorification of rule. Admittedly, some works were intended for all eyes, while some were restricted to those who could go beyond the rood screen of the cathedral or could enter the inner sanctums of palaces and courts. Some things were made for only one human user, but in the spirit of devotion common to all; and some, like the gargoyles that crown Notre-Dame-de-Paris, were intended only for the eyes of God or gods. Art, in the sense of craft or skill, might then be exercised by guild-masters and others in special places and for special audiences. But by and large, the arts, all equal, all woven together in the great public works, lived alongside every other aspect of daily life. They shared the belief systems of ordinary people, served ordinary purposes like prayer or power, and although the erudite could look forward to unearthing the secret meanings of a rose window at Chartres or the masonry of Lincoln hidden from the eyes of the unlearned, nonetheless the unlearned could still look upon the same windows and carvings with pleasure and profit.

The more strange therefore it is to have to investigate the provenance of the concept of art with which we have become familiar in the modern period. How did art become a separate entity from culture generally, in a historical process which at the same time makes culture a field of practice separate from art? What has that process meant for the histories of art and culture in the twentieth century, and what does it tell us about the tasks of video practice at the brink of the twenty-first? Perhaps this is not the most urgent group of questions to ask of modern history, whose themes include the emancipation of the serfs, the break-up of religion, the rise of rationality, the market, imperialism, urbanisation, of technology and of the myth of progress, the implacable spread of science, the domination of bureaucracies, the poisoning of the environment and the triumph of capitalism. Yet in many ways, in microcosm, it allows us to understand the kind of processes which govern the emergence of our contemporary world. That a human faculty which has at certain moments at least been believed to hold the key to an essential core of human nature should have become so separate from everyday experience as has been the case for over a hundred years now: that surely is an important prelude to looking at the cultural politics of the present.

One of the central problems facing video, then, is the emergence of art as an autonomous activity. To some extent, this shift can be understood positively, as the emergence of a free play of visual production from under the shadows of theology, morality and governance. This is the kind of freedom celebrated in the more abstract forms of video, and would include not just tapes made for the gallery market, but also the kind of 'pure entertainment' represented by the videographics deployed in TV title sequences. The kind of light-show videos used in clubs or the title sequences for youth programmes are typical, using the full range of technical devices to produce fields of pure colour, shapes with no particular reference to reality.

Yet this notion of freedom is not achieved without some costs. In freeing itself from the purposes designed for it under the holistic regimes of feudal culture, art at once lost its social role in the broad field of everyday life and became internally hierarchical, with painting – and, to a lesser extent, sculpture – occupying pride of place. Those arts that still do retain a social role are demoted to the

ranks of decorative or applied arts. So the sheerly playful, decorative work of club video artists, or the skilful work of Matt Forrest for Snapper Films/Initial TV in the credits for the British Channel 4 series *Wired*, are considered as mere design, ejected from the hierarchies of painting and sculpture, so that their freedom to innovate is paid for at the price of lowered status. Thus the internal hierarchy removes the emergent artist from the ranks of his peers.

The word 'his' here is not accidental. Historically, the more art is removed into its own sphere of activity, the less it can be approached by women, and by the same token those things that women do that might otherwise have been constituted as mysteries – weaving, dyeing, embroidery and all the other crafts that could be undertaken during the slack winter months – cease to be considered as art. In finding its autonomy in emancipation from the religious and political tasks set for it in mediaeval times, art also loses, over a period of centuries, its roots in the living culture around it. Furthermore, despite pleas to the contrary, art's autonomy is not achievable without taking on board some (if not all) of the founding cultural formations within which it comes into existence. Of these the most profound must be the almost complete exclusion of women from the domains considered artistic, and also of women's familiar media from the defining selection of media that make up the newly formed notion of art. So the socioeconomic exclusion of women is carried over even into this autonomous domain. It is one of the more familiar battles of video culture, perhaps exploiting television's historically important position in women's lives, that it demands a place for women in the centre of the video art world, with practitioners like Catherine Elwes, Max Almy, Dara Birnbaum and Tina Keane at the head of their profession.

As an autonomous field of endeavour, and one with its own internal logics, art enters into a set of processes both internal and external, becoming an unsettled, questing affair characterised by the conflict of 'isms': classicism, Romanticism, modernism, post-modernism, and so on. In the history of art in the modern period (which historians tend to date from the fourteenth century), the succession of 'isms' moves between reference to ancient models, reference to individuality, and reference to the broader social world, each superseding the other, but all leaving their traces in the accumulated meanings accruing to individual works or collections. The cult of the artist became a central tenet of art appreciation

rather late, reaching its full flowering in the Romantic period. That we know something of the biography of Van Gogh or Gauguin becomes as important as the artworks themselves. As an 'ism', modernism is a reaction against Romanticism, and shifts the emphasis away from the artist to the work or, more specifically, towards the attributes of the work in which the author plays the least role. Thus for F. R. Leavis the tradition, or for Clement Greenberg the approach towards absolute painting become the central issues, rather than the input of individuality. In the machine aesthetics of the Bauhaus and Purism, or in the late works of Matisse, for example, personality is to be eliminated from the functioning of the work. For the British critic Clive Bell, the relevance of art derived neither from representation nor from 'technical swagger', but from what he referred to as significant form: 'to appreciate a work of art we need bring with us nothing from life ... nothing but a sense of form and colour and a knowledge of three-dimensional space' (Bell 1982, pp. 72–3). In pursuit of this purity, Bell champions 'primitive' art as a bastion of this significant form: 'either from want of skill or from want of will, primitives neither create illusions, nor make display of extravagant accomplishment, but concentrate their energies on the one thing needful – the creation of form' (Bell 1982, p. 72).

In the introduction to *Primitivism in twentieth Century Art*, the catalogue of the major exhibition at MOMA, New York, in 1984, William Rubin writes: 'I want to understand the Primitive sculptures in terms of the Western context in which modern artists "discovered" them. The ethnologists' primary concern – the specific function and significance of each of these objects – is irrelevant to my topic' (Rubin 1984, p. 1). If modernism is a reaction against Romanticism, and prizes the anonymity of the artist within the work, it does so with regard to the artefacts of colonised peoples by rejoicing in the removal of the work from the culture in which it has meaning. In the case of the holdings of the great imperial museums – the British Museum, the Musée de l'Homme, the Smithsonian and so on – what artists and critics found was an art already uprooted and alienated from its home culture (by force, in this case), and which therefore seemed to share their sense of autonomy. But of course, this kind of autonomy of colonial art could only be purchased at the price of colonisation. The meanings and functions of such objects in their home cultures are irrelevant. So that the

interpretations of colonised people concerning their own artefacts are likewise irrelevant, since they do not know how to see their own works as autonomous, as significant form. Thus the skills of the colonised are, like the skills of women (but in a different way), excluded from the domain of high modernism. Once again, in the formation of its autonomy and increasingly, art becomes the creature of fundamental truths of the society which it so wishes to escape. In excluding both women and 'primitive' cultures, it loses touch with the vast majority of the human race.

Worse still, it can be argued from several standpoints that in the nineteenth and early twentieth centuries, in the period of the historic avant-gardes, the easel painters even lost touch with their most natural allies, the new ruling bourgeoisies of Europe and North America. Had the artists, in one of those terrible verbal slippages that cursed the nineteenth century, mistaken the economic category 'bourgeoisie' for the abusive adjective 'bourgeois', by which one meant Philistine, boorish and soulless? Were their erstwhile patrons really so incapable of appreciating the formal breakthroughs of Impressionism and its followers? Or did the artists deliberately spurn the art market, the salons and dealers, bringing calamity upon their own heads? There is little to suggest that artists like Monet and Renoir were impoverished in their lifetimes, though undoubtedly other, more traditional artists made a more handsome living. Certainly, after the 1917 performance of the Cocteau–Picasso–Satie–Diaghilev ballet *Parade*, conceived of in the wake of Zurich Dada and performed in a city in hearing distance of the front line, it appears that collecting the works of even the most rebarbative vanguardists became more than a fad. Fashionable, wealthy Paris sought out and lionised the daring young men; it was the critical moment at which the revolutionary potential of the avant-garde was undercut, the beginning, for John Berger, of a period in which it is possible for the modern artist to share, maybe without wishing, the position and privilege of the rulers (Berger 1965, pp. 84–90; cf. also Willett 1978).

Perhaps we have a tendency, in the rewriting of art history from the standpoint of the late twentieth century, to overemphasise that episode between the 1870s and 1917 (largely confined to Paris) during which the cult of art for art's sake, the apogee of art's autonomy, seems to us in retrospect the most significant theme. Other painters continued to make a living, and visual culture was, if

anything, more likely to have been enriched by the rise of advertising, the popularisation of photography and the advent of the cinema. Yet the startling and profoundly influential experiments of the artists of the period, the reorganisation of the art market towards the selling and the status of vanguard art, and the belief among artists, critics and curators subsequently in the autonomy of art have had an impact which we are still feeling. Just as the Romantic cult of the artist persists in art writing and curatorial practice (as well as in more popular versions such as the Hollywood artist's biopic), modernism returns as a central thesis of art criticism, first with the New York School of the 1940s and 1950s, and again in general histories of twentieth century art. Yet we should not give up the struggle for art simply because it looks as if we have already lost out to autonomy and aristocratic collectors.

In the history of art, the term 'modernism' is most closely identified with a particular aspect of this process of autonomisation. Freed from the necessity to teach, art can pursue art answers for art questions. This is its most modern characteristic: to exist apart from the world, and to pursue ends other than those of the world. To this extent, it can be read, as it was by Theodor Adorno, as the negation of bourgeois culture, the obverse of mass exploitation through the mass media. Freed from the necessities of the everyday world, it still shares the conditions of its existence with that world. And yet, existing or at least pursuing its aims separately and differently, art can be, by the mere fact of its existence, a critical presence in the world, a presence that announces another agenda, another set of parameters for judgement. Perhaps this is why artists, more than most people, tend to appeal to posterity to judge them, being by the nature of their calling somewhat removed from the criteria used elsewhere every day. And we tend to agree with them: if I can't make head or tail of it, let posterity sort it out. And maybe not just this or that piece of art, but art in general. What has modern painting got to do with me? It is still surprising to realise how violent people's reactions can be to art. In 1955, the British papers were full of the Tate Gallery's purchase of Matisse's huge late abstract *The Snail*, and again in 1966 over his four large bronze *Backs*. The proof of the case for posterity is, of course, that today we would all agree with the curatorial judgement to get into Matisse while the man was still alive. Thus posterity serves art: but art, in return, serves to reproduce the ideology of posterity as judge.

More recently works by Roy Lichtenstein and Carl André have brought on apoplexy in the letter columns of the London *Times*. It is surprising how powerfully such offences against public taste are felt, and equally astonishing that it is relatively rare that works are vandalised. Art then has a life in contemporary society. Galleries form a major item on tourist itineraries, and new galleries like the Liverpool Tate and the Bradford Museum of Photography, Film and Television are consciously sited and designed for their appeal as tourist attractions. But even such user-friendly museums retain some of the hieratic standing of their nineteenth century forebears, in which cathedral-like architecture and the golden glow of ornate frames recoup for art some of the religious aura of an earlier, sacred role of the visual media. The great public collections function not only as markers of national kudos but also (especially those founded in the nineteenth century) as elements of a specifically modern project of edification and enlightenment under the banner of 'rational recreation'. Though each gallery sets about promoting particular artists and works, through its choices of which works to hang and in which order, through guided tours and lecture programmes, pamphlets and advertising, it also promotes the idea of painting as such. As Baudrillard notes:

> One might believe that, by removing the works from this parallel market to 'nationalise' them, the museum returns them to a sort of collective ownership and so to their 'authentic' aesthetic function. In fact the museum acts as a *guarantee* for the aristocratic exchange. It is a double guarantee:
> – just as a gold bank, the public backing of the Bank of France, is necessary in order that the circulation of capital and private speculation be organised, so the fixed reserve of the museum is necessary for the functioning of the sign exchange of paintings. Museums play the role of banks in the political economy of paintings;
> – not content to act as an organic guarantee of speculation in art, the museum acts as an agency guaranteeing the universality of painting (Baudrillard 1972, pp. 141–2)

This perception of national galleries as banks can be argued across several related fields: the University as the bank of knowledge, the National Film Theatre as the underwriter of moving-image culture.

Part of the purpose of writing about electronic images is that they have no institutional home, and suffer (as well as gain) from this lack in their public status. Indeed, the very absence of an audience, most notably in the UK, for video and electronic arts is further ground for facing up to the actuality, if not the desirability, of video art's autonomous status.

The autonomy of art, marked by its separation from everyday life in the gallery, is the necessary condition for the circulation of art works as commodities. The gallery lets us know that painting is, in and of itself, valuable. So the freedom of art from the concerns of education, morality and religion is also the freedom of exchange in a 'free' market. In many ways, the position of video outside the national collections and therefore outside the commodity market for artworks has driven it to pursue logics other than that of an autonomous art. Perhaps it is in the recreation, for a brief period in the late 1970s and early 1980s, of collective work practices in the Workshop sector that we can see this complex, socialised cultural practice at its most distinctive. Sharing in some ways the utopian moments of the Arts and Crafts Movement in Britain or the Piscatorbuhne in Germany, where a flight from high art opened the possibility of group productions (in the Arts and Crafts instance consciously modelled on the mediaeval guild system) for a wide public, the workshops and related production groups encouraged not just the production of works (of which the most memorable are mainly shot on film) in collectives, but also developed the idea of 'integrated practice', melding production, education, exhibition and training.

There emerged, in the British video scene in particular, a dual set of concerns: on the one hand, a grouping of artists investigating the specific properties of the medium according to a modernist, autonomous aesthetic that might both grant them a place in the gallery world and open up that world to a far more complex set of representations and practices; and on the other a concern for documentary-style productions whose rationale lay outside the medium itself, and whose circulation depended more on sympathetic organisations (women's groups, trade unions and educational institutions among them). The workshops, exploiting what D. N. Rodowick (1989) refers to as a 'political modernism' in which avant-garde techniques are drawn into the service of sociopolitical videomaking, oscillated between these two positions, making

purposive works whose formal concerns were to be understood in terms of political objectives.

The autonomy of art re-emerges in the politicised forms of modernism, especially those concerned with the moving image, in terms of a regard for the specificity of the medium. In its earliest forms, this appears in Eisenstein's development of montage as a specifically filmic organisation of vision over time. In the workshops, it appears as a belief that new messages demand new forms, and that the old forms carry reactionary ideologies even when their content appears to be progressive. This kind of debate gave, as its explicit roots, the theatre of Brecht and the films of Godard. Yet there are striking parallels with the debates in North American art circles in the late 1930s, which I believe bear exploration in this context. Most of all, the workshop sector found itself in an aesthetic impasse in the early 1980s, and has taken up only some of the possible routes available to escape from it, quite probably as a result of the crisis in arts and moving-image funding in the period. An exploration of aspects of modernism may help find other ways of dealing with the problem.

Among theoreticians of modernism in art, few have been as influential as Clement Greenberg (1986a) who, in a 1939 essay on 'Avant Garde and Kitsch', analysed the shift away from the 'natural' bourgeois audience for contemporary vanguard art. In their place, he found artists addressing not their audience, but the very processes of art itself. Writing from a position strongly influenced by Leon Trotsky (who had co-authored, but not signed, an important manifesto published a year earlier in the same *Partisan Review* for which he himself was writing: cf. Chipp 1968, pp. 483–6), Greenberg argues that the difference between avant-garde and kitsch (roughly described as both trash culture in North America and the official art of the European dictatorships) was that 'If the avant-garde imitates the processes of art, kitsch, we now see, imitates its effects' (Greenberg 1986a, p. 17). Genuine art reflects upon its severance from life through a prolonged engagement in the material practices of art's production. In doing so, art unpicks the seamless web of representations and ideologies, revealing through its formal investigations the formal contradictions of bourgeois society. Kitsch, meanwhile, merely manipulates form to provide its practitioners with techniques which, in turn, merely reproduce the common sense of what the world is like and how one should fit

into it. At the same time, kitsch depends so heavily on familiarity that it can be used in the European dictatorships as proof that rulers and ruled share the same, familiar art, and by implication the same world-view, morality, politics.

If not as thoroughly worked-out, this line must remind us of Theodor Adorno's work on modernism, and especially on music: on the one hand 'jazz' (which for Adorno included all popular music), replicating the rhythms of factory and office, introducing time management into the realm of leisure; and on the other the harsh elegance of Schönberg and Berg's atonal music, in which the very logic of classical music drives it to a point at which the 'naturalness' of harmony and counterpoint is unmasked as ideological. It is unfair to both Greenberg and Adorno to call them elitist and let the arguments slip at that. Adorno's 'melancholy science' is a more productive pessimism than most postmodernisms, and Greenberg's position at this cusp of his career is perhaps at its most fruitfully ambivalent.

Greenberg's targets are not so much the distant victors of the struggle over Soviet socialist realism as they are the emergent cultural activists around *Partisan Review* and related papers. Of these only John Steinbeck, the novelist, is actually named as a 'puzzling borderline case' (Greenberg 1986a, p. 13) comparable to Georges Simenon in Belgium. The enemy, in terms of painting, is Norman Rockwell, cover artist for the middle-brow *Saturday Evening Post* and popular chronicler of sentimentalised Americana. Somehow, one feels that the true targets are not the clearly popular, but those politically committed artists who have taken over a realist framework in pursuit of a popular political art: artists like Ben Shahn, Peter Blume and Margaret Bourke-White, and the many more associated with the Federal Arts Project of the Works Progress Administration or the Artists' Congress. Likewise the opposite end of the political spectrum, as represented by the Regionalist painters James Steuart Curry, Thomas Hart Benton and Grant Wood, also devoted themselves to a fierce American naturalism in opposition to what they perceived as the homosexuality and Marxism of abstract art.

Greenberg, like Adorno, is making the case for a genuinely critical art: an art which refuses the beliefs, the values, even the techniques of its host culture, and which instead devotes itself to exploring the terms of its own autonomy (and, by inference, the nature of the gap

between art and society). To insist on the salvation of either the proletariat or the American nation through a blind belief in realist devices of representation was naïve, uncritical, lazy, kitsch. The best art of the time was for him European and abstract. Where kitsch fights to maintain the status quo, or even the status quo ante, the avant-garde's most important function becomes 'to find a path along which it would be possible to keep culture *moving* in the midst of ideological confusion and violence' (Greenberg 1986a, p. 8), and 'since the avant-garde forms the only living culture we now have, the survival in the near future of culture in general is threatened' (Greenberg 1986a, p. 11).

Though at times ready to succumb too much to European models, and thence to overlook the achievements of some key North American painters like Stuart Davis, Georgia O'Keefe and Marsden Hartley, and though he too easily reduces the work of modern avant-gardes to sheer work upon the materials of poetry or painting, 'Avant-Garde and Kitsch' is still one of the finest expressions of modernist art criticism. Within a matter of years, however, Greenberg's position had moved from that of tyro, praising only what was not American, into the most fervent of American nationalists. The crucial qualities of modern painting were flatness and extension. The sheer physical nature of painting – that it is two-dimensional, and of a fixed shape – dominates its function. To be interested in painting is to eschew any involvement in representation (that would be literature) or depth (volume and space are the concern of sculpture) or time (the business of cinema and music). Painting needs to be purified of these extraneous interests and engage itself exclusively in the abstract workings of its own purity. This hardening of perception into dogma not only entails a rewriting of art history as the approach towards this messianic goal: it draws us towards a limit point, beyond which painting is scarcely conceivable. In the New York abstract expressionists, especially Pollock but also Still and Newman, Greenberg found a native American avant-garde whose pursuit of the all-over canvas and the painterly matched his yearnings for an art completely freed of social relevance. Yet it was, in the terms of one 1955 essay, "American-type" painting' (Greenberg 1982a), a vital element in the making of the New York hegemony over the post-war art world, seeking a European stamp of approval to ratify the market in living American artists among American collectors, already the richest market in the world.

In recent historical work on the emergence of Pollock and the others as ambassadors of the USA in the Cold War, Greenberg's formulation of modernism takes on a sinister ring. *Partisan Review* was in receipt of CIA funds while it promoted the notion of an American art encapsulating individuality, progress, freedom, passion, scale, machismo and modernity itself. Ironically, this art became the first avant-garde since the second decade of the twentieth century to become intimately involved in the dominant class itself. The emergence of an American modernism, unlike the rebellious modernism of Europe, was a project to invent culture where, according to commentators like Greenberg, it had never existed before. As Andreas Huyssen (1986) argues, the North American experience of modernism as new orthodoxy is far more oppressive than the European history of proactive avant-gardes pursuing a series of modified goals in constant rejection of the previous establishment.

It is this North American modernism, recaptured in parallel though different ways by Theodor Adorno in his American years, which has formed that 'high modernism' against which postmodernists would see themselves rebelling. Most of all, the teleological aspects of Greenberg's writing, according to which painting, sculpture and poetry all ascend inevitably towards the absolute, have become a target for attack. Yet the conception of medium specificity, which is Greenberg's longest-lasting contribution to the growth of modern aesthetics, does remove him from both the errors of pure taste which he shares with F. R. Leavis and from the Romantic necessity of placing the figure of the artist centre-stage in any critical language. Placing the art, rather than biography or connoisseurship, at the heart of the aesthetic experience is in its way a democratic leap, suggesting that there is only the moment of perception in which art exists, and that the barriers erected by scholarship or hagiography are redundant. In 'Modernist Painting', Greenberg argues that modernist art 'converts all theoretical possibilities into empirical ones, and in doing so tests, inadvertently, all theories about art for their relevance to the actual practice and experience of art' (Greenberg 1982b, p. 9).

One way of reading this purist, even reductive conception of art is to see Greenberg attempting to philosophise an extension of the first, pristine moment of perception. When first we see a painting, it has its impact, and that impact grows or diminishes with further

acquaintance. But the point of arguing the paintedness of painting (or Bell's 'significant form') is to justify enjoying most, and for the longest time possible, that first instant of awareness. Certainly this is a more open stance on how paintings can be enjoyed than the scholarly or even the mythopoeic versions of earlier modes of art criticism, even though often couched in terms that may strike us as elitist. And certainly it is an advance on much interpretative criticism to insist on the status of an artwork as a thing produced in a specific way, using specific techniques and addressing specific issues particular to the medium in which it is made.

Perhaps the more prescriptive aspects of the theory – that painting should not seek to emulate sculpture or literature, for example – are less relevant to video, which embraces in any case the sculptural and the narrative. The notion of a democratic culture has moreover expanded in the decades since Greenberg to encompass a far richer and more diverse notion of society than the two-dimensional bourgeois/proletarian model on which so much of his writing and that of other modernists is premised. Yet the notion of medium specificity is a central one in understanding the development of video as a cultural form, and one that must be addressed in investigating video as art.

Not that this is itself without problems. Video is a bastard medium, however narrowly defined. Film, photography, electronic cameras, computers and a plethora of sources for sound combine, potentially and actually, with a massive variety of playback. Yet the early days of video practice are filled with effectively modernist statements and events. Thus Robert Rosen on Ernie Kovacs: 'Kovacs was convinced that the fledgling medium could never come to realise its full potential if it were treated as little more than filmed vaudeville or illustrated radio. Rather he sought to develop the inherent characteristics of television' (Rosen 1985); or David A. Ross on *Merce by Merce by Paik*: 'What quickly emerges is the notion that time is the subject of this work, time as experienced by the dancer in action, and the relative nature of time as the malleable component of video art' (Ross 1985). Paik's early experiments with magnets show a profound understanding of the modernist aesthetic, and a deeply subversive one. Placing magnets in or on a monitor tuned to receive broadcast TV distorts the image, foregrounding the mechanics of reproduction and providing precisely that negativity which Adorno prized. Against the endless flow of broadcast, a direct

address to the presence of the image on screen produces both an immanent critique of the everyday naturalisation of the medium as window, and simultaneously generates a visual experience in its own right.

Likewise explorations of instant playback exploited the early reel-to-reel technology to unearth the capabilities of the new medium as a goal in itself. What was so special about video? What was its special calling? How could it inform the pervasive concern with the flatness of painting or the spatial qualities of sculpture? What were its specific qualities? And the answer came back almost immediately that video dealt in a new way with time. The technology of the surveillance, closed-circuit TV camera was unpacked so that recording and playback were separated, if only by a matter of seconds, in order to quiz the spatio-temporal assumptions of audience and makers alike. (It seems somewhat ironic that the replacement of the clumsy old reel-to-reel technology by user-friendly cassette systems has made this aspect of video art's history almost impossible to restage.) Of course, this mixing of audience and technology becomes in some senses theatrical, and the performance aspects of the medium also open themselves up for exploration. Video has again a special relation to modernism: every pursuit of the medium's specificity uncovers a new impurity, a new relation between video and the adjacent arts. As a kind of rag-bag through which all other media can be reached, video takes on the qualities of an epic medium, in the sense both of Ezra Pound (the epic contains history) and of Bertolt Brecht (the epic theatre challenges the notion of the artwork as complete in itself). As epic, video deals in time and difference, and its specificity is that it is constantly changing. It is easy to leap from here into a platitude about postmodernism.

However, the modernist aesthetic is far from worked through yet. Though theoretically it is hard to defend a single defining characteristic, individually, video works and writings about them return constantly to the thematics of medium specificity, if only in attacking a piece for its lack of respect for the medium. Thus I would feel quite happy about dismissing a pop video on the grounds that it fails to understand the media of video or of broadcasting. Likewise criticism that reacts to video pieces as if they were films (or novels or sculpture) seems worth removing from the lists of vital video reading. At the same time, that a piece of work has been originated using a movie camera (or ultrasound or cel animation)

seems shallow ground to refuse to undertake a serious analysis of it in relation to an aesthetics more proper to electronic media.

Thus when a given work suggests or is presented as an exemplar of a particular mode of video's specificity – that the monitor is treated as a light-source; that the work deals with the nature of the signal; that the nature of magnetic tape or instant playback are at stake, and so forth – even though there are many possible defining characteristics and few if any of them cover all domains of video practice, still there is an air of legitimacy and seriousness about such claims. When Godard draws on the screen in *France/Tour/Détour/ Deux Enfants* (1978), or when Jaap Drupsteen orchestrates Stravinsky's *The Flood* (1985) in a maelstrom of paintbox effects, though both pieces were conceived of as television, they take on the modernist lineaments of video in as much as they address the medium for itself. By comparison, everyday television dismisses the processes of its making and its existence as broadcasting in favour of a naturalised and universalised flow, in which the existence of screen and speakers are entirely subordinated to the pretence that the activity 'television' will continue with or without its material form. The function of the modernist conception of video as self-aware and medium-specific is to insist on just that materiality.

One crucial difference between video and painting, however, is that video is not visible unless it is changing. If Greenberg and Bell are indeed prioritising the original moment of perception, then that concept of the moment is not applicable to video. The unit of video is not the single frame but the movement from frame to frame, the disappearing of one and the appearing of another, so that no single frame is ever complete enough for it to be recognised as the particular moment of origin. As we will see in Chapter 4, the idea of origin has its own problems in contemporary theory, but in any case we would have to suggest that there can be no originating moment in the experience of video as image or sound (you cannot, needless to say, freeze a sound). From this point of view, the closest video has ever come to modernism would be Nam June Paik's *Video-Buddha* (1974–88), in which an eighteenth century Tibetan statue of the Buddha contemplates his image via closed-circuit TV; yet even this still moment of contemplation, in its circular organisation, presumes a sense of changelessness grounded in TV as change. And, again, this is a work in which Korean zen also plays its part, a religious work whose provenance has little to do with the Western

modernisation through the secular, the rational, the instrumental use of logic, the empirical, the autonomous. Here the modernist exclusion zone around the 'primitive' might lead us into reading Paik's Buddha as modernist, since we have devised routes for understanding which exclude the theological. Paik's reading of the record–playback circuit includes the modernist version, as epic video includes history, and in including, challenges its apparent inevitability. But Paik's Buddha offers an alternative state of stasis to either the modernist artwork *pur et dur* (pure and hard) or the immobilisation of a society that proclaims itself 'at the end of history', a Buddhism that both incorporates and negates the secular. An alternative stasis, though it be defensive, is still, as an alternative, proof of the principle of difference, the fundamental historical process.

So video as art marks itself off from the world. As installation, or even as intervention in broadcasting (taking all the risks of repressive tolerance which that implies), video instigates a process of difference or perhaps, more specifically, imitates such processes. In insisting on its own temporal procedures, it marks itself off from the love of fixity so characteristic, beneath the glittering surface of novelty, of late capitalism. Even when closest to the formal procedures of 'low' modernism, the techniques of advertising, pop video or TV trailers, video art works upon the logic of the form rather than of the content. So Greenberg, back in 1939, spotted the crucial factor which can lead us out from the impasse of modernism: 'When there is an avant-garde, generally we also find a rearguard. True enough – simultaneously with the entrance of the avant-garde, a second new cultural phenomenon appeared in the industrial West: that thing to which the Germans give the wonderful name of *Kitsch*' (Greenberg 1986, p. 11). The avant-garde is not conceivable beyond the difference between it and everyday culture. So far, modernism as a doctrinal statement on the history of art since Courbet has focused on the production of the avant-garde as a *different* mode of working in culture. The task which video has set itself is parallel to that which emerges as the new dominant in the years immediately after the triumph of abstract expressionism, the self-conscious looting by high art of the super-markets of popular culture. But where this late modernism of pop art is marked most heavily by its ironic attempts to obliterate the difference between art and culture, video remains in the business of exploring that difference, that relationship.

3

In Pursuit of the Lost Audience

By the time he wrote 'Modernist Painting' in 1965, Greenberg had espoused another aspect of modernism, in common with Leavis and Adorno: the notion of continuity, or backward-looking history that traces influences from painter back through painter to establish that there is nothing definitively new, nothing definitively dangerous or subversive, about modern art. At the same time, I have tried to argue in the previous chapter that 'primitivism' plays a core role in modernism, a colonial and neo-colonial turn of formal interest towards the technical and/or expressive possibilities of exotic cultures. Gauguin's Tahiti (a more exotic alternative to Paris than Brittany), Picasso's masks and Breton's characterisation of Mexico as the truly surrealist country are all colonial gestures.

Again, there is the question of constructions of femininity in the late nineteenth and early twentieth centuries, often aligned (in Gauguin and Picasso) with 'primitive' techniques, with homophobia (cf. Gauthier 1971), with misogyny (cf. Duncan 1973) and with the naturalisation of heterosexuality within the new bourgeois domains of public and private (cf. Pollock 1988; Woolf 1985): femininity as object rather than subject. There is the issue of the growing market for living artists, the trade in reputations as a kind of futures market for art as commodity. There is the issue of the relations between high art and popular culture raised at the end of the last chapter. And there are issues still to be addressed concerning the emergence of new technologies during the modernist epoch.

If we were to make a map of these (not necessarily competing) definitions of modernism, and then to arrange a paired map of their negations, would it give us a map for our generation of artists and

cultural practitioners? How would it look? Instead of a universal there would be a local audience; a refusal of the centrality of heterosexuality and a consequent belittling of the public/private divide; a sense that gallery and museum, as twin elements of the commodity trade in paintings, have no place in art; ordinary people seizing the techniques of high art, rather than vice versa; and an overcoming of the subject/object binary. In all of these negations, to maintain the most persuasive and powerful negation made by the modernists, is the calling into question of the role of the individual artist. What might such an art look like?

In June 1990 there was a commission to make a video with the residents of an embattled estate in Runcorn, part of the Barrett homes and roundabout zone of the Warrington New Town area in Cheshire, England. Simon Robertshaw was brought in as animator by Halton Borough Council and Moviola, a local arts trust.

The Southgate estate dates from the 1970s it was designed by James Stirling, and was a prize winner. It is concrete (soaks up the rain) with round windows (collect condensation) built on 'decks' (space for vandals) on the architectural metaphor of a ship, and is popularly known as Legoland. Like Manchester's Moss Side, eminently policeable. By then two-thirds empty, as residents moved on to better homes, there was yet a strong sense of community locally, a sense of problems shared and common struggles; but it was about to be bulldozed.

The community resource centre that housed the video project had never used video before. In 16 working days, what began as a community documentary emerged as an extraordinary installation in Shopping City, one of those nightmare indoor shoparamas that pass for the nub of communities designed by businessmen. In a circle stood three pyramids of washing machines, each housing a monitor seen through their round doors, playing on the estate's architecture. The monitors showed two tapes, one a straight documentary treatment moving from complaints about the estate through the achievement of the community in making it a living environment, to the proposals to demolish. The other tape was an architectural survey, edited through circular masks for daylight shots, and shot using a circular, camera-mounted spot for night. The sound of interviewees mingled with jolly shopping music recorded by one of the team on a Yamaha keyboard. The whole McCoy sat on a podium surrounded by a ropelight beneath a ceiling-mounted

sculptural clock in brushed aluminium commemorating the opening
of the aforesaid shopping nightmare by HM Queen Elizabeth the
Second. Nearby was a rival display of fitted kitchen ranges, along-
side which the piece took its place. A surveillance camera watched
from the mezzanine.

Southgate Video Group's installation *S.T.R.E.S.S.* (1990) was the
product of a collective process focusing on conditions of living,
including but not dominated by, the operations of sexuality (for
example, in footage of a children's festival), which insists on the
public nature of its practice while employing emotive forms, and
concentrating on the local dimension that gives it its meaning. It is a
piece that uses its local appeal to work over the binary opposition of
pubic and private, and which in doing so shifts the relation of the
viewer from contemplative subject to active participant in the power
relations that create the matter of the art. This is not so much an
escape from the gallery as an art that has nothing at all to say to
such a culture (even *Performance* magazine turned down a review as
'not our sort of subject').

And more: the way the piece voices its protest in public, as public
art, made by the same public that shops here daily, bringing their
homes into the wonderland of consumerism; the way it echoes the
neighbouring fully-fitted kitchens installation (but is more interest-
ing to look at); the way the Manweb TV rental shop (which supplied
the monitors) peers coyly round the end of the kitchen ranges with
formica mahogany trim; the way this art engages with the serious-
ness of its making, and shows itself appropriately; an art that,
finally, is now dismantled, as the estate has been, and is as unlikely
to be rebuilt. It was an ephemeral art that denied the eternal verities
of traditional Romantic or modernist aesthetics. The 'community'
which has always been disparate and desperate has begun to steal
back from art what art walked away with when it left the public
behind and went indoors to the gallery. And in the process, it hints
of an art that changes utterly what we can understand by art.

I am tempted to say that this is the shape of the art of the future.
But in this pursuit of solutions to the problem of modernism, social
and historical solutions, it is essential to keep a weather eye on the
social and historical material on which this art, consciously or
unconsciously, is premised. Though this is to some extent a
futurological and therefore utopian project, I want to ground this
description of *S.T.R.E.S.S.* in a map of modern art which diverges

from the standard Cézanne–Picasso–Pollock scenario, and look instead at the work of three artists for whom the problem of the popular and the avant-garde was central. I hope that this will help to uncover what it is that seems to me so important about this work and other works which, in a way that seems to me especially significant for video, do not make their stand on one side or the other, or on what I believe to be a bogus annihilation of the gap, but precisely and with malice aforethought in the space of difference between art and popular culture.

In an important essay on *The Theory of the Avant-Garde* (1984), Peter Bürger recapitulates, with some important modifications, the Adorno–Benjamin hypotheses concerning the growing divorce between art and ordinary life, and between artists and the bourgeois audience, during the period of the historical avant-gardes, especially in the first quarter of this century. For Bürger, the founding moment of modernism is that in which art's autonomy frees it to become a commodity in the marketplace, interchangeable with nails, overcoats and turnips. The 'historical avant-gardes' such as Cubism, Futurism, Dada and Surrealism set themselves the task of reintegrating the autonomous realms of art and life, even at the risk of abolishing the institution of art itself. Thus the Dadaists announced the death of art (and held a wake), while in Russia and Germany particularly, artists devoted themselves to politicised forms such as Heartfield's photomontages, Grosz's lithographs, Rodchenko's adverts and propaganda posters, or Tatlin's *Monument to the 3rd International*. It is difficult for English-language cultures to grasp this aspect of modernism. For us the equivalents are almost all literary, and almost all bound up in one form or another of fascism.

On the continent, according to Bürger, however, the struggle to reach or create a new audience for art led to a thoroughgoing critique of everything to do with art as practice, from formal concerns to the status of the art object, from appropriate media to the cash nexus. He pinpoints in particular a break with the earlier preoccupation (associated here with Georg Lukács) with organic unity, and sees it subjected to fragmentation as new prominence is given to parts rather than wholes in, for example, analytical Cubism or the extraordinary prevalence of montage as a technique in painting, photography, sculpture and film. Yet, he argues, there is no point at which the modernist avant-gardes manage to consum-

mate the marriage of art and social praxis. The task of overcoming art's autonomous relation to life is unachievable. Instead he sees art in the 'post-avant-garde' era as symptomatic of the breakdown of reason itself in late capitalism. Art can no longer be theorised as a conceptual whole. At the same time, it has ceased to have a function, internal or external. Art has failed.

There seems little reason for maintaining an interest in art, except perhaps as an institution, for it is the institution of art that has won in this struggle. Far from being demolished by the assaults of Dada and the rest, it has survived and ultimately incorporated the insurgents who tried to destroy it. In the process it has become ever more efficient at its fundamental tasks of translating political engagement into the purely formal interests of art and, in a parallel process, of extending and stabilising the kinds of subjectivity evoked by such practices. Art in the post-war period, then, returns invigorated to the function of conserving the status quo.

Bürger himself recognises the need to historicise theories of art. Theoretical activities are as much bound up in the particular historical circumstances of their making as any other practice. His own input is very much circumscribed by the historical failure of the utopian movements afoot in Europe in 1968. Thus he can offer no theory concerning contemporary cultural practice beyond the suggestion that it escapes totalising theoretical appropriation (not because the theories are improbable, but because late capitalist society has itself become irrational), a lynchpin of philosophical critiques of modernism from Horkheimer and Adorno (1973, first published in 1947) onwards. The effect is one of bleak pessimism – itself a somewhat glamorous option for prophets of despondency – combined with a complete withdrawal of materialist analysis from the field of art.

Yet for reasons that I hope will become apparent, I do not believe that such an admission of defeat is helpful. In 'The Author as Producer', Walter Benjamin argues that!

The crucial point, therefore, is that a writer's production must have the character of a model: it must be able to instruct other writers in their production and, secondly, it must be able to place an improved apparatus at their disposal. This apparatus will be the better, the more consumers it brings in contact with the

production process – in short, the more readers or spectators it turns into collaborators. (Benjamin 1973, p. 98)

Much the same needs to be said of theoretical and video practice: either a work – be it of verbal or of video material – is productive in its own right or it fails, on a standard based on how many of its consumers it turns into producers. Of the two theses, Bürger's defeatism or Greenbergian elitism, the latter seems the more productive of new ideas and new routes forward. If we can begin from Greenberg's insight into the avant garde's need for an other against which to measure itself, then we can unearth an alternative history of the twentieth century, which I will mark through the device of three proper names: Marcel Duchamp, Andy Warhol and Joseph Beuys.

In the work of these three artists we find a concentration on the act of making, on the productive. In their use of cheap materials, yet materials heavily invested with significance, the practice of all three indicates something of the directions in which a democratic culture might move. At the same time, the recuperation of this body of work as itself an authorial, Romantic discourse of genius, tragedy and heroism within the international art market is a prime example of the workings of repressive tolerance and the recuperative powers of the art institution. This should lead us, however, neither to Bürger's defeated abandonment of the art world as a scene of struggle, nor to Greenberg's lofty, ultimately remote idealisation of the purity of art. Instead we will investigate what it is in Duchamp, Warhol and Beuys that made such unlikely candidates key figures in the making of the contemporary consensus in the art world, and what can be seized back from that work for the understanding and development of contemporary democratic cultural practice.

Marcel Duchamp's work can be understood as a momentous grapple with the implications of photography for fine art. More than instigating an anti-illusionistic art, it also gave artists a range of new techniques which otherwise make no sense at all. Photography not only afforded Duchamp content for his work, but became an integral element in the aesthetic he was developing. In the weird universe of *The Bride Stripped Bare by her Bachelors, Even* (1915–23), the concrete nature of photographic techniques play a major role. The Butterfly Pumps in the Bride's Emanation (clear squares in

the painted cloud in the upper section of the work) derive from photos of curtains drifting in the wind in Duchamp's Paris apartment. They are printed into the composition as mattes which remain unpainted. Krauss (1986) introduces the term 'index' to describe this function: these are the physical traces of a physical presence, just as the photographs are mechanical and objective records of the wind in the gauze. As the light from the curtains is imprinted on the photographic emulsion, so the photographic images are imprinted on the stuff of the Emanation. Likewise the process of dust-breeding used to give texture and colour to the conical Sieves in the lower portion of *The Bride* take on formal devices from photography in the sense of direct and physical contact between the artwork and the material world which is the condition of its making, just as the photo takes its imprint directly from the light that reaches the film through the lens.

At the same time Duchamp is concerned with the new terms under which subjectivity develops in the twentieth century, crucially between the relation of the body and the new technological world. Within the technical horizon, the biological models of the psyche familiar from Freud are superseded by the mechanical models that will solidify the worlds of Pavlov, Skinner and the behavioural psychologists. At the same time, however, like Flann O'Brien's bicycles, the machines are humanised. Thus the bachelor machines are instrumentalised desire, while the Sieves and Waterwheel are desiring instruments. The comedy arises from the way desire is described as a thing to be weighed and measured, and how the devices for measuring become themselves desiring subjects. The interface produces a new kind of logic and ultimately, in the form of a machine/human logic, a kind of internal necessity and a new kind of fate.

This fateful inmixing of the biological and the mechanical thus necessitates an artwork whose internal logics, like those of the machine, supersede the relation of art to audience. Having found the first principles on which this hybrid of human and machine is to work, the audience is not invited to relate the work to external reality, but purely to submit themselves to its new and crazy logic. In a second moment, however, the work yields its intricate relation to the world, and obliterates its apparent removal from it: the modernity of the materials and the 'abstract' aesthetic speak directly to the new century's concerns with the human/machine

interface. And it implicates sexuality in that relationship as surely as does the famous factory sequence in Chaplin's *Modern Times* (1936). The serious side of the comedy that Duchamp's wacky, rule-governed system threatens is that, as long as we do not understand the new laws of subjectivity, remade in the age of the machine and of the index, we will be enslaved to them.

The importance of Duchamp's *Bride* to video at the end of this century is that it broke (and continues to break) the Kantian aesthetic of the thing containing in itself its own rationale; that it insists on the break-up of taste, good or bad, as an aesthetic formula; that it insists on an at least two-fold moment of appreciation. And furthermore that, as Octavio Paz has it, it promotes 'a horror of indifference' (Paz 1978, p. 71), that indifference which is at the fountainhead of modernist aesthetics. In a crucial passage in the *Critique of Judgement*, Immanuel Kant distinguishes the aesthetic faculty from anything to do with desire:

> The delight which we connect with the representation of the real existence of an object is called interest. Such a delight, therefore, always involves a reference to the faculty of desire, either as its determining ground, or else as necessarily implicated with its determining ground ... Everyone must allow that a judgement on the beautiful which is tinged with the slightest interest, is very partial and not a pure judgement of taste. One must not be in the least prepossessed in favour of the real existence of the thing, but must preserve complete indifference in this respect, in order to play the part of judge in matters of taste. (Kant 1952, pp. 42–3).

We might uncover here a sense in which the purity of autonomous art is founded not only on the exclusion of the popular as other but also of desire as other, a notion that might then inform our understanding of the exclusion of colonised peoples and women from the mainstream of modernism in art. For the slippage between disinterest and indifference, between the erasure of desire and the erasure of difference, is a profoundly normative one, and it is to Duchamp's credit that he precisely moves back into the domains of interest and difference in the formal as well as the more metaphysical aspects of his work. It is interesting, too, to note that Kant foreshadows Greenberg's critique of kitsch in a note to the *Critique of Judgement* in which oratory is differentiated from poetry as 'an insidious art that knows how, in matters of moment, to

move men like machines to a judgement ... Force and elegance of speech (which together constitute rhetoric) belong to fine art; but oratory ... merits no respect whatever' (Kant 1952, p. 193). Purity of intention and a concern with the form at the expense of content characterise the modernist aesthetic even at this early, emergent stage. As we will see, the impurity of the oratorical becomes a central figure in Warhol's work, and in some ways Duchamp's abandonment of painting after the *Nude Descending a Staircase* of 1912 can be seen as an abandonment of rhetorical art, the art of Kantian taste.

One factor in this abandonment of painting is the use of structural absences at the heart of the *Bride*: of the invisible elements, those that were never painted, of which only traces remain; of the supplementary documentation (Duchamp 1960, 1975); of the reference to unrepresented dimensions (the third dimension is inferred by the use of vanishing point perspective in the sledge, in the mode of production of the Shots in the upper right of the work, and by the fact that the piece has a front and a back; the fourth is implicit in the seizure of instants of time: indeed, one of Duchamp's titles for the piece is *Delay in Glass*). A second is that we are driven backwards in time if we are to understand the work: the devices used in its making, like the Dust Breeding or shooting paint-dipped matchsticks from a toy cannon to determine the position of the Shots, become as important or more so than the work as represented in a gallery. The start line of interpretation lies somewhere before the making of the thing itself: the work omits not only conclusion but even a clear place from which to begin. And it demands continuation: after the famous breakage, Duchamp announced the Glass 'finally unfinished'. Paz mentions a limited edition plexiglass reproduction (Paz 1978, pp. 49–50n.), and the version that I know is Hamilton's loving reconstruction at the Tate Gallery, London; but compare these with the versions included in the *Boîte en Valise* or the various schematic versions by Hamilton (in Duchamp 1960), Duchamp (Paz 1978, p. 31), Suquet (Moure, 1988, pl. 78), as well as the various sketches and notes in Duchamp's writings. The issue of origin is consistently displaced, even as the body of work poses itself as in some way the origin of a later practice (as here I make it at least a touchstone).

In this sense, Duchamp also reinvents photography. Not only does he seize its principles for other methods of marking the passage

of the real across the surface of the 'finally unfinished' work, but he also quizzes the apparent facticity of the relationship as in the pencil and plaster-cast self-portrait *With My Tongue in my Cheek* (1959). For the scientists of the nineteenth century photography represented the achievement of an ancient dream: Muybridge, for example, managed to define the movement of a galloping horse for the first time, disproving artists like Stubbs who spent a lifetime getting it wrong. Photography captured once and for all the instant of time. It came as a guarantee of the positivist notion of facts. Science dealt with facts. The world was made up of facts. Photography captured facts. The impact of this positivism on art practice was immense, especially on the Impressionists, whose very name derives from the process of imprinting the fleeting moment on the retina. Duchamp's indexical techniques, however, do not record reality or seize the instant: they 'delay' the real, and in that delay (the philosopher Derrida might call it a *différance*) both foreground the mediating role of the media used (glass, lead, dust, oil, varnish) and insist on the temporal and thus processual nature of the phenomena investigated. Desire, after all, cannot exist outside time, even – or perhaps especially – when, as in the *Delay in Glass*, it is frustrated.

In *The Dialectic of Enlightenment*, Horkheimer and Adorno argue that scientific progress denotes an attempt to dominate nature, but that consequently 'The more the machinery of thought subjects existence to itself, the more blind its resignation in reproducing existence' (Horkheimer and Adorno 1973, p. 27), leading to 'the self-dominant intellect, which separates from sensuous experience in order to dominate it ... the separation of both areas leaves both impaired ... The more complicated and precise the social, economic and scientific apparatus with whose service the production system has long harmonised the body, the more impoverished the experiences which it can offer' (Horkheimer and Adorno 1973, p. 36). In the pursuit of domination, the intellect is first separated from the body, and then devoted not to bodily interests but to the instrumental tasks which are all that modern society allows to the mind. Meanwhile those bodily interests are impoverished by their disjuncture from the mind, and debased, so that we end up with intellects and intelligentsias devoted to managing and administering tawdry pleasures to their 'merely' physical bodies and, on the social scale, to a labouring class divorced from mental stimulus and a managerial class divorced from their bodies. This attack on the

power of positivist science to shift the goals and activities of whole societies is echoed in Duchamp's reworking of the photographic. In his reinvention of the material substrate of the index, he forms part of the modern movement away from the determinations of science and towards a mental universe in which nature and science interact according to a logic that, from the standpoint of the prisonhouse of evidence, looks like madness. This in turn aligns itself with a movement between the popular and the aesthetic. For example, Duchamp uses the figure of the Chocolate Grinder in the *Bride* on the basis of an old proverb: the bachelor grinds his own chocolate. The circuitous entry of masturbation into a gallery artwork may remind us of Freud or of an earthy folklore: the point is that both are legitimated in this transition from high to popular art and back again.

For Duchamp, popular culture included the manufactured goods which would provide the materials for ready mades: combs, urinals, bicycles, coat racks, cheap prints and advertising, shovels, corkscrews. Like Courbet's use of perspectival techniques from popular prints, the Impressionists' engagement with low life, or Picasso's bus tickets and wine labels, these elements take on the form of raw materials to be transformed by the artist's hands and, from the artist's point of view, into something beyond their impoverished and interested everyday lives. But at the same time, Duchamp shares with Joyce a profound belief in the value of popular culture, in however degraded a way, to speak to and from the deepest longings of the human heart. Moreover, unlike the claims of post-Romantic art to speak to and for the eternal, popular culture revels in its transitoriness. At the heart of Duchamp's art lies this link between the mode and the modern which, in Habermas's view, is the key to understanding modernism's revolutionary understanding of time (Habermas 1987, p. 9).

The photographic seizure of an instant from the flux of time is itself characteristic of this new understanding. The hard-earned epiphanies that discovered the anti-aesthetic in everyday items like a bottle-drying rack have their parallels in the enjoyment of the box Brownie. Cheap, popular photography reveals the profundities that emerge into everyday culture as sheer pleasure, sheer novelty and sheer nostalgia, regardless of the aesthetic dimensions of the actual snap taken. The process of photography, the haphazard results of amateur photography, are crucial to the development of Duchamp's

practice, bridging the fine and the applied arts, high and popular culture.

Still it's true that Duchamp remains on the high culture side. Marginalised in the history of art presented by curators and galleries, he retains a position among practitioners and fans that saves him from obscurity, but not from misrepresentation. The cultural Cold War focus on art as self-exploratory and self-fulfilling practice excluded, in its rewriting of history, the great figurative art of the century, the political work and the work that crossed over into the public domain, such as Surrealism, for example, now almost wholly represented in the English-speaking world without its revolutionary impetus. As Batchelor and Harrison observe of the painter Max Ernst, 'He may have got his history right, but according to the canons of modernism, he got his art wrong' (Batchelor and Harrison 1983, p. 48). Much the same might be said of Duchamp. Yet while Duchamp's work continues to provoke, it still is seen as provoking a debate within aesthetics, not one that profoundly alters the terms on which aesthetics can be debated. As such, he is again erected as a monument to that art (like Pollock's or that of the historical avant-gardes for Greenberg and Bürger respectively) beyond which it is impossible to go.

The question of what is or is not art, and the corollary as to how far the art world can go in tolerating aberration before its own legitimacy is called into question, are raised again and again in video practice. I would like to argue that the interventions of Warhol and Beuys in the institution and production of art are exemplary of the problematic of art as it must now exist for video. Each attacks, in appropriate ways and especially through the choice of media and techniques, the attempt to rebuild the sacred aura of the unique work of art. For Warhol this takes, characteristically, the form of foregrounding commodity status as itself a use value in the contemporary art market. Beuys most typically questions the materials available to and the permanence associated with the work of art. In this sense Warhol should be seen as a critic of the institution of art (and so as a Kantian 'orator'), and Beuys as critic of the art object. Both are therefore involved in practices which relate closely to Duchamp's earlier project: the fundamental questioning of the notion of art itself.

I do not wish to argue a case for a Duchamp 'influence' on Beuys and Warhol. Influence is a model of history which, by reading the

past backwards from the present, can always discover continuity and self-validating tradition. Pollock is influenced by Picasso who was influenced by Cézanne who was influenced by Manet who was influenced by Courbet who was influenced by Le Nain, thus 'proving' that there has been absolutely nothing new under the twentieth-century sun. On the contrary, sociocultural tendencies which had been in the making since the end of the eighteenth century come, I believe, to a state of crisis in the late years of the nineteenth, bringing about a radical shift in the visual and literary worlds. Indeed, with Benjamin, I want to argue the radical discontinuities between art movements within specific historical moments as well as over time. Only thus is it possible to understand that there are dialectical processes, perhaps several, at play in the formation of art practices generally, and in video in particular. While retaining the concept of competence as an intertextual awareness brought to bear on specific experiences by audiences and makers alike, I want to dismiss the concept of influence, and with it the underlying theses of absolute continuity within the tradition, of permanent values supposedly inherent in great works, and of the naturalised and universalised conception of art.

At the same time, there seems little point in making a cult of absolute novelty. Benjamin criticises *Neue Sachlichkeit* (New Objectivity) photography for just such pandering to the needs of the art market:

> It has turned abject poverty itself, by handling it in a modish, technically perfect way, into an object of enjoyment. For if it is an economic function of photography to supply the masses, by modish processing, with matter that has previously eluded mass consumption – Spring, famous people, foreign countries – then one of its political functions is to renovate the world as it is. (Benjamin 1973, p. 95)

What Benjamin here criticises is the renewal of the art institution from within by practitioners unconcerned with changing the technical means of production, only applying old techniques to new content matter. It is worth maintaining a sense of distance from the disdain with which he treats the word 'modish': to dismiss fashion is not the modernist mark of distinction and taste, but a failure to distinguish between those elements of fashions which are

evidence of cultural productivity, and those, in low culture or high, which are symptoms of the pursuit of novelty for its own sake. Cultural industries, galleries included, are always in pursuit of the Next Big Thing: this should not debar us from using novelty where appropriate.

How then does Warhol, clearly involved in fashion, novelty, the market, even the business of influence, emerge into this rigorous pantheon of materialist aesthetics? Certainly there is an aesthetic mode, deriving perhaps from Duchamp's ready mades, which selects from the world of the popular elements for art. The Campbell's soup cans, and even more clearly the Brillo boxes, are celebrations of an anti-aesthetic. They offer for our enjoyment the novelty of perception that allows us to look at graphics and product design, in their most mundane guises, with new eyes. They suggest that anything can be material for art, the more contemporary and despised the better; just as, a hundred years before, Baudelaire had discovered 'how poetic we are in our top hats and tails and patent leather boots'. To this extent they are simply celebrations of the culture of capitalism. Moreover, they make a move which extends the reach of Greenberg's cult of the surface, of flatness and extension, as the central programme of modernist painting. This they achieve through a movement from the surface to the superficial, a movement re-echoed in the ephemerality of moments caught in the early films like *Kiss*, *Eat* and *Couch* (all 1963), in the use of yellow-press images for silk screens, and in the famous-for-fifteen-minutes format of *Andy Warhol's Interview* magazine or the intensely abstract persona of the *Diaries*.

To such an extent, Warhol falls clearly within the world of modernism His populist concern with audience, his misogyny (especially in the films), his exploitation of the popular as kitsch and his relation with the market in art all indicate ways in which his art can be and is retained within the culture of high capitalism. Yet the corpus is redeemed for materialism precisely by its interest in the means of production and exchange. When Warhol named his studio The Factory, it was with a clear project to make commodities. Warhol's works are commodities first and art only second. True, the recuperative powers of the gallery system, aided and abetted by Warhol himself, have been led to subsume the commodity form within the art, the better to move the art as commodity. It is the business of a materialist critique to reverse that relation: to insist

that the serial production of identical images within single pieces (such as the multiple images of Monroe) and across whole print runs (such as the album cover graphics for the Rolling Stones) marks out the primacy of the commodity relation over the aesthetic despite the gallery system. Even more, the serial images of car crashes, atom bombs or the electric chair seem to emphasise the horrors underpinning the capitalist art market just as much as, in celebrating the surfaces of these representations, the prints empty them of significance. This dialectic of technique (removing horrific images from their contexts, printing them in flat tones) and content (they still remain horrific; even Monroe carries the weight of a modern tragedy) inveigles the viewer into sharing in the incompleteness of the work. More: works like the film *Empire* (1964), eight hours of the Empire State Building designed to be projected as moving wallpaper, or the Brillo boxes, are a deliberate invitation to imitation.

For video and videographics, this relation between empty and full images is central. Victor Burgin, speaking of his work in computer-manipulated imagery, says 'What I like about digitisation is that it brings everything onto a common ground' (Burgin 1991, p. 8). That commonality is at one and the same time frightening and liberating: frightening, because it suggests the fundamental indifference of the medium, its reduction of the significant and the insignificant to the same traffic of microelectronic blips; and liberating because, as Daniel Martinez says in the same issue of *Ten:8*, 'What I like about working with new technology is that it doesn't care who uses it. It cannot discriminate' (Ziff and Martinez 1991, p. 36). Warhol's silkscreens begin a process of analysing these fundamental dichotomies of democracy (if everyone is an individual, individuality is no longer interesting) and of art (if everyone can do it, it's no longer precious). The very availability of the new media technologies, opening them up to Benjamin's utopia of proletarian producers, also opens them to Adorno's charges of the endless replication of anonymous, commodified culture.

Beuys appears at the opposite end of the political spectrum. Here is my fat and my felt, his works seem to say: where are your significant materials? Such openness is crucial to a democratic culture. On the other hand, Beuys's orientation towards an idiosyn-cratic Eurasian mythology leads him into a use of symbols that ultimately leaves the work, once again, to be all too easily

restructured as gallery art. In as much as these symbols hark back to previous usage, they threaten to close off the immediacy of the work under a miasmal and finally repressive burden of apparently eternal verities. On the other hand, as a personal system of reference, they hurl the artist into the role of Romantic genius. However, in Beuys's case, it is once again a commitment to intervention in the means of production that saves the work from the graveyard of fame. First, his works are ugly: misshapen, dirty, broken-backed (this quality is maintained in the grainy black-and-white photography of Ute Klophaus, who documented most of his work). Second, much of the most significant work was ephemeral – especially the performances – or subject to decay, such as the sculptures made of organic materials like fat, wax, blood and honey. Third, much of the symbolism is so cryptic that it throws itself open to multiple (mis)reading, engaging the spectator in the process of making meanings in an age in which, if Adorno and Bürger are to be believed, there is no rational core to social meaning. Finally the sheer idiosyncracy of the iconography elicits the crucial response 'I could do that.' This is precisely Benjamin's point: in the moment of recognising the fallibility of the artist, we are allowed to recognise our own capacity for action.

Beuys's vast output and its various histories have spawned a literature of impressive volume. Certain elements, however, are particularly interesting in our context. First, Beuys makes the great breakthrough into the centrality of the material to sculpture. After Beuys, the first thing we ask of a work of art concerns its materials: we have to ask what wood is, or gold, or blood. Though the mystical ramifications of Beuys's specific use of materials can traverse the space from biography to cosmology, from the specific to the near-random, yet the reverberations of certain works are undeniable. Few performance pieces hold the imagination like *Coyote* (Rene Block Gallery, New York, May 1974) in which Beuys re-enacted and atoned for the European invasion of North America by having himself delivered, felt-wrapped, to a gallery and spending a week there in company only with a wild coyote. Among the rich ambiguities of the piece (coyote as enemy, coyote as trickster god, for example), the role of multiple copies of the *Wall Street Journal* delivered daily to be torn, shat and pissed on by the coyote is pretty clear. Moreover, Beuys is one of the first artists to demand an

attention that we can call green: an attention to the origin of the paper in the woods that once were the coyote's home.

Of all the practices that make up the complex praxis marked by the name of Joseph Beuys, a praxis in which art and life become inextricably mixed up, it is his work as a teacher that marks out his special position in the Duchamp/Warhol nexus. Integral to his art was the establishment of a public persona, not far removed from the silence into which Duchamp lapsed after publicly renouncing art (while privately continuing to make it) or the *Vanity Fair* period in Warhol's life. Beuys' public self lay somewhere between shaman and agitator. Thus the *Honey Pump* of 1977 was part and parcel of the Free International University. The sculpture consisted of two ship's engines lubricated with 100 kilos of margarine pumping two tons of honey around spaces at the important Documenta show at Kassel, West Germany. Simultaneously, during the 100 days of its installation, participants from all over the world discussed subjects from human rights to the energy crisis in thirteen workshops (Tisdall 1979, pp. 254–64). Neither the sculpture nor the Free University are comprehensible outside the utopian yearnings shared by both. Public and private, body and intellect, individual and group, object and process: Beuys queries art's founding binaries. Whenever a blackboard figures in Beuys's work, it must be considered within this configuration of teaching, learning and group practice, a practice which insists that everyone is an artist, and consequently that the narrow definitions of art must be done away with.

This short sketch of a trajectory through the twentieth century presumes that the demands of the age cannot be met by refusal of technological change, or by its mere celebration, but that the changes themselves must become the matter of art. Such matter can no longer be determined by its status as positive fact, but must be understood as process, in which both origin and destiny are up for grabs. Likewise, though the Romantic genius is in flight, the figure of the artist, his/her biography and body, come to centre stage as fragile, transitory, irreplaceable elements of the work, while at the same time the subject, like the object, is thrown into question. I presume that Duchamp's silence, Warhol's glamour and Beuys's teaching are each modes of breaking through the limitations of self-explanatory, self-fulfilling definitions of art. In all these ways, and working within the parameters of modernism, these artists labour to disrupt the self-enclosure of art in order to reopen their works to the

audience lost in the pursuit of purity. It is in the context of this struggle that the work of the Southgate Video Group makes sense.

The gutted washing machines with their freight of images – washing dirty laundry in public, laundering public moneys? – alongside the trappings of shopping mall culture deploy Beuys's insight into the specificity of the media used. The multiplication and repetition of images beyond the point of redundancy echoes Warhol's strategic use of mass production, as they reveal the equation of factory and home in so much public housing. There is humour in throwing together the serious and the trivial: the punning of laundrette and architecture, and the vital connection of the art to the moment of its making breath with Duchamp's ghost. Most of all, the work drags back into the public domain, and makes political or social use of, the high art traditions which, over the bridges named Duchamp, Warhol and Beuys, were dragged into the temples of modern art. That this struggle over the meaning and nature of art has purpose is clear, I think, from the success of the *S.T.R.E.S.S.* installation. That work achieves its importance in this writing from its position in this history: the struggle to produce an audience for art. What is in question there is whether art must change so radically in order to be adequate to its audiences that the aesthetic dimension as we have come to know it becomes entirely redundant; or, on the other hand, whether this practice and schemes like it can provide the grounds for a historical, dialectical and materialist aesthetic.

4

The Subject of Art

Though modernism killed the Romantic genius, its ghost still haunts the corridors of art history. In figures like Beuys, Warhol and Duchamp, the issue of the individual returns to the discourse of art. And in video, the matter returns with greater power. In this chapter I want to investigate further the relationships between art and culture through an analysis of the role of the individual.

The essay by Walter Benjamin quoted in Chapter 3, 'The Author as Producer', originated as a speech given in 1934 to the Institute for the Study of Fascism, and was intended as a significant foray into the current debates on committed (or 'tendentious') art. The year 1934 was marked not only by the official adoption of socialist realism in Stalin's Russia, but by the final show of modernist work in Hitler's Berlin, an exhibition of Futurists brought in from Italy. Only a matter of months previously, official Nazi propaganda organs had demanded that 'all artistic productions with cosmopolitan or Bolshevist tendencies must be thrown out of German museums and collections; they should be shown first to the public, the purchase price and the name of the responsible museum officials must be made known; but then all must be burned' (Chipp 1968, p. 474n). This was also the period of the Popular Front against fascism, which had given rise to the Institute where Benjamin was speaking, and of the famous *rappel à l'ordre*, the call to order which launched a Left front of the arts firmly based on a return to classicism after the experiments of the first 30 years of the century.

For Benjamin and his circle, the whole project of modernity was at risk, and with it the struggle against fascism and the very possibility of cultural life. In Benjamin's terms, such movements as Activism and *Neue Sachlichkeit* (and by implication socialist realism) relied upon the 'richness of the creative personality, which

has long been a myth and a fake ... To expect a renovation – in the sense of more personalities and more works of this kind – is a privilege of fascism' (Benjamin 1973, p. 97). Beneath this condemnation lies a deep-seated disdain for the 'spiritual renewal' demanded by fascism, an aestheticisation of politics at odds with the socialist idea that no amount of genius makes up for the suffering inflicted by fascism. Instead, Benjamin puts his faith in the work of Tretiakov, Brecht, Eisler and Heartfield, artists who had intervened directly in the technical production of art. Evaluating political art forms, he suggests that what matters is the way in which formal innovation is placed at the disposal of subsequent artists, adding to the repertoire especially those effects through which spectators become most closely involved with the activity of production, whether physically (perhaps by making their own photomontage) or intellectually (by mulling over the options open to Brecht's characters): in short, by bridging the gaps created by art's historical autonomy. Thus, Eisler's music for example, with its avowed aim of turning the concert into a political meeting, is praised for eliminating 'first, the dichotomy of performer and audience and, secondly, that of technical method and content' (p. 96).

Such an overcoming of the cult of genius – the creative personality – and eternal values – expressed in the division of technique and content so familiar in the gallery reception of Duchamp, Warhol and Beuys – lays the groundwork for a materialist aesthetic. Kant would have it that the value of a work of art lies in the lack of interest (in the dual sense, in German, of will and desire: gain, profit, self-interest and appetites) with which it is received. In place of this idealist position, Benjamin argues for an interested and engaged relation between artist and audience such that the divide between them is thrown into question. Thus a work can be judged on its use-value, measured both in terms of its immediate relevance to new formal methods opened up for further productive work, and in its more mediated impact on social practice. Such a double undertaking might take place simultaneously (Tretiakov's wall newspapers, in which others also acted as authors, for example), or it might be sparked off over time, as new techniques sink in and become available for new work, as might be the case with Dadaist photomontages taken up anew by John Heartfield in his book and magazine covers. In each case, the intervention in the means of production is crucial. Anything else only perpetuates the bourgeois

apparatus and its institutions which, especially in the mid-1930s, had become the strongholds of fascism. Video in the 1990s can act as creatively in the face of the seeming completion of bourgeois rule: effects like scratch video, radical networking, even viruses are just such producerly interventions in an otherwise totalitarian regime. The humanist response in the 1930s, rather like the New Age response today, was to assert the primacy of the individual against totalitarianism. Benjamin, working in the hinterland between modernist aesthetics and materialist philosophy, posits a new subjectivity in its place. In this chapter, I want to investigate the ways in which Western debates over the relation of individual to society were reworked in the twentieth century and how, in video specifically, they return with a new urgency.

The problems of art and cultural practice, from this perspective, are the same as the great issues of society in the twentieth century. What is the relation between public and private? What kind of culture finds itself riven between high art and popular culture? What has happened to the unity one might expect of a culture? And how are we to deal with the rift? Does this split derive from the same sources as what many commentators regarded as the split between mind and body? And what had that to do with the growing division of labour and the split between work and leisure? What are the rules of sexual and racial difference, so central to the shaping of Nazism, and so crucial, differently, to the questioning of identities at this end of the century? What is the status, in mass societies, of personality and individuality? Such questions were renewed in the 1970s feminist slogan, 'the personal is the political'. Art shares these social processes of questioning, though it investigates them differently. I want therefore to begin with the question of the role of the artist: is art best understood as the self-expression of an individual?

Even the Kantian account of the aesthetic leaves out the concept of the artist as a central one in the appreciation of the artwork. Yet the Romantic insistence on the personality of the creator returns in every gallery guide, every TV documentary on the history of art, not out of ill-will or bad faith, but because this is still an element of the dominant mode of understanding art. Indeed, much of art's importance to Western ideology is founded in the equation of creativity with individuality, and of both with the formative concept of freedom. This formed a vital part of the political use made of the New York artists by the CIA in the 1940s and 1950s, but there does

not need to be such a conscious political aim: we presume originality as a prime quality of art practice, and we root it in the origin of the artwork in the personality of its maker. In what follows, we will be investigating the terms under which visual arts can be made, and what the role of individuals might be in the process.

Goethe's 1810 *Theory of Colours* is singled out by Jonathan Crary as the earliest example of an interest in optical afterimages, an interest which seems to represent a breakthrough in Western philosophies of vision in that it sees the body as productively involved in the processes of seeing. Crary argues that this new emphasis destroys the previous division of inner and outer on which theories of vision (and, as Richard Rorty (1980) argues, epistemologies based on them) had previously been founded. This in turn disrupts both the idea of an unmediated visual relation between the world and the 'mind's eye', and the idea that the two are distinct. Vision becomes therefore itself an autonomous entity in which the physical properties of external nature and of the body combine into a single object for intellectual contemplation (Crary 1988, p. 35). Frederic Jameson expands upon this topic in *The Political Unconscious*, where he argues that:

> as sight becomes a separate activity in its own right, it acquires new objects that are themselves the products of a process of abstraction and rationalisation ... The history of forms evidently reflects this process, by which the visual features of ritual, or those practices of imagery still functional in religious ceremonies, are secularised and reorganised into ends in themselves ... with the autonomy of the visual finally triumphantly proclaimed in abstract expressionism. So Lukács is not wrong to associate the emergence of this modernism with the reification which is its precondition; but he oversimplifies and deproblematises a complicated and interesting situation by ignoring the Utopian vocation of the newly reified sense, the mission of this heightened and autonomous language of colour to restore at least a symbolic experience of libidinal gratification to a world drained of it. (Jameson 1981, p. 63)

I will return to the question of 'libidinal gratification' below. For the moment, the crucial issues concern the status of the artist in the newly-formed field of the visible.

It is essential to understand that vision also has a history. Though most infants are born with the power of sight and taking pleasure in vision, that instinctual, biological delight is as much subject to socialisation as sexual drives, hunger or the need to defecate. In different societies and in different periods of history we find as many organisations of looking as we find rituals about eating or modes of sexuality. A novel way of looking (for example, the narrative forms of aborigine painting) can be baffling for a society weaned on perspective and maps as the dominant orders of representation. The ability to see paintings as flat fields of colour and shape, while perhaps not entirely without precedent, is nonetheless characteristic of a specific historical moment. It is within such regimes of vision that artists work: they form the paradigms within which it is possible to paint at all. In our period in particular, the instinctual pleasure in seeing is organised around a sense of the visual as discrete, and this discretion marks a further condition without which we cannot understand the growth of visual arts, and painting in particular, both in general (painting among the other arts) and in the particular (the specificity of the movement from Turner, Europe's first Goethean painter, via the Bauhaus and de Stijl theosophists, to the abstract and conceptual art of the present day). At the same time, it has to be pointed out that although the specifics do change, sometimes with amazing speed, there is an overarching organisation of vision as an autonomous category which underpins a whole epoch of art-making since the end of the eighteenth century.

But even given such necessary conditions, and given the kinds of shared constraints which ensure that no art, no matter how remote, is ever produced entirely outside the social constraints of its time (or consumed outside the social constraints of the time and place of viewing); given all this, surely there is a place for the expression of individuality within those constraints? Surely we can recognise the brush strokes of a Van Gogh as different in style from those of a Picasso? Surely the physical processes of making are as dependent on the personal as they are on the social?

Perhaps at no time has the issue of personal versus social in art been so fiercely and productively debated as in the Bauhaus in Germany in the 1920s. Under Gropius, the Bauhaus strove for a new social contract for art, but in doing so confronted the most powerfully-felt ideals of the artists who worked there. On the one hand Itten, head of the Basic Course until 1927, encouraged a

heteroclyte mysticism, while on the other Gropius himself could write the following list of principles for the school at its refounding in Dessau in 1925:

A decidedly positive attitude to the living environment of vehicles and machines.

The organic shaping of things in accordance with their own current laws, avoiding all romantic embellishment and whimsy.

Restriction of basic forms and colours to what is typical and universally intelligible.

Simplicity in complexity, economy in the use of space, materials, time and money. (Cited in Willett 1978, p. 119)

Shortly afterwards he wrote in the school magazine: 'A house is a technical-industrial organism, whose unity is composed organically from a number of separate functions . . . Building means shaping the different processes of living. Most individuals have the same living requirements' (in Willett 1978, p. 121), a statement prefacing a description of standardised housing. Among these statements we can trace at least three major strands: a residual aesthetic of organic unity, casting its eyes back to Romantic aesthetics; a modernist aesthetic of the purity of form reliant upon the medium chosen, like Greenberg's flatness, here expressed as an architectural refusal of sculptural uses of decoration; and a new aesthetic, which would be known then and later as the machine aesthetic.

It would be crude and misleading to see this aesthetic as an exclusively capitalist one, even though Gropius specifies the cash nexus as central to his definition of 'economy' in art (and this statement covers not only architecture but the whole school). Though we perhaps associate utopianism today with a humanistic rejection of machines, in the 1920s the idea that technology would not only liberate people from toil but also from the ravages of desire was a common one. The great Italian philosopher and revolutionary Antonio Gramsci wrote in the *Prison Notebooks* in praise of the concern of American industrialists with the sexual lives of their employees that 'the new type of man demanded by the rationalisation of production and work cannot be developed until the sexual instinct has been suitably regulated and until it too has been rationalised' (Gramsci 1971, p. 297). This kind of rationalisation of sexuality he saw as both the necessary outcome of the collective work-processes of the new factory systems of Ford and Taylor and

the necessary precondition for the emancipation of women and the lessening of the burden of sex crimes in rural areas. The machine aesthetic is then an element of modernism, even a period within it, in which at least one problematic field of difference – that of sexuality – can be subsumed within the determinate rationality of machine-based production.

At the same time, the machine aesthetic provides an escape from the tyranny of individuality. Already at this stage, some of the major figures of the European avant gardes had begun to search for an end to the cult of personality. The move of German and Russian avant gardes particularly away from painting and handicrafts and towards photography and cinema, and away from individual projects towards collective ones, was seen by participants as a move away from the capitalist insistence on competitive individualism. The new humanity promised by the booming industrial economy of North America, and the Russian Revolution was one in which the rhythms of the age were determined by the rhythms of machines, so that the pursuit of individual goals seemed therefore irrelevant or even obstructive to the modern.

In a brief, dense essay first published in 1927, Siegfried Kracauer extends this analysis through a detailed philosophical account of the provenance and status of the Tiller Girls phenomenon, the geometric displays of dancing girls fashionable throughout the West at the time, and perhaps most recognisable today from Busby Berkeley production numbers of the 1930s. On the one hand, he argues, these displays are sexless, since they subordinate the individual body to the pattern, and because it is not whole bodies but separate parts of them, legs and arms, which form the elements of the pattern. To this extent the dancing girls represent a triumph over nature shared by the factory worker, subordinating individuality to rational organisation, and being reduced from bodies to 'hands'. On the other hand, though, he argues that the kind of rationality evoked in the new machine for displaying bodies is not rational enough: that the pattern-making involved, like that of the mass gymnastics favoured by the Nazis, is still mythological. If reason is the as-yet-unrealised goal of human history, capitalism is only a stage, possessing a rationale but not reason, and it is this capitalist rationale which is celebrated as abstract patterns. Yet these abstractions fail to reach through to the actuality of nature, since they are motivated by a rationale which understands only the self-perpetuating pursuit of

profit, not the production of value through the transformation of nature. So he argues that from the perspective of reason the mass ornament, as he calls these ordered displays, 'is the crass manifest-ation of inferior nature. The more decisively capitalist rationale is cut off from reason and bypasses humanity vanishing into the emptiness of the abstract, the more this primitive nature can make itself felt' (Kracauer 1989, p. 152).

This distinction is an important one in comprehending the debates over machine culture in the 1920s and afterwards. On the one hand, a teleological notion of history, deriving from Hegel, sees the gradual emergence of reason as humanity's historical destiny, one tied closely at this time to the success of socialist revolutions. On the other, the practical, instrumental detour of rationality under capitalism sees the dominance of commodity production usurping the place of this progressive goal of the whole species, and putting in its place a false rationale, one that favours only the few, and substitutes wealth for value.

It is interesting to note that here, as in other essays on the same subject (see Berghaus 1988), Kracauer centres his exploration of competing notions of rationality on the bodies of women, the most manifest site of sexual difference in the culture of his day. The pursuit of rationality must be understood in an evolutionary frame-work, he argues: those who dismiss this culture fail to recognise that it is here precisely that the defining characteristics of the age are to be deciphered, and that true rationality must evolve along a line which 'leads directly through the mass ornament, not away from it' (Kracauer 1989, p. 154). Even in this more sophisticated model, then, we find a firm belief in the opposition between reason and sexuality, with a key indicator of rationality being its ability to overcome the limitations of nature in the form of the body and desire.

At the same time, however, this meticulous attention to the typical forms of everyday culture also opens up a broad field of issues already raised above. Kracauer shares with his contemporaries, Adorno and Horkheimer, an awareness that the public and private worlds, divorced in the same historical division of labour that produces the separation of body and intellect, are entering a new relationship in the 'administered society' of the early twentieth century. The proximities between Tiller Girls and the Taylorised factory or office is a constant theme of their cultural criticism, as is

the appeal to reason as the last remaining ground from which to judge the poverty of such a culture. The Girls represent the same cultural drift as 'the fabrication of masses of workers who can be employed and used uniformly throughout the world' (Kracauer 1989, p. 147). Their uniformity, as much as their fragmentation into the functional elements of their bodies, makes them more than metaphors of capitalist production: they are symptoms of precisely the same organisational rationale as the factory (in which the individual gesture has no meaning at all until envisaged from a standpoint outside that of the individual) and the serried lines of seating in the stadia where they performed. In the mass ornament, Kracauer finds the same rationale governing spectacle and specta- torship as governs work: even in a field 'which no longer has erotic meaning but at best points to the place where the erotic resides' (p. 146), the private realm of the erotic is subsumed within the public rhythms and organisational principles of work. Like Gropius's model town, in which individuality had little or no place, Kracauer's observation of the Tiller Girls indicates that the divisions between public and private are breaking down, in a process which it behoves intellectuals to further rather than to hinder. As we shall see (Chapter 7 below), in Adorno's commentaries on jazz, to some extent the dividing lines between races are also seen to tumble before the central logic of administrative and instrumental reason under capital.

However, it was not only modernism, and not only Marxism, which provided the raw materials for a thoroughgoing re-evaluation of the relevance of individuality for art and culture in the early twentieth century. The works of Sigmund Freud found an eager readership on both sides of the Atlantic, so much so that by 1927 V. N. Vološinov was able to write that 'anyone wishing to fathom the spiritual physiognomy of modern Europe can hardly bypass psychoanalysis; it has become too signal and indelible a feature of modern times' (Vološinov 1976, p. 8). In our context it is pointless to try to unravel the complexities of either Freud's intellectual career, or the trajectories which various forms of psychoanalysis have taken in cultural criticism since his death. Where critics like Benjamin, Adorno and Kracauer focus on the macro-structures of historical societies in the West, psychoanalysis traces the structures of the inner life of people. In many versions, including some of Freud's own, there is an attempt to secure a scientific (that is, universal)

validity for such concepts as the unconscious and repression by suppressing the idea that psychic structures are also historical. Yet it is precisely the value of psychoanalysis to cultural criticism that it offers us a position from which to articulate together the social and the individual, while maintaining a critical (that is, local and historical) stance towards them.

So our interest turns not towards the uncovering of phallic symbols, or towards psychobiography (a turn of psychoanalysis towards the Romantic conception of the artist, of which Freud's own essay on Leonardo is a prime example), but towards the key discovery that the psyche is not a unified whole. Just as modernist critics have argued the reification and alienation of elements of society from one another – as in the historical emergence of autonomous art – so Freud points the way towards an understanding of the psyche which is internally divided and fragmented, and which, like society at large, is subject to shifts and changes. But while Freud concentrates on the micro-scale of a human lifetime, we will here take the liberty of understanding psychoanalysis also on the macro-scale of historical time. Thus those activities which are encouraged, allowed or debarred in a society give the precise parameters of what will remain conscious, and thus too their obverse: those activities which must stay unconscious, or those that can shift in and out of consciousness.

From his ahistorical standpoint, Freud looks to those processes which are most general to all known societies, such as the prohibition on incest. This gives him the possibility of claiming for psychoanalysis the discovery of a universal principle. But perhaps it is the more incidental issues which are of greater significance: those more or less contingent restrictions or sanctions which differ between societies. Thus one might wish to make a set of connections between the historical shifts in the organisation of vision described above and the kinds of psychic operations, conscious and unconscious, to which they give rise. This historicisation of Freud's fundamental insights into the instability, fragmentation and autonomy of psychic processes gives us both a better understanding of the place of Freud's thought in the making of modernity, and the materialist basis which, as a self-consciously positivist science, it so critically lacks.

We should not of course expect to find major fault lines in the geology of the psyche within such a small time span as the one we

are engaged with here. However, there is a critical version of psychoanalysis that perhaps gives us an insight into the relations between Freud and the problem of the artist. It was Vološinov who first noted that 'the critical analysis of Freud's psychological theory will bring us directly in contact with precisely the issue that is of utmost importance and difficulty in human psychology – the issue of verbal reactions and their meaning in human behaviour as a whole' (Vološinov 1976, p. 23), a statement based on his fundamental belief that:

> A human being is not born as an abstract biological organism but as a landowner or a peasant, as a bourgeois or a proletarian, and so on – that is the main thing. Furthermore, he is born a Russian or a Frenchman, and he is born in 1800 or 1900, and so on. Only this social and historical localisation makes him a real human being. (Vološinov 1976, p. 15)

Vološinov, and separately the French psychoanalyst Jacques Lacan, come to the conclusion that the fundamental insights of psychoanalysis need to be brought together with the study of language in order to anchor them fully in lived experience. Language, Lacan argues, is the material of inner life, and that what is not language, like the unconscious, is structured like a language. And we know that language changes over time: thus we must accept that the structures of conscious and unconscious too shift over time, and in response to the profoundly social nature of language.

Always a pessimistic science, since it deals with the aetiology of human unhappiness, psychoanalysis concerns itself with the difficulty of human relations, and centrally with the failure of social structures like the family, language and culture to provide a totally satisfying place in which the individual can live. At the same time, given the present inflection, it traces the sources of unhappiness back to a mismatch between the instinctual and the social. Each form of unhappiness is unique, but the causes of it are common, and by and large the routes open to us to live out that unhappiness – art, for example – are common too, in the sense that they also have a social place. Thus psychoanalysis can restore to materialist philosophy the problematic of the individual, which had been excised in a utopian demand for a 'new man' without desires and without personality. At the same time, this materialist understanding of

individuality doesn't act, as it does in liberal and humanist philosophy, as a positive given, on which the philosophy of freedom, the rights of the individual and the right to property (founding instances of capitalist accumulation) can be built. Instead, in a materialist psychoanalysis, individuality is itself seen as a product of socialisation.

This insight is fundamental: individuality is not given. Descartes was wrong to start from this position, in his famous formula 'I think therefore I am'. Thinking, insofar as it is verbal, is profoundly social. And it is this verbal thinking that gives rise to the individuality effect as a historical formation, one that exists only in specific societies. Individuality cannot therefore be taken as an a priori principle, since it depends on historical circumstances to come into being: as a concept, and as a social phenomenon, individuality lacks autonomy and internal coherence. The central term of liberalism is the difference between individuals: for psychoanalysis it is the difference within individuals, a difference that derives from the social interaction between individuals, from what is common to them. The inter- and intrapsychic are continuous, and both are marked by internal difference. It is the impossibility of maintaining equilibrium between the instinctual demands of the body and the socially-sanctioned representations of them in language, art and culture which marks the profoundly obtuse nature of our dealings with the world and ourselves.

In this context, it is intriguing to look back to the surrealists. Based in France, a country whose medical establishment resisted psychoanalysis tooth and nail, poets and artists seized upon the new science as a tool for change. Centrally, political revolution and a revolution of inner life were seen as one. But additionally, for some artists at least, the use of chance, automatism and found objects provided a way of escaping, once again, from the social demand that they be individuals. The bonds of the capitalist rationale were to be burst by the powers of irrationality, through the mobilisation of the unconscious by means of techniques like montage and free association. As Walter Benjamin observes of surrealist poetry, 'Language takes precedence. Not only before meaning. Also before the self. In the world's structure, dream loosens individuality like a bad tooth' (Benjamin 1979, p. 227). In the opacity of dreams, language acts according to its own logics, not those of its instrumental use in human communication. Benjamin concludes his account of surreal-

ism by arguing that it addresses the mind/body division, but that it presents also the possibility of addressing the emergent form of collective humanity, for which technology provides a kind of body for the collective. Only the surrealists, he argues, have understood that 'when in technology body and image so interpenetrate that all revolutionary tension becomes bodily collective innervation, and all the bodily innervations of the collective become revolutionary discharge, has reality transcended itself to the extent demanded by the *Communist Manifesto*' (Benjamin 1979, p. 239). Surrealism, then, can be read as a genuinely revolutionary turn of art, if only because it tends to hasten along the revelation of rationality in an irrational world, here by insisting upon the extent to which such profoundly human artefacts as language and images transcend our control.

In this analysis we can therefore see Surrealism as once again an insistence on difference, as the Surrealist-inspired Lacan would argue the centrality of difference to the structure of both language and the psyche. Such issues return as themes and techniques in contemporary video art. Anne Wilson and Marty St James's *Portrait of Shobana Jeyasingh* (1990) is a wall-mounted installation of 14 screens making up an image of the classical Indian dancer. Each screen takes a part of the dancer's body, and superb technical control observes her gestures and turns. Playing on the inability of TV to give a complete account of even a single human body, the installation comments on the metonymic relation between body parts and the whole, of which, in TV's gaze, they are the dispersed and unreuniteable elements, much like the calves, thighs and arms of Kracauer's dancers. At the same time, in making its unreal dissection of the human form (at its most classically visible in the dance) so integral a part of the work, it foregrounds precisely that fetishistic fragmentation which is so characteristic of capital's abortive attempt to rationalise the body. In its disfigurement, the gap between natural and technological body is reaffirmed, and the difference between the two brought to the centre of attention.

Even more than earlier dance-inspired pieces like *Merce by Merce by Paik* and John Sanborn and Mary Perillo's *Visual Shuffle* (1986), the *Portrait* emphasises the transition from dance itself as sheer presentation to video recording as manifestly representation, since by dividing the body into segments it isolates the moments of the dance into spatially and temporally discrete entities. Identity, the

matter of most portraiture, is dependent on the wholeness of the body as a guarantor for the coherence of the person. Yet the performance is not the person to begin with, a point made by a wink to camera multiplied over several screens in the same artists' *Portrait of Duncan Goodhew* (1990), where the wink acknowledges the social nature of the 'real' sportsman behind the public face, yet in a context in which the 'real' is still veiled, paradoxically, by the efforts of the multi-screen portrait to capture the whole person. The return to the physicality of the body as the core of aesthetic experience is redoubled in the choice of subject. More even than ballet, South Asian dance subjects the body of the dancer to ancient disciplines, and voids the body of personality as it becomes the carrier of traditions. But these traditions are alien to the West, whose cultural, artistic and technological traditions are deployed in the making of the piece, so much so that it has to address the 'exotic' quality of the Indian other. Through its sheer attentiveness to the minutiae of gesture and motion, and through its technical fragment-ation of the body, the piece returns us to the splendid and irremovable specialness of being *this* gesture, this hand, this person, this culture. The flesh, therefore, masked, encoded, clothed in the fetishism of Western technology, remains beyond the work, not as other, but as difference.

Where, then, are we to find the position of the artist in this? Certainly the names Anne Wilson and Marty St James mark a field of connections: there is legal copyright in the work; there is a body of five years' worth of experiment in video portraiture; there are two artists living in the East End of London who work to make this and other pieces come about; and there are the artists as performers, for example in the performance-installation *Hotel* (Air Gallery, London, 1988). The modernist response might be that the artists have no place in the appreciation of the work: that either it operates in and of itself, or it does not, and the biographies of its makers are irrelevant. The film critics associated with 'political modernism' denounced belief in the importance of the artist to the work as 'auteurism', pointing out that film is an industrial commodity subject to the laws of the marketplace, and bound to the practical wisdom of the language of film and to cinematic exhibition. Much the same can be said of art practices: as we saw in the analysis of Warhol, art is a business, and even such tricky commodities as installations have to abide by the rules of the art world. Of the

varieties of modernism explored so far, only psychoanalysis opens up a route for understanding the relationship between artist and work, and it is not one of authorship. The artist is bound to the work not by being its metaphysical origin, but by the materiality of the practice of making work. The process of making produces the artist as much as vice versa. Both share the moment and the place of making; share, if you like, a language, or at least the problems of a given language. Neither is that language itself eternal or universal, for it is subject to historical change, and itself embedded deeply in the social formation in which it is made. The problems, then, of fitting or not fitting into the givenness of a specific historical language are common to maker and made, and it is that problem, the dialectical tension between the givenness of language and the untidy and unhappy fit of artists and product within it that gives art its specific negativity *vis-à-vis* the dominant culture of its own time and that of its consumption.

In his great canvas of 1954, *Les Constructeurs*, Ferdnand Léger exhibits precisely this kind of tension. On the one hand, he illustrates the admirable, even heroic dexterity of the builders of this great tower, a kind of anti-Babel in which collectivity is already the social norm. The ease with which they defy gravity, taking over the new space of the air which the twentieth century opened up for common consumption, is matched only by the insouciance with which they trample on the last representative of nature among them, a branch ready for transformation into building materials: human, rational stuff. On the other hand, like all of us, he recognises the gap between reality and painting, and specifically between the dirty, dangerous job of building skyscrapers and the paradisaical utopia which is his subject matter. The tension comes out particularly in the shifts within the canvas between abstraction and representation, between the geometrical composition of the girders as pure form with their play of primary colours and sharp lines and the realist representation of the men, and in the multiple, confusing, Escher-like perspectives of the scaffolding in which they climb. Léger opts here, as so often, for a utopian equilibrium between the claims of reality and reason, between pessimism of the intellect and optimism of the will. This is not how things are, but how things should be: the contradictions of the form re-echo this fundamental contradiction in the genesis of the painting. Such contradiction seems to me the lifeblood of art considered as a negation of contemporary life, and

helps us to understand the dialectical relation of the individual to society as one which is again characterised by negation, contradiction, difference.

The complexity of this relation of negativity may become clearer through another example. Catherine Elwes's (*Wishing*) *Well* (1991) is of a remarkable simplicity. On a stepped plinth stands a column more or less the right height to look over. Inside, the column is hollow, and at its base, face up, lies a video monitor showing a black-and-white image of a child seen through water, into which, from time to time, a stone appears to drop. Very quietly, the soundtrack reproduces the distant, echoing voice of a child, too far away and muffled to decipher. You strain to hear it, but to no avail. The child's face fails to resolve into someone identifiable as well: even its gender is indefinite. Yet its position is all too clear. The kinds of address to the viewer are multiple, and easily recuperable through the ambiguities of the title: 'Well, well, well' – there you are, that's it, no more to say or do; or wishing the child well, wanting its escape; or perhaps the child is the genie of the wishing well, but a perverse one that confronts our wishes with its own; the well as source, a metaphor of the womb, wellspring of life, but contained and, in its refusal of gender and its replacement of water with images, dried up – a well? You wish! And so on. The multiple ambiguities refuse to gel into a hierarchy, some one meaning focussing the others around it. In a comment on the piece, Elwes writes 'As I sit inventing "meaning" for this piece, I am aware of reluctantly imposing closures where my intention was to open up possibilities. Perhaps the answer is to spill out a proliferation of readings' (Elwes 1991, p. 23). The artist's business is to open rather than to close. So this simple, powerful image of loneliness is layered with crisscrossing interpretations because it refuses to be anchored in any single location (such as 'Is the artist a mother?'). The critical relation is here not between artist and work, or even artist and audience, but between the audience and the work. Designed so that only one person at a time can see and hear, the piece thus damps down the ordinary communicative pleasures of looking and listening. The subject of the work, in many senses, then becomes the loneliness of the viewer, not of the child: our remoteness from it, rather than its remoteness from us; our inability to act, rather than its.

Typically, the artist's own comments on the work at its opening at the Bluecoat Gallery in Liverpool, England, concerned the height of

the column: too high for many of the people who wanted to look into it, a last remnant of the artist's own body saved as the height of the installation. The artist's role seems to diminish into the practical job of enabling the work to exist, to enable possibilities. At the same time, however, it is clear that the work does address individuality, and in the collocation of a female signature on the work and the figure of a child seems also to demand an enquiry into gender. Yet such an enquiry into gendered individuality would be misplaced if we used it only to enquire of the artist what she was thinking of when she made it. The enquiry is properly addressed to the moment of viewing, in which the artist can share, though without the determining role given her in Romantic aesthetics. What we confront in the well is an other, one whose demands of us we respond to with demands of our own. This is not even a reflection of our own desire (this is a screen, a light-source, and therefore only a very poor reflector if the lighting allowed for reflections at all) but a counterdesire, the well itself wishing, demanding of us an impossible nurturing (for the child, after all, is a recording, and cannot hear or see us). This is not a wish, but wishing: a process without end, a desire which cannot be satisfied because it is desire, and if it were satisfied, it could no longer exist. (*Wishing*) *Well* confronts us with the loneliness of desire, as it demands of us ever more interpretation, ever more investment which we throw into the well like copper pennies; meanings as lost in the enormity of desire as coins down a hole in the ground.

 In this brief excursus on the role of individuality, then, we come to the conclusion that personality, individuality, identity present themselves in the modern period not as solutions to the riddle of origin, but as themselves multiply fragmented, unstill and unhappy, perhaps finally better characterised as processes rather than things. And if we were to ask what the processes are, then one answer at least would be that they are processes of formation, that subjectivity is a process which pursues interminably a goal of giving form to the chaos of nature, internal and external, but which has never yet achieved, in historical societies, such a final comfort. We act, not in pursuit of a pre-existent Absolute, but as if there were one to pursue. This is the figure of 'libidinal gratification' raised by Jameson: a mythical lost plenum of sensation that psychoanalysis identifies with the infant child's experience of wholeness as it sucks at the breast. It is also the self-transcendence of reality which Benjamin identifies in

the *Communist Manifesto* as the historical goal of humanity, as it is the true reason that Kracauer searches for through the mechanical rationale of the Tiller Girls. However we describe this mythic goal or mythic origin, it continues to function as the motor of cultural and artistic process, the negativity which Adorno ascribes to the avant-garde. For modernism, then, individuality is a stage through which we must pass, and which must therefore be explored and negated as we do so. We will go on to look at the ways in which this problematic has been addressed in the realms of television and film studies, as a prelude to a more detailed look at video media practices.

5

Vision: Video in the Field of Film

Frequently described as an art form by its more sycophantic admirers, throughout its 100-year history film's formal parameters that might make that pious description take on concrete shape have proved elusive. Early attempts like *The Assassination of the Duc de Guise*, performed by members of the Comedie Française in 1908 to accompaniment specially composed by Saint-Saëns, are frankly documents of more popular or more elevated, traditionally recognised art forms. It is virtually a truism to repeat that the popular forms of pioneer days were superseded, in a attempt to attract higher-spending bourgeois audiences, by imitations of the themes and narratives of the bourgeois theatre. To this extent, from early days, cinema was a hybrid form, drawing its inspiration from the easel painting, the proscenium arch theatre, the nineteenth-century novel and traditions of reportage and scientific documentation deriving from photography. The photographic tradition, extending back already over 60 years, was itself in turmoil as the Eastman–Kodak process brought the snapshot within range of the masses. At the same time, there was enormous competition from the illustrated press for news audiences. So it is unsurprising that the photo-documentary tradition in cinema was soon swamped in the commercial imperative towards a steady supply of film product for the booming cinema market of the later 1900s. No-one, after all, can guarantee the supply of earthquakes, assassinations and wars; a studio producing narrative cinema on a systematic basis can, however, promise pretty faithfully to deliver films to a tight and regular schedule. Over the years to 1916, then, realist drama became the norm: the mainstream film was born.

For some, this hybrid origin is a bastardisation of the intrinsic qualities of film. Under the impact of Greenberg, many critics and filmmakers have argued the case for a cinema shorn of all literary, dramatic or painterly qualities: a pure cinema, as Greenberg championed a pure painting. For such practitioners, the question is also one of audience. The mainstream cinema, attracting vast crowds throughout the century, dominated popular entertainment and communication until the 1950s. Even subsequent to the break-up of the classical studio system between 1949 and 1956, the values and stylistic traits of Hollywood cinema still dominate Western television and radio production, as well as accounting for the lion's share of the video sell-through and rental markets. Given the scale of the industry and the economic power of the major players, as well as the rapidly acquired expectations of audiences, it is unsurprising that the opportunities for artists to reach mass cinema audiences were limited. The corporate structures, even in Europe after the First World War, were already huge by 1920. At the same time, few artists were prepared to turn their backs entirely on the audience for film. Instead, much artistic work in film begins with a critique of the cinema-going public and their relationship to the screen. In the emergent critique, the question asked concerned an accusation, levelled at dominant cinema, that it failed to do more than titillate, pacify, delude or corrupt the mass audience that flocked to it. There emerged a sense of moral duty to propose, and political euphoria at the prospect of, a different kind of cinema: one that would educate, agitate, instruct or otherwise transform its audience.

The experiments in film beyond the mainstream, those that attract the epithet 'art' (usually an adjective in association with film, more rarely a noun), have been many and contradictory. In this complex negotiation over the meaning and nature of art in film, we need to make some preliminary distinctions. The term 'art film' has come to mean, in English-language circles, mostly narrative films made for a particular kind of distribution and a particular kind of audience, the art-house market. Such films are marked less by their stylistic interest and more by their concern for themes other than those normally treated by mainstream popular cinema: a literary mode of film-making. Films signed, for example, by Woody Allen, Satyajit Ray, Akira Kurosawa, François Truffaut and Federico Fellini, while they do develop personal styles of imaging and story-telling, do not set out to question at fundamental levels the nature of film as

a medium. Indeed some critics would add to such a list titles like *Un Chien Andalou* or even the work of Brakhage and Snow (work which is more commonly seen as avant-garde than art-house).

It is this domain of the avant-garde (sometimes referred to as 'artists' film') that interests us here, since it is in these films, and in the discourses around them, that we come closest to the concerns voiced, otherwise, in video discourses, especially themes concerning the difference between art and popular culture, questions of sexual difference and identity, and issues concerning the relationship between films and viewers. In this way, the avant-garde film and its associated theoretical practices form a bridge between art and video discourses of the psyche. Fundamental to the avant-garde film is the problem of representation, the relationship between reality and its recording and processing in the techniques proper to film: lighting, framing, camera movement, printing, editing, *mise-en-scène*, sound recording and sound editing. The many different theories of representation begin from a simple observation: film utilises a two-dimensional screen to observe a three-dimensional reality. There is, moreover, an irreducible gap between what we see on screen and the events that previously took place before the camera. So questions arise not only concerning space but also time: the present of the audience is not that of the 'pro-filmic' (the objects and actions placed in front of the camera and microphone). Mainstream (and art-house) cinema stand accused of producing an illusion of shared time and space – an illusion of presence – through techniques such as continuity editing and deep-focus cinematography. The avant-garde has seen it as its business to challenge this production of illusion by attacking norms of film style or pro-filmic realism, or both.

An important rationale for this practical critique of mainstream cinema derives from an area of film studies called apparatus theory. Apparatus theory sets itself the task of extending film theory's critique of the ideological burden of mainstream films by analysing the kind of subjectivity to which they seemed to address themselves, arguing that films addressed themselves to an ahistorical, unified and idealised, transcendent subject. For example, putting the case that 'as he identifies with himself as look, the spectator can do no other than identify with the camera', Christian Metz argues that the camera's representative in the cinema is the projector, 'An apparatus that the spectator now has behind him, *at the back of his head*' (Metz

1982, p. 49). Here Metz declares that although vision has become an autonomous entity, the cinema exerts its fascination so completely as to bring about an identification between the looker and the look, and that this is done specifically through the intermediary apparatus of the camera and the projector, which seem to come from within the spectator, and which seem to respond to a wish to see what happens next. Yet what is happening in fact is that the spectator's own desires are being remodelled into the ideological forms of mainstream cinema through this powerful use of identification. The first step in identifying with macho heroics is to identify with the camera/projector as source of the image. That way you can be assured that this is your own fantasy, despite the fact that it was made by someone else.

This coincidence of viewer and vision was seen as the cornerstone of subjectivity in the cinema, where the term 'subject' (as in 'subjective') refers both to the grammatical subject of a sentence ('the person or thing that does the action') and to the notion of subjection, being subjected to the experience of identification. The aim of Hollywood film was, it was argued, to provide a coherent, unitary point of view from which alone the film, any film, becomes comprehensible, and therefore can perform its ideological work. Using all the means at its disposal to create coherent illusions of coherent worlds, Hollywood speaks to the viewer as if s/he too were a single, unified, coherent subject. Having been called into being by the structure of the cinema itself, this unitary subject becomes the grounds of possibility for the suspension of disbelief so important to fiction, but also for the concomitant reality effect of film, the way in which we accept the fictional world as behaving like our own and according to the same rules. The reality effect in turn is the principle on which the cinematic rules for the representation of social formations of gender, class and race are based. For apparatus theory, then, the establishment of the viewer as a transcendental subject of the cinema is the major prior condition for all the social and ideological work of the film. Here alone could the viewer be anchored to the chain of images, stitched into the fabric of the film so tightly that it would be impossible to distinguish between the spectator's desire and that of the film.

Typically – and as a theory, this theory emphasises the typical – the subjectivity produced by the cinematic apparatus was seen as ungendered. Metz points out the dialectic of presence and absence,

the illusion of the presence of the star, say, combined with the actuality of his or her absence from the spectacle, as crucial to cinema. But this emphasis tends to ungender the spectator, whose bodily presence is understood to be subsumed into the unreality of the film through the identification of the spectator with the faculty of vision. In offering to annihilate the historical autonomy of vision in a kind of libidinal gratification, a return to the wholeness that the child experienced at the breast before it entered history, cinema was also understood to be offering to annihilate the sexual difference which infants learn as the first rule of socialisation. This disavowal of sexual difference is therefore the ground for the specious unity, totality, mastery and satisfaction which, variously, theoreticians of the apparatus attributed to the cinematic subject. The success of the whole operation of film depends then on the homology between cinema as an industrialisation of subjectivity and a psychoanalytic explanation of the psychic apparatus. In some accounts, cinema facilitates regression to infantile states of satisfaction through the analogies between cinema and dream, the cavernous darkness of the cinema, the scale of image that allows the eye to wander across the frame while filling the field of vision totally. For others, cinema is the supreme moment of a history in which different forms of media strain towards the most perfect analogy with pre-existing forms of the psyche. For others still, the form of regression is determined by the form of cinema and imposed on the spectator. In each of these three approaches, though, it is the cinema itself that determines the state of its spectators, rather than individual films, and mainstream cinema is most to blame for this manipulative relationship to the viewer. The medium, fundamentally, is the message.

Although there are differences in the explanations on offer – facilitation of natural regression; potent analogies between media and psyche; determination of regression by cinematic form – yet there is no doubt that the technology is the supreme explanatory framework. Though most contributors to the debate insisted that this was not a technological determinism, since it mapped the interrelations of industry, ideology, subjectivity and science into the production of the actual machines used in cinema, yet the machinery, so determined, still sat 'upstream' from the experience of any specific film. Metz catches this strange mix of coherence and contradiction at its complex and provocative apogee when he writes:

When I say that 'I see' the film, I mean thereby a unique mixture of two contrary currents: the film is what I receive, and it is also what I release, since it does not preexist my entering the auditorium and I only need to close my eyes to suppress it. Releasing it, I am the projector, receiving it I am the screen; in both these figures together I am the camera, which points and yet which records. (Metz 1982, p. 51)

In the identification of subjectivity with technology, Metz sees a set of contradictions (for example, between active and passive viewing) being resolved rather than opened up. Cinema thus mobilises many of the contradictions that most affect us (how many mainstream films revolve endlessly about the problem of sexuality) but, by its very architecture and technology, it is doomed to offer us resolutions of those contradictions.

The risk here is that the theory, having identified a monolithic quality of cinema, takes it on board as the essence of the experience of film going. The erasure of sexual difference in the theory, as well as the phenomena it describes, is particularly worrying. In this context, Joan Copjec and Constance Penley both note that two key essays by Jean-Louis Baudry (1976, 1985, first published respectively in 1975 and 1970) are differentiated by a shift from the word *appareil* to the word *dispositif*, the former carrying rather stronger connotations of machinery. Penley cites Copjec approvingly to the effect that 'Patriarchy can only be an effect of a particular arrangement [*dispositif*] of competing discourses, not an expressive totality which guarantees its own self-interests' (Penley 1989, p. 71, citing Copjec 1982, p. 58), so arguing that previous apparatus theory had presumed that the maleness of the apparatus (and consequently of the transcendental subject) was given, whereas it needs to be understood as a product of an internally contradictory cluster of practices. So we could argue that the theory imposes a coherence on cinema experience that doesn't in fact exist: the projector is not in the back of your head but above it; sound cannot be received and released, as Metz would have it, in the same way as vision; we rarely experience ideal viewing conditions; and we bring our own complex sets of interests and experience with us to the cinema. Thus apparatus theory is good only in the general; in the particular, we find that there is a hierarchy in the 'competing discourses' which Copjec identifies, one that does foster a transcen-

dental subject of patriarchy, but which by no means determines absolutely the ways in which films are watched.

However, I would suggest that cinema needs to be understood as a machine and an institution that promotes, if it does not determine, the erasure of difference through the promotion of a central, all-translating, normalising position for the spectator, rather in the way that perspective gives us a place in front of a picture. This norm is ultimately an idealised masculinity, identified with the infantile sense of wholeness reconstructed in cinema's encouragement of regression. Regression, in fact, is crucial, as it gives the subject a sense that s/he is outside (prior to) history: the transcendence of the transcendental subject is precisely the transcendence of history. The construction of a patriarchal and transcendental subject then makes patriarchy itself seem transcendental, universal, natural, given. If this rearrangement of apparatus theory is correct, then it would follow that the technology and institutions of a medium can be said to have ideal ideological effects, or effects ascribable to the ideal of cinema viewing, through the ways that they address the spectator, prior or in addition to the material specificity of individual viewing moments, where that ideal effectivity is never totally achieved. This opens in turn three avenues of enquiry. First, how much power can the individual bring to bear on the experience of viewing, and how much is down to the apparatus? This is the substance of the next chapter. Second, in these days of rapid technological invention, can it be argued that new technologies are in some way perfecting the address to a transcendental subject, or pursuing new ways of addressing new subjectivities, or are actively producing them or the possibility of their existence? This issue we will leave to the second part of this book. But the third we can go on to immediately: can there be an image practice which disrupts the power of the apparatus so radically that it will produce new kinds of subjectivity, or at least refuse the ideologically-loaded transcendental subjectivity which the mainstream cinema so ardently promotes? Such, after all, is the reason for having an avant-garde in the age of feminism.

Among accounts of avant-garde film, perhaps the most persuasive have been those based on the kind of semiotics that informs apparatus theory. A wide and difficult terrain, the language of avant-garde criticism is also one whose history is full of contradictions and abrupt changes of position. As Rodowick (1988) argues, it is impossible to define this area of contention as a unified

theory, lacking as it does genuinely common procedures for evaluating the validity of its statements. Yet certain common areas of concern do emerge. Perhaps the clearest expression of modernist concerns in film semiotics emerges in Peter Wollen's seminal essay of 1975 (reprinted in Wollen 1982) on 'The Two Avant Gardes'. The first avant-garde is the painterly tradition traceable through the films of Richter, Eggeling, Léger and more recently of Paul Sharits and the group around the London Filmmakers' Coop. The second is a more literary, theatrical, or documentary strand running from Eisenstein to contemporary political documentarists. Common to both is the problem of representation, whether understood as a difficulty between film and reality, or as a question of the internal dynamics of the sign itself. Following the Swiss linguist Ferdinand de Saussure, Wollen analyses this internal dialectic as one between signifier – the material form of film as sound and image – and signified, the specifically mental image or meaning associated with it. For dominant cinema, the relation of signifier to signified, of image/sound to meaning, is immediate and necessary. Without this essential unity, none of film's other work on meaning and subjectivity is possible, nor is it possible to create the illusion of reality in cinema unless the processes of signification used are themselves internally coherent.

The two avant-gardes are divided on the point at which they see the greatest disparities between signifier and signified, and at which they want to intervene. Eisenstein's montage theory, like the poetic styles of Dreyer and Bunuel, takes work at the level of reference – relations between cinematic sign and reality – as its focus, and finds it necessary to alter the signifier only in order to represent reality better. Yet, Wollen argues, such cinema remains in thrall to illusionist principles. By putting the medium into the service of a particular perception of reality (in Eisenstein's case Soviet socialism, in Bunuel's the dream), this avant-garde reproduces the idealist identity between film and reality which fuels dominant cinema, the conception of reality presenting itself as self-evident, ignoring the specific qualities of the film process. At the opposite extreme, the abstract tendency (most lucidly celebrated in Malcolm Le Grice's *Abstract Film and Beyond* written during the following year: Le Grice 1977) runs into a Greenbergian scenario, in which concern for the specificity of the medium turns into a slavish concern for the purity of the art form, the pure presence of film

as film, autonomous and self-sufficient in the face of the social. In semiotic terms, this represents an interest in the signifier, the materiality of the sign, at the expense of its relationship to reality. (Another variant on this tack sees film as a universal language of images capable of expressing inner emotion, a concentration on the signified at the expense of signifier and referent.)

Wollen's loyalties are split. In common with his peers in the political intelligentsia after 1968, he believes powerfully in the political efficacy of film. At the same time he is convinced of the value of the rupture in Western systems of representation represented by the modernist tradition. The – partial – solution lay in the work of Jean-Luc Godard, a body of politically grounded films that constantly quiz the relation of sound and image, image and reality, the internal dynamics of dialogue and narrative: Wollen singles out *Le Gai Savoir* (Godard 1968). Wollen's own film collaborations with Laura Mulvey (*Penthesilea, Riddles of the Sphinx, Amy!* and others), continue in this vein, drawing on the history of film, its processes and common rules in order to break down the hegemony of reference (realism) without falling back into work purely within the sign, as occurs in the painterly tradition (abstraction) or the illusionistic new realism of Eisenstein. In this sense, Wollen argues, the history of modernism is a history of the relation of signifier to signified, and of the sign to its referent. Abstraction is simply an unschooled emphasis on the signifier at the expense of reference, and realism an undue emphasis on the referent, ignoring the potential of the sign. He proposes not a synthesis but a film practice which, while emphasising the gap between signifier and signified, the line in the sign, sees in their opposition the possibility of making new meanings in the real world.

The problem of the translation effected by the eye upon its objects informs much of modernism, as we saw in the previous chapter. For Greenberg, the novelty of analytical cubism lies in a combination of the teleological tendency towards the goal of a pure art with the more adequate representation of (how we look at) the world. A more materialist critique, like Duchamp's, would argue that the business of modernism can be understood as a negotiation between the fortuitousness of the Real (as in the dust breeding for the Sieves in *The Bride*) and the engineered selection and appropriation of its effects for artistic uses. I argued that the importance of the work rests in the ways in which it foregrounds its internal contradictions;

we might now add, and the contradictions between it and the world. The internal difference is a measure of the external. For Wollen, this has to be understood in terms of the relations between signifier, signified and referent. By concentrating on the transformation of reality into signifier by the technologies of signification, it becomes possible, in Wollen's analysis, to think of the political purposes of work within signification: by working on the sign and its internal structures, we can not only disrupt the production of coherent subjectivity in the mainstream cinema, but devise a practice which is capable of creating meanings that as yet have no existing referents: a political avant-garde aimed at creating the art of the future today.

Characteristic of this position is the assertion that the work should be done within signification itself. This will, of course, leave Wollen open to criticisms of Greenbergian idealism, a position of art working on art for its own benefit (see Willemen 1984 for a powerful and important version of this critique; also Rodowick 1988, pp. 55–61). At the same time, however, we should note that this respect for the medium itself, in its specificity, is an important part of the work of film theory: like Duchamp's concept of photography as delay, this work on the processes of signification insists that there is no transparent medium through which we view the world. From a materialist perspective, this means that foregrounding the way a work is produced, while hampering 'pure' communication, also interrupts the processes of ideology, and may even make new ideological formations more possible. This, however, leads us in turn back to the issue of the audience. Film semiotics and its theory of the subject tend to veer towards a belief that the subject is formed in and by the text. But if that is the work of the text, what is the audience up to?

Wollen's co-director Mulvey set the terms for this debate in her much-anthologised 1975 essay 'Visual Pleasure and Narrative Cinema', which proposed, through an application of Lacanian psychoanalysis, a model of the spectator of mainstream film as the subject of (and subjected to) the processes of making sense set up by film. From a perspective formed in the resurgence of feminism in the 1970s, Mulvey argues that narrative cinema uses mechanisms of identification to restructure the psychic formation of the viewer within dominant modes of subjectivity, especially of gendered subjectivity. Concentrating on the issue of pleasure, she argues that films organise the biological, instinctive pleasures of looking into

socially-determined (and therefore patriarchal) structures of voyeur-
ism and fetishism, both differently involved in producing illusions of
power, especially of power over women. Here she is extending
arguments already raised in our account of apparatus theory.

 This theory of the subject as textual effect clearly counterposes
two possible models. On the one hand, dominant cinema is held to
reproduce a 'Cartesian', transcendental subject, an 'I' which is
capable of knowledge and action, and which is guaranteed by that
capability: 'I think, therefore I am'. But for apparatus theory, as for
Mulvey and Wollen, the alternative Freudian model comes into
play: the 'I' is a material subject who has to come into being socially,
historically, biographically. As a result, the model of subjectivity
they offer is characterised by the splits, discontinuities, imbalances
and lack of a clear centre that result from the ill fit between the
society and individual. The Lacanian version of Freud which
influenced the formation of this field of speculation emphasises, as
we noted above, the relation of subjectivity to language. The
Oedipus complex, in particular, is reread as the story of the child's
acquisition of a place in what Lacan calls the Symbolic, the domain
of all social, rule-governed systems into which the child must fit, and
the home, therefore, of language. The first rule to learn, in this
account, is the law of sexual difference, the law on which all
language and social structures will ultimately be based. Entry into
the Symbolic is then characterised by a traumatic struggle in which
the most vivid instinctual feelings have to be forced into a shape that
conforms with social norms.

 It is not only the necessary repression and the threats by which it
is achieved that are painful and only ever partly successful, however;
the characteristics of language itself further destabilise the subject.
Language, in a Lacanian slogan, speaks us as surely as we speak it.
But language never ceases: its constant flow is proof that it is itself,
as we are, radically incomplete, always pursuing the next signifier,
and the next. What's more, the split between signifier and signified,
and between the speaker and what is spoken, are also theorised by
psychoanalysis as symptoms of the endless internal instability
produced in socialisation. Yet it is the business of cultural forms
to try constantly to reorganise this chaotic chorus of subject
positions into something that will fit into the large-scale organisa-
tion of society. We need such structures, since a life without them
would be nasty, brutish, short, and even less happy than a social

existence. Thus it is that structures such as language, table manners and sphincter control become 'second nature' to us.

Such constant reorganisation, it is further argued, is always undertaken under the aegis of the hegemonic class: that faction in a given society which has assumed the mantle of power, and which is therefore in a position to declare its interests as universal interests. All is not lost, however; given the internal incompletion and instability of language, and the parallel state which it produces in the subject, there remains the possibility of change. From this politicised perspective, it is possible to theorise hegemony as a field of struggle not only between classes but at the level of smaller social groups, even of the individual. Furthermore, the importance attached to language opens the door for a further step: a recognition of cultural struggle as an important, viable, even essential part of the political struggle against the dominant class or, in some formulations, against the principle of domination itself. For mainstream cinema engages us in idealist categories of the transcendent subject and its empirical knowledge about reality, and through them reassigns us to marked places in the social order through the regulation of signification in the cinema. Therefore Wollen, Mulvey and others can argue that an avant-garde, armed with the modernist concern for work at the level of signification, can use different textual and apparatus strategies to pry open that unitary ideal, and open up the possibilities of instability, fluidity and therefore of personal and political change.

The most persuasive and, in some ways, the most extreme version of the textual politics of art cinema can be encountered in the work of Peter Gidal. A filmmaker, theoretician and teacher since the 1960s, Gidal was a founder member of the London Filmmakers' Coop, a group established to provide the fundamental facilities for avant-garde filmmaking for its members, and simultaneously to open a space for communal practice in filmmaking, theory, exhibition and distribution. Among the equipment deemed essential (and sometimes built by members) were, unusually, developers and optical printers, allowing filmmakers to work at many more moments of the production process, while the building base allowed for an extension of production into areas of exhibition, discussion and exchange. This represents the possibility of intervening in the apparatus of cinema, and experiments included filming and refilming screenings to accumulate a many-layered, audience-responsive

film and also, repositioning the projector, using multiple screens and so on, thus shifting the ground away from the ideal cinema experience. Gidal's theoretical work needs to be understood in the context of this group ethic of physical work on film in an extended production process.

Towards the end of the 1960s, when the Coop took shape, the issue of avant-garde film was well to the forefront of theoretical interest in cinema and was to remain so throughout the 1970s. The impact of this attention is visible in the growth that clearly took place between the publications of Curtis (1971) and Le Grice (1977). In many ways that commitment to alternative practices and 'independent' cinema remains, and is central to the ethos of contemporary video practice; what has changed is the centrality of abstract, 'structural' or 'materialist' film to that concern. In that sense, the publication of Gidal's important *Materialist Film* in 1989 needs to be understood, again, historically: as he says in the concluding sentence of the book, 'Radical experimental film is countered by the desire to leave the cinema, in the face of the materialist avant-garde' (Gidal 1989, p. 160). Gidal is here ambig-uous, observing the flight of the audience from 'difficult' cinema, while offering a choice: either a materialist avant-garde, or we abandon cinema altogether. If there remains a public for alternative film and for experimental video today, it tends to be for work deriving from what Gidal would characterise as external interests – exile, gender, identity, class, sexuality – rather than for the material work on film signification.

At the heart of Gidal's aesthetic, and in the first chapter of the book, lies the notion of the one-to-one relation: 'The importance of the history of each viewing is inseparable from the subject/viewer's own history but not somehow determined by it. This gives the material of film power through which the cinematic event persists' (Gidal 1989, p. 11). This forms Gidal's response to the criticism of 1970s work, that it was too tightly bound up in the effectivity of the text. Here he recognises the specificity of the audience in the particular screening, but still maintains that it is the film, as a whole event, and as a material practice, that holds the key to the viewing situation. In fact, in a sophisticated move earlier in the book, Gidal has already begun to investigate the undermining of the 'subject-effect' analysed by Baudry. Discussing Kurt Kren's film *TV* (1966) he says:

We are confronted with the impossibility of adequately lengthy perceptual identification of the represented. In this film, a *process* made of durations, the quantity of time, is not sufficient for anything to proceed, here, as imaginarily communicated space into which one could somehow identify. The viewer as subject of the content is made impossible. Rather the durational sequences become the subject/object *film* through repetition and the abstract. The distanciation process inculcated thereby produces a viewer who him or her self also then no longer can maintain an anthropomorphic self-identity. Rather the film processes each 'him' and 'her' over and over. An equalisation takes place between viewer's processes and film's. Repetition expels identity. (Gidal 1989, p. 144)

André Bazin (1958) had praised cinema for its increasingly exact rendering of reality, especially of space through the development of deep-focus cinematography. Baudry had attacked precisely this aspect of cinema as a lure that attracted audiences into the visual regimes of the dominant subjectivity. Gidal here praises Kren's film for contesting this ideologically-loaded realism, in particular the expression of space and time in films as the grounds for identification. More even than the painting that presents itself as only a painting, this disturbs the ease with which a film might be produced as a pure object for aesthetic consumption. Kren is praised for disrupting the production, through film, of objects for vision as well as for identification: without objects, no subjects. Not only does this conjuncture of technical manoeuvres disrupt the formation of the viewer as transcendental subject: it makes *any* kind of subjectivity impossible.

While it is fair to emphasise that this is a textual model of subject production, it is also worth pursuing Gidal's political rationale for these theoretical and practical moves. Alongside the critique of coherent, Cartesian subjectivity in mainstream film, leading to a negative politics that simply disrupts that construction, there grew up a more radical critique formed in the crucible of 1970s feminism. In the work of influential French feminists like Kristeva, Montrelay and Irrigaray, femininity is posited as the subject position which cannot be spoken. Where earlier psychoanalysts had suggested that girls experienced the same castration complex as boys, only inverted, Kristeva argued that the pre-Oedipal relation with the mother,

characterised by a pre-Symbolic 'chora' of as-yet unformed and unsocialised drives, offered a model of subjectivity outside patriarchy: a 'feminine' subject. Irrigaray investigated the labia as an alternative to the phallus as the central signifier of desire: her title *This Sex Which Is Not One* (*Ce sexe qui n'en est pas un*, 1977) indicates both that femininity cannot be defined as a sex at all, and that its founding principle is not single but dual. In Montrelay's influential study *L'Ombre et le nom* (1977), we find an insistence that the physical nature of the woman's body is situated in a double negative: only the male child can fear castration, for the girl already 'lacks lack'. As such, women cannot enter the Symbolic on the same terms as men, and their different relation to language, founded on an imaginary (that is, pre-Oedipal) relation with the mother threatens the destruction of the Symbolic itself. Since the Symbolic embraces both language and social structures, the inference must be that femininity is so deeply different that it becomes the most potent of all political forces for radical change.

These psychoanalytic concerns are important to Gidal's work because they suggest a form of subjectivity radically other than that which is policed into existence in the dominant culture. As such, they offer to Gidal, as they did to Mulvey, ways of thinking about a possible future subjectivity, something that might be worked towards. This in turn provides a way of thinking about avant-garde practice as not merely countering dominant ones, but producing its own. Neither is this, for Gidal, a merely utopian project. Utopias in this sense are route maps for film practice, a pledge that a future of some kind exists. This future has the added beauty of not predetermining its goal.

Nonetheless, it is true that such feminisms run the risk of inventing an essential femininity based on biology. While this problem remains, the contribution of these explorations to film theory modify them towards a sense that all subjectivity can be deconstructed towards a pre-Oedipal base, since before the Oedipus, sexual difference has no meaning for the infant. So Gidal can argue that 'A materialist film makes a viewer a not-knower' (1988, p. 56). At the same time, he is careful to distinguish between materialist practice and the production of films that pretend to an absence of meaning in the pursuit of pure visuality, Greenbergian films. Neither presuming the transparency of meaning, as in realism, nor wishing to remove his work entirely into Kantian disinterest, he argues that

work at the level of signification is not without purpose but precisely undertakes the tasks which Stephen Heath (1979, p. 97) had criticised him for not recognising:

> Those meanings, images, words, still arbitrary, can function as the specific effect of a cause, or the specific effect of various causeless elements, that is their use for political struggles and meanings. *The production of meaninglessness in representational practice functions exactly to process such a position.* Thus film producing meaninglessness *does* (*pace* Heath) mean 'in meaning, crossed by meanings, those of the history of cinema they inevitably and critically engage included – and productive of meanings, not least the complex meaning of their, of that, engagement'. (Gidal 1989, p. 77)

The disruptions of logic, reason, linear narrative and identity produced by materialist film must to some extent produce meaninglessness, but one conceived of positively. Like the femininity conceived of by Mulvey, Irrigaray, Kristeva and Montrelay, Gidal argues for the production of a subjectivity recognising its historical anchors but engaged in recreating that history without subject or coherence. 'Meaning', regardless of its content, means the construction of subjectivity and coherence according to the hegemonic pattern. But meaninglessness also means something: it 'means' by virtue of its difference from ordinary, dominant signification. So, like meaning, meaninglessness too is social, historical, even ideological. But it offers a more profound challenge to the common supposition that meaning is a given, an essence inherent in all human discourse, than is possible for a mere art-house movie.

Though few artists have pursued this trajectory with the rigour of Peter Gidal, David Hall's work in video does carry some of the same weight and the same concerns. In the installation *A Situation Envisaged: The Rite II* (1988), Hall builds a great monolith of 14 monitors, their screens facing the wall while they replay broadcast television, without sound, so that a raging aurora of phosphorescent colours surrounds the black mass of the technology. A single screen faces the viewer, replaying an image of the moon recorded on a reconstruction of John Logie Baird's original mechanical televisor system of the 1920s. A soundtrack orchestrates the sound of many

broadcasts into a composition, almost musical. To some extent, the piece is legible as a purification of television through the medium of video sculpture: the removal from broadcasting of the anchorage in referentiality that underpins its claims to represent the world to its viewers. Though television could not claim either the power of cinema (in terms of the special qualities of cinema viewing such as scale, volume, darkness, quality of reproduction and so on) nor its immense potential for imposing subjectivity on its audience, yet the younger medium has a power of is own. As the ubiquitous hearth of the contemporary home, familiar as furniture, and as a source of images as reliable as tapwater, TV produces its own kind of subjectivity if looked at through the gaze of film theory. TV flow and TV presence – its address to the viewer as if it was always live – keep broadcast and viewing in a perpetual present, united now by time rather than by the spatial devices of the cinema. In removing broadcast to an unfamiliar setting; by piling broadcast upon broadcast to the point of anonymity; and by taking the next step, which is to fulfil that move towards anonymity by defacing the image, turning its face away, Hall removes the contingent content of broadcasting, leaving us with the sole experience of TV as a light source, as fundamental as the moon. The reduction of sound to musical accompaniment simply furthers this purification of the medium to the point at which it is only itself.

So we can read Hall's work as a Greenbergian, idealistic attempt to simplify TV down to its basic functions, at which point it should reveal, on the Greenberg thesis, the purity of form alone, a work, in Wollen's terms, on the signifier. Yet the piece is considerably more ambitious than this. In his notes on the piece as shown in Oxford in 1991, Hall quotes Raymond Williams to the effect that 'Unlike all previous communications technologies ... TV was a system primarily devised for transmission and reception as [an] abstract process, with little or no definition of preceding contents ... It is not only that the supply of broadcasting facilities preceded the demand; it is that the means of communication preceded the content' (in Iles 1990, p. 39). TV is already an abstract process, at least in the sense that, invented as a distribution medium, it functions autonomously from its content. So to remove the content from the set is a simple if powerful gesture in restoring to TV its own actuality. Yet at the same time, this is a critical act, suggesting that all TV is the same, or that watching the phases of the moon might be as (if not more)

entertaining and instructive. Thus the meaninglessness of the piece is the first building block in an elaborate statement of the relation of the artist to television. If meaninglessness is the quality of TV, not of the work, then the work's reproduction of meaninglessness is itself an act of signification, one with a genuine referent in the shape of the broadcasts which it replays. Meanwhile, if the monitors don't provide us with meanings, we will provide them ourselves: the aurora of light as smoke, as solar eclipse, as the specific palette of the electronic painter; the monitors as the black pillar of Kubrick's *2001* (1968), as a prison in which we keep our images, as the night sky against which the moon shines ... The difference, however, between these meanings and those supplied by normal broadcasting is that, while still occupying time, they are not shaped by the flow of TV time into TV's characteristic set of temporal structures and narratives. They do not follow schedules, storylines, the hiatuses of programme breaks or the micro-narratives of ads, the longer loops of weekly time slots and seasonal timetables. The flow that broadcasting so successfully fragments into manageable (and managed) chunks is here set free. TV's organisation of time is such that it turns the perpetual present which it is capable of into the time of timekeeping: split apart into measured segments, carrying, as Adorno would say, the rhythms of the factory and the office not only into leisure time but into the family home, centre of the reproductive processes of capital. TV brings the time-organisation of capital into the domestic arena.

Hall's *The Rite II*, then, unsettles this temporal organisation of viewing subjectivity by confronting it with a view of television which is profoundly utopian: TV as continuous process, continuous change, rather than continual repetition. In doing so, he addresses the viewer not as the subject of an organised, hierarchical ordering of time, but as a subject relatively unformed by the processes of meaning-making within the 'text'. Instead, we are left to spend time, to take time, to while away the time, beguiled but not bewitched. So he creates a brief utopia, not only negatively by removing sexist and racist representations, ideological commentaries and so forth, but positively by creating a play of light in which we TV subjects are freed to explore the passing of time and its multiple meanings in our own time: not as one, but in the plural. At once focusing on and undermining the nature of TV as flow, as a medium without content, he makes us aware of the processes in which TV produces

itself as content, and us as its subjects, while simultaneously removing the chains of subject formation, subjection, that normally bind us to the administration of time, the time-budget, of TV.

And so, finally, he is engaged, like Gidal, in an exploration of the utopian possibilities of subjectivity. This time is undifferentiated: it is impossible to tell if we are at the beginning or the end, or which burst of colour comes, logically, meaningfully, Symbolically, before another. To some extent, then, this too is an idealist version, heading through its sheer beauty towards that libidinal gratification from which we began this exploration. To some extent, Hall obliterates difference, rather than addressing it. But it could be argued, in his favour, that to shed the imposed differences of dominant television is precisely to throw yourself into the maelstrom of the processes of differentiation, just as there is always an urge, looking at the piece, to look along the narrow gap between screens and wall to identify which programmes are actually playing. You can't see much when you do: only the fact of the gap between image and light, only their difference, endlessly renewed.

6

Enthusiasm: Video Looks at Television

Gidal reserves particular vitriol for the idea that it is viewing that produces meaning, at least when such a thought is merely asserted rather than thought through. Under the rubric 'Context', he argues that 'it is an idealism to try to isolate specifically made up viewer-contexts... Such an idealist position sees groupings of individuals, misnamed "context", producing the world from their individualities' (Gidal 1989, p. 89). Perhaps the target of this attack was the work of the Birmingham Centre for Contemporary Cultural Studies, home of a major intervention by sociologically-inspired theoreticians in cultural and media theory in the 1970s and 1980s. Where film had followed the path of textually-based notions of subjectivity, the advances in television studies, especially the early work of David Morley (Brunsdon and Morley 1978; Morley 1980a, 1980b, 1981), began to ask questions of the 'social reader', the actual people who sit in front of the set. To what extent is the textual formation of subjects overdetermined by their prior involvement in social and cultural structures of class, gender, family life, race, employment and so on? In the 1980s, elements of this critique have emerged as the foundation of an approach to the evaluation of mainstream media quite at odds with the 1970s debates in film theory, and it is towards the more recent formulations of these themes that I want now to turn my attention.

Few authors have pursued the context of viewing with such enthusiasm as John Fiske. If Gidal is the most extreme of text-centred thinkers of film, Fiske is at the opposite extreme of viewer-led thinking about television. This may have to do with their different concentrations (film, television) or investments in media

91

and their uses (filmmaker, lecturer). It may have to do with the
different provenances of film and TV studies, coming respectively
from literature and sociology schools, especially given the impact of
anthropology and ethnography on recent sociology of the media. Or
there may be an issue concerning the sociocultural standing of film
(a separate activity from daily life) and television (deeply imbricated
in it). Certainly the question of the ability of audiences to make,
actively, sense of television has become a mainstay of media
education theory and practice at almost every level, and in general
we are embarrassed by the modernism of Gidal's position: his
commitment to struggle at the level of the signifier, his concern
for subjectivities and political forms that do not (as yet) exist, his
determined stand against the domination of the popular. To this
extent, Fiske is a far more comfortable option. Thoroughly at home
in the pleasures of viewing, with a thoroughly *laissez-faire*, post-
modern approach couched in a celebratory and free-wheeling prose,
Fiske is far less knotty than Gidal. For Fiske the question arises:
what are the cultures in which we live? And how, within them, do we
make use, differentially, of media and messages?

For Fiske the central questions of culture are not posed by the
avant-garde, though in some ways his arguments depend upon a
kind of negativity familiar from Adorno. Here he is on the subject of
postmodernism:

> [Postmodernism] refuses sense, refuses the notion of subjectivity
> as a site where sense is made, for sense-making is the ultimate
> subjecting process. Sense, common sense, is the prime agency
> where the social machine enters and destroys the individual, so, in
> rejecting sense, postmodernism is rejecting the social machine and
> its power to regulate our lives and thinking. For Baudrillard this
> rejecting of sense is the ultimate political act, and the only resistive
> one available to the powerless masses in late capitalism. (Fiske
> 1987, p. 254)

How does this differ from Gidal's defence of critical mean-
inglessness? Though claiming here that postmodernism represents
a clean break with the modernist tradition, it is clear that Fiske's
prized texts (here music video and *Miami Vice*) are being deployed
to a very similar purpose to Kren's *TV Film* in Gidal, the atonal
music of Adorno or the productivist artists lauded by Benjamin: in

representing to the dominant the formal incoherence of its own strategies of making sense, these key texts negate the subjection by which the dominant culture is characterised. In some ways, Fiske can be read as overstating Kracauer's position on subjectivity, arguing that 'the glitzy, flashing images of the marketplace' already contain within themselves the logic of their own destruction. At the same time, however, it is also clear from Fiske's juxtaposition of 'the social machine' and 'the individual' that what is at stake is precisely what Gidal characterises as the idealist position on individualism. Since Althusser's anti-Hegelian readings of the young Marx (especially in *Pour Marx*, 1965), materialist philosophy has been extremely wary of having recourse to a hypothetically original human condition from which the present mode of social organisation is in some way an 'alienation'. Yet here Fiske clearly does see the status of the individual as a given, and the action of the 'social machine' as an alien intrusion. Presumably, by reversing the effects of this machine, which he credits with 'destroying' the individual, the individual is reconstituted as the subject of postmodernism. In this sense, then, individualism would appear to be Fiske's political response to the position of powerlessness he ascribes to the masses under current conditions.

It would be a shame to make this rather offhand comment carry the weight of a major statement of Fiske's politics or aesthetics: part of the price of writing, in *Television Culture*, a global overview for the general reader is that fine points of technical detail get left aside. At the same time, the continuities between his aesthetic position and that of certain kinds of political modernism are important and we need to pay attention to the specific areas which are blurred in this presentation of his case. In the shift from avant-garde to popular culture, a very different politics comes into play, one that moves the emphasis towards the whole cultural context of viewing rather than a cultural critique of television programmes (though Fiske also devotes a good deal of his work to analysing particular texts as well). Drawing, in the diptych of books *Reading the Popular* (1989a) and *Understanding Popular Culture* (1989b), on the work of Michel de Certeau, he argues that the dispossessed, the disempowered and the marginalised mass of the population build a genuinely popular culture out of the mass spectacles of commodity capitalism by playing upon their weaknesses and internal contradictions. Thus the kids who hang out in shopping malls are subverting, or at least

bending to their own uses, the very cathedrals of consumerism. They come not to buy, not even to look, but to be looked at, to pose, and to pose the threat of theft or violence. Fiske clearly not only admires these guerrilla tactics, but is himself a cheerfully unembarrassed connoisseur of popular texts and pleasures. This gives his recent work both its charm and its danger.

Extending the arguments of such ethnographers of television audiences as Ang, Morley, Gray and others, Fiske argues that the judgmental attitudes of the text-based theoreticians of the 1970s are inadequate to an appreciation of the fullness of popular pleasures. At the same time he works through British cultural studies approaches associated with the Birmingham Centre, *Screen Education* and the Open University (cf. his essay in Allen 1987). Both these fields of endeavour drew, and to a considerable extent continue to draw, upon the concept of hegemony first formulated by the Italian Marxist, Antonio Gramsci. Faced with the urgent political problem of understanding why the Italian working class had thrown in its lot with Mussolini, Gramsci set about analysing the historical process involved in establishing, maintaining, disrupting and changing the consensuses and equilibria that mark the formation of cultures. Where the concern of much ethnographic study has been with the ways people are coopted into maintaining the status quo, cultural studies has taken up Gramsci's theses in the more specifically British historical context concerning the (admittedly partial and, we now know, fragile) success of the working class in winning the struggle for a socialised state. This in turn produces an interest in those instances in which the processes of cooption into the culture of capitalism break down. In other words, the traditions in which Fiske trades have, albeit in varying degrees, a commitment to social and cultural change.

Fiske's innovations come in two interlinked phases. First, he is exclusively interested in cultural formations. The political is for him just another form of cultural life: a logical outcome of the 1970s vanguard position on the importance of cultural struggle that gave rise to cultural studies. Economics is left in an ambiguous theoretical limbo in which it is both marginal to the discussion of culture (a variant of the autonomy theses of modernism) and controlling (as suggested by the quote above, where 'late capitalism' is the landscape in which the masses move). So, in a paragraph summing up relations between the economic and the cultural over the last 150

years (Fiske 1989b, p. 43), he can contrast early capitalism ('its power was naked') with corporate capitalism ('a shift towards invisibility') and with late capitalism ('so distant, so removed, so inapprehensible that its power to order and control the details of everyday life has paradoxically diminished'). In this reliance upon unchallenged economic-historical categories, the economic becomes a hidden guarantor of the established order, scarcely more than a guide to historical periodisation. And as such, despite Fiske's lack of interest, or perhaps because of it, the economic guarantees the shape of popular culture. The absolute status of 'late capitalism' (untested in its global or historical processes or failures) is responsible for democratising everyday life. We are already living after the emancipation; see how much we enjoy ourselves!

On this basis, the problematic of general social change, which had both motivated and frustrated previous media and cultural studies theoreticians, can be abandoned. The distance between the centres of cultural production and the spaces of cultural life, between rulers and ruled, are so vast that there is no point in, or need for, struggle. If Nietzsche could announce the death of God, postmodernists not much more extreme than Fiske can announce, under the thin veil of the death of the proletariat, the demise of the ruling class. In the postmodern world, everyone is equally subject to rule: thus the ambiguity of his closing lines in an essay on 'British Cultural Studies and Television', 'the people still manage to make their own meanings and construct their own culture within, and often against, that which the industry provides for them. Cultural Studies aims to understand and encourage this cultural democracy at work' (in Allen 1987, p. 286). The ambiguity lies between the impulse to encourage resistance and the celebration of its existence: is there a need to do more than watch and admire, since the fear of complete domination by the media is so obviously unfounded? This cultural 'democracy' is, then, presumably a culture in which individuals gradually rediscover their alienated individuality through the gaps in postmodern texts. In place of an avant-garde, we have a field of tactical refusals, tricks and twists through which Fiske delightedly discovers evidence that the culture of late capitalism is alive. That life is itself an adequate goal. He is not, as Gidal is, interested in how to renew the culture, or prepare the ground for such a renewal. Fiske shares the disbelief of Daniel Bell (1962), Fukuyama (1990) and Lyotard (1984) in a teleological shape to history. And like them, he

mistakes the end of faith in a predetermined goal of history for the abolition of the future.

Fiske's moves – from avant-garde to popular, from text to audience, from politics to culture, from film to TV – are typical of shifts in theoretical and media practices during the 1980s, and indeed his importance is less as an original thinker than as a lucid exponent of an intellectual trend. There are, I think, two things that need saying about this trend: that it presumes too much the givenness of what television is as institution, as programmes and as viewing experience; and that it understands its position as a novelty, though it can be read as a rewrite of earlier strands of intellectual modernism.

To take the latter point first, we need to understand the 'postmodern' culture Fiske celebrates as an extension of the pursuit of the audience investigated in Chapter 3, for the problem of the audience has not only existed for art. In the historical separation of art from popular culture, the field of the popular is opened up to a new mode of organisation too, perhaps most clearly visible in the nineteenth-century shift from the radical presses of the first 30 years of the century to the rise of the popular press as mass medium; or, stated more generally, from the folkloric to the industrialised forms of popular culture. For much of the nineteenth and early twentieth centuries, the folkloric was especially prized as a source of images and styles, although the montage elements of both Cubism and Dada already mark an interest in industrialised forms. At the same time, however, industrialised popular culture spent (and spends) a great deal of its time in educational mode, delivering documentaries, current affairs, history in the form of stories, programmes and games. Moreover, the often-remarked symbiosis of popular press and music, film, radio and television surely represents an effort on the part of industrialised culture to sustain audience interest in its products, much as curation and criticism function to maintain interest in fine arts. The two, apparently separate, domains share a structure of internally-organised legitimation, in which the interests of scholars legitimate the quality of each domain, and these qualities in turn (aesthetic value, popularity) legitimate scholarly interest. And it is also true that both keep a weather eye cocked for the activities of the other: advertisers, for example, looking out for the latest art techniques, or artists like Jeff Koons watching for the emergence of new popular forms. This is not a new

situation: popular music, radio and magazines, for example, have consistently derived new crazes from the developments of the avant-garde just as much as the avant-garde has derived its inspiration from popular prints, songs and recreations throughout our period. The much-heralded rapprochement between avant-garde and popular cultures in postmodernism is a simple continuation of the dialectic established in their historical divorce, each acting as the Other for its partner. What is signally new, perhaps, is the argument that there is no longer any difference between them, a situation already heralded in Benjamin's essay on surrealism, where the surrealist unconscious is aligned precisely with the proletariat. The difference between this position and Fiske's is solely that of the standing of history. For Fiske, television's 'carnival of style ... destroys the power difference between the object and the subject of the gaze and produces empowering pleasures for the subordinate' (Fiske 1987, p. 264). For Benjamin, 'destitution – not only social but architectonic, the poverty of interiors, enslaved and enslaving objects – can be suddenly transformed into revolutionary nihilism' (Benjamin 1979, p. 229). Benjamin recruits the past in the struggle for the future; Fiske sees only the incessant present.

If we understand these two statements as different perceptions of the same phenomena – the relation of a critical culture to everyday artefacts – we can begin to perceive Fiske's postmodernism less as a major historical shift in human relations, and more as a political alignment. This is not to say that nothing has changed: it is still changing. This is the dispute I have with the second weakness in Fiske pointed out above: the too willing acceptance of TV as it is. The necessary critique of the audience-as-dupes theses of 1950s media sociology has become trapped in its own variant of positivism; for effects theorists as for resistance theorists, the one unarguable fact is the givenness of television as such. The problem is admirably stated by Charlotte Brunsdon:

> What we find, very frequently, in audience data is that the audience is making the best of a bad job. The problem of always working with what people are, of necessity, watching is that we don't ever address that something else – what people might like to watch (and I don't mean to imply that these other desires simply exist without an object, but that is another paper). The recognition of the creativity and competences of the audience must I

think, be mobilised back into relation to the television text and the demands that are made on program makers for a diverse and plural programming which is adequate to the needs, desires and pleasures of these audiences. Otherwise, however well intentioned, our work reproduces and elaborates the dominant paradigm in which the popular is the devalued term. Having started with 'What is good television?' I would like to finish with 'What are we going to do about bad television?' Nothing, if we're not prepared to admit it exists. (Brunsdon 1990, pp. 69–70)

This precise and lucid invocation of the necessity to think – and by implication to produce – television otherwise can be further elaborated in relation to Meaghan Morris's observation that:

the term 'production' in cultural theory has atrophied instead of being re-theorized. These days it is often used as a shorthand term for 'talking economics'. 'Consumption' means talking about sex, art, 'cultural politics' and fun. Before completely relegating the former to the realm of *déjà vu*, however, it may be as well to consider that in the late twentieth century, after a century of romanticism, modernism, the avant-garde and psychoanalysis, economics, in fact, may be considerably more enigmatic than sexuality. (Morris 1988a, p. 22)

Fiske is then unusually reticent about the terms under which television (and culture generally) is produced. In the triple problematic of cultural studies – institution, text, audience – his avowed enemy is the text-centred approach, and his positive critique of that an audience-centred one. But in this simple binary opposition (see Fiske 1987, p. 240), the institution, the site of production, is simply elided; it is presumed as a given and therefore not questionable within the terms he has set for himself.

It was precisely the investigation of the insitution – or perhaps we might return to the term 'apparatus' here – which instigated theoretical work on television. The nexus of technology, legislation, economics and professional norms that characterise the establishment of the TV apparatus form the grounds on which the activity of the active audience is possible and thinkable. On the one hand this leads towards the global/local problematic identified by David Morley (1991; see also Morley and Robins 1989), which is taken up later in this chapter. On the other, it leads us back to

Walter Benjamin, especially the criteria enunciated in 'The Author as Producer' (see Chapter 3 above), according to which the business of a progressive artist is to reinvigorate the means of production: to create not just works but techniques which can lead to ongoing productivity among their audiences. His crowning example, Brecht's epic theatre, is far more than 'resistance' and 'subversion' of existing pleasures: it is the formulation of a new order of pleasures which the dominant actively discourages. In 'The Work of Art i. the Age of Mechanical Reproduction' of 1935, a year after the composition of his work on authorship, he extends this argument into the foundations of such productive practices.

In the process of becoming autonomous, he argues, art begins to lose the 'aura' of the sacred which had surrounded it before. In particular, new reproductive technologies such as colour printing, gramophone recording and photography instigate the era of what later commentators refer to as 'post-auratic' art, an art in which criteria of authenticity and uniqueness are misplaced, and which replaces ritual with politics. Thus Dadaism is credited both with enacting the obsolescence of visual art, and with prophesying, in its shock tactics and its refusal of accommodation with the spectator, the replacement of visual arts with newer technologies, notably film. Thus the job of art is not so much to negate the present as to enable the future, a distinction which put Benjamin at odds with Adorno. The negative returns, however, in Benjamin's Epilogue to the essay, in which he argues that where the technological advances of a society are not matched by a correct development of them for productive purposes (that is, in pursuit of human interests), then they are capable of transferring their energies to the pursuit of war: 'Imperialistic war is a rebellion of technology' (Benjamin 1969, p. 242). So, if Benjamin is a technological determinist, it is in the framework of a philosophy of history which sees the failure of societies to devote their full technical capabilities towards the fulfilment of human needs as the cause of an alienation of technology from social control. Deprived of historical purpose, it begins to take on, like art, a historically autonomous role, and we begin to experience it as an alien entity which seems to control our lives. When technology becomes 'negative' in this sense, though it can be seen as critical of contemporary society, it tends to devote itself to its destruction, not its amelioration. We might note here the mutation of the Bauhaus's devotion to practical uses of design,

alienated through a blind devotion to the marketplace, turning into the practice of designing for Junkers bombers. Hence the urgency of his essay.

There exists another, more utopian, version of the technological-determinist line, one of whose most impressive expositions is to be found in Gene Youngblood's *Expanded Cinema* of 1970. Published with a preface by Buckminster Fuller and greatly inspired by Marshall MacLuhan's notion of the Global Village, Youngblood's enthusiasm is infectious. This kaleidoscopic account of counter-cultural expropriations of emergent technologies is still one of the best antidotes to the blasé fatalism of much contemporary cultural studies. At the conclusion of his survey of work (mainly North American, and mainly of the 1960s), he quotes biologist John Bleibtrau to the effect that 'It seems we are in the process of creating a mythology out of the raw materials of science in much the same way that the Greeks and Jews created their mythologies out of the raw materials of history.' Youngblood comments 'We are making a new world by making a new language ... There is only one real world: that of the individual. There are as many different words as there are men. Only through technology is the individual free enough to know himself and thus to know his own reality' (Young-blood 1970, p. 419). It would be unfair to tax Youngblood too much with the ideologies of his time. The Whorffian hypothesis – that linguistic structures determine how we perceive reality – is a natural ally of uncritical utopianism, and the all-American status of the individual as lynchpin of a new world is transparently ideological to us now. (All the same, it seems to re-emerge in Fiske's work, as we saw above.) Yet this countercultural technoanarchism is in many ways the legitimate heir of Benjamin's more desperate themes. The fundamental argument is not that television is bad for you, but that it is fundamentally old hat, uninteresting, outmoded. And where Benjamin was delighted in the surrealist discovery of the revolu-tionary potential of old fashions and decaying restaurants, he would also have loved the discovery that the glamour and glitz of television was producing at least anarchism, if not quite the 'revolutionary nihilism' he identified in Breton. If that pre-revolutionary nihilism takes the form, in Youngblood, of the actions of cultural guerrillas, that at least indicates an intuitive grasp of the importance of cultural struggle to the larger project of enhancing the internal contra-dictions of capital.

What I find so hard to forgive in Fiske is his denial of those internal contradictions, in such a way as to imply that the role of cultural activists is simply to enjoy the enjoyment of the 'ordinary' people. For all its theoretical naïveté, Youngblood's version has at least the virtue of encouraging making, the active engagement in that sphere of production which is so signally lacking in the postmodern analysis of culture. Its corollary in cultural politics has been the effective demolition under Thatcherite monetarism of the independent sector of film and video production, moving committed work from the access arena to the world, not of production, but of product: the worlds of the art galleries and the broadcasters. A managerial-administrative logic has usurped the place of politics, and the success of a project is measured not in its effectiveness but by counting heads. Videomakers themselves begin to believe that a graveyard slot on Channel 4 is worth more than direct confrontation with an audience. At the same time, audiences (and the intellectuals too, for they are also part of the audience) have begun to return to the status of masses, with the regular publication in popular papers of the ratings for the previous week. Like fans waiting for the latest top twenty listing we root for our favourites, hoping they will appear higher in the chart. Though ethnography tells us that the audience is fragmented, differentiated, even atomised, and their attention distracted and intermittent, we believe simultaneously in the power of numbers. Audience, as has been argued so many times, is the product of television: the reverse is not true. Audience impact on the production of television is limited to their function as mass, as pure statistic. The discomfort of banal television is a function of this gap between the institutional and the ethnographic positions of the audience.

Address to the dual function of the audience, as statistics and as individuals, as mass and as existential players, is at its most graphic in fundraising events, most famously with Live Aid. The combination of direct address ('Give us your money now') and statistical information on the amounts collected encourages identification with a common cause, certainly, but also with the commonality of television. That these two forms of address should be narrativised in the context of shots of a mass audience for the open air spectacle and that the whole procedure should then return as news (and object of theoretical discourse) seems wide open to Adorno's analysis. Under the guise of participation and interaction, the actual produc-

tion process is flagged only to be removed again. The whole is as interactive as teleshopping, and its liveness characterised by manipulation of technical resources as spectacular in its own way as the performances on stage. And yet, even as I write, I am aware of the opposite pull: the one that sees the event as an expression of outraged impotence in the face of global emergency, a refusal of governance, a playing-out on the part of the powerless of an act of power. In its heroic unrepeatability, Live Aid accrues some of the powers of ritual about itself: an auratic television. For a brief moment, let's say, television exposed its own entrails, its power, its ignorance, its enslavement to the culture industries, its greed for content, so huge a greed that it will even relinquish self-control. At such a moment, TV itself can be as negative as high art. And yet. Still it is television: still capable of restructuring around this aberrant showcase of dissent, of turning righteous anger into entertainment. Even the loss of control most deftly characterised by Bob Geldoff's curses is recuperable, for what was never in doubt was the continuity of, the fact of, television. The self-conscious irony of the first outing of the music business as Band Aid – a sticky plaster to staunch a severed artery – disappears into the sentimental monument to itself which Live Aid's sequels have become.

I know that Live Aid at least did something, however small, in the face of horror. I recognise that, if it scarcely raised awareness of the economic causes of famine, it at least expressed a widely and deeply felt anger at the wilful indigence of politicians faced with mass starvation. And I cannot think of other ways to speak through, to and with so many people on so urgent an issue. But the issue is then returned to criteria of quantitative evaluation, of administrative categories, of political action and 'public opinion' gauged by the acts of TV subjects first addressed as individuals and then massified. Fiske's optimism then would appear as merely the reverse perspective on a pessimistic account of TV as control.

What, then, would a truly popular television look like? Amateurish, of course, a discovery which has already led to a plethora of hand-held, impromptu youth programmes revelling in their own rough edges, and as convincing as those 'Let's put on a show' pop musicals of the 1950s and early 1960s. Merely stylistic responses seem inadequate, addressing only the textual effectivity of single programmes or segments. The problem is less one of texts, more one of an impasse over the status of the audience, a genuine problem of

status that requires an address to the givenness of the television apparatus. This means precisely to address the question of what might be meant by production in cultural studies. Certainly we need a definition which is extensive, as the Filmmakers' Coop practice would indicate. Production does not mean exclusively wielding cameras or appearing on screen: it encompasses the financial and administrative structures of making and viewing, the engineering, distribution, exhibition and the theoretical practices (as forms of promotion or public relations) that provide not just a context but another actuality of making. The structure of broadcasting (and the institutional construction of the audience: see Meehan 1990) is monolithic, excessively centralised, globalising. Productivity then, should begin at the local level.

Which in turn raises the question of what is local in an age of global communications and global corporations, increasingly important to video in particular, which shares so many aspects of so many communications media. Rather than grapple with definitions, I want to take a look at the conditions of recycling of some work by Australian artist Peter Callas. Callas's recent tapes have been made using computers to generate flat, cartoon-like characters, frequently drawn from popular graphic styles like comics and card games, which are set to motion across planes parallel to the vertical plane of the screen. Callas collects quantities of images, transcribes them on to the computer and animates them to musical scores. The images revolve, in each tape, around a common thematic, and develop during the running time of the finished tape, while at the same time maintaining their flat, planar space so meticulously that the phrase 'moving wallpaper', that most derogatory term for television, comes startlingly to mind.

The idea of moving wallpaper as a suitable practice for art dates back at least to Warhol's film *Empire* (1964), 8 hours of silent, grainy 16mm (shot and shown at 16fps). Lou Reed and John Cale's song 'Style it Takes' describe it thus:

> I'll put the Empire State Building on your wall
> For 24 hours glowing on your wall
> Watch the sun rise above it in your room
> Wall paper art, a great view.
> (Reed and Cale 1991)

while Gregory Battcock argues that 'The subject of *Empire* is, then, an investigation of the presence and character of film – legitimate if not a requisite concern for the artist. And the terms established for this investigation are the black and white of film technology and the obvious, yet frequently denied, limitation of time' (in O'Pray 1989, p. 45). Mike O'Pray observes that 'It was precisely the motionless, long-held stare of the camera that eroticised so much of the early work, even *Empire* as Warhol himself was quick to realise' (O'Pray 1989, p. 172). O'Pray specifies the analogy with Kleinian analysis of the depressive phase, characterised by concern for whole (as opposed to part) objects. This example of moving wallpaper, then, attracts at least four key readings. First, it is a modernist technique concerned with the plane, with the medium, with its specific qualities; second, it can be related to the political modernism described by Rodowick, engaged in a negative relation to the temporal dimension, 'frequently denied', as Battcock observes, in the mainstream cinema; third, it is a disturbance of the eroticisation of autonomous looking, and thus of the autonomy of the sexual in modern society; or fourth, it is a pure commodity, something pretty to put on the wall. Other related works, like Brian Eno's *Memories of Medieval Manhattan* (1988), designed to fill up the blankness of large, flat-screen high-definition monitors while not in use, develop the theme of ambience in similar directions. The 'screen-savers' in use on many personal computers – ambient graphics designed to stop on-screen pages burning their outlines permanently on to the display screen – are increasingly familiar versions of the same principle. To some extent, Callas's work, though far more lively in palette and motion, can share in these concerns.

At the same time, the repertoire of images on which he draws in some recent work establishes a different relation. In *Night's High Noon: An Anti-Terrain* (1988), the flicker and speed of imaging (Callas' wallpaper is more *Star Wars* than William Morris) is such that it is easy to miss the steady accumulation of mythographies of Australia: Ned Kelly, bushrangers and corroborrees. But in the wallpaper are other signs: atomic orbits, storybook Japanese. Each uprooting of the Aborigines has been effected with the urgency of Australia's meetings with global modernity, such as its defence against invasion from the North, or racing for nuclear supremacy. In one illuminating moment, two images are reversed out from one another: a white child gazing from a cliff-top at a volcano and an

aborigine gazing from the same place at a sailing ship. One is witnessing the violence of nature, the other experiencing the nature of violence. And if the graphic style recapitulates the storybook and comics imagery of the artist's childhood, it is precisely to slow down, make difficult, a regression to infantile plenitude by demonstrating the density and the cruelty of those puerile childhood imperialisms.

The insistence on such grand abstractions as nature and violence in such historically specific experience is precisely what is at stake in the cultural processes at work in both global politics and the new media. In Callas' videographics we see the interplay of great forces as they reshape themselves over and over. This is an iconography that could not have been deployed in white Australia 15 years ago: that the technology exists in which it can be worked through is surely a product of that cultural shift, a need to understand the global forces at work in the local. What makes the graphic work, culturally, is that it can partake both of the central rhetoric of rediscovered land-based cultures in Australia and of the history of their eradication at the hands of settlers. The computed image is itself as rooted in the machines that store and transmit it as territorial cultures are in the land that supports them, and is as powerless before the fragility of the medium as land is before the colonist, the commodity market and the international explosion of tourism and agribusiness. The power of Callas's work derives in part from the purely decorative handling of historical enormity, in that way extending the tradition of the history painting. The returning fascination of the industrial cultures with our own rootlessness, and its mirror in the rootedness of other cultures, is part and parcel of the dialectic at work here, as is the slippage between infantile pleasures of brightly coloured caricature and the high seriousness of his subject matter. A dialectic of enormous abstractions impinges on the fragile lives of colonists and natives, while both are apprehended on the brink of their mutual dissolution and erasure, as historical entities as well as representations, media products dependent on the erratic technology of tape, so easy to erase.

Broadcast in the UK as part of the *White Noise* season of video art (produced by John Wyver for BBC2) and again in a Channel 4 season of Australian film, *Night's High Noon* has to exist as television. For those of us engaged with video practice, the screenings of the both seasons were events, 'locally' as important to us as Live Aid, and perhaps as ambivalent: as Mike Mazière points out,

such broadcasts tend to be considered 'new television' (in Houghton 1991, pp 42–4), suggesting a dependent relationship for video *vis-à-vis* TV. But the subtitle to the Callas tape suggests another way of negotiating the relation. As anti-terrain, the videographic apparatus, made without cameras, has no defining relationship to referentiality. But as a terrain, even an anti-terrain, the flatness of the screen can move us from wallpaper to map, while simultaneously denying its status as a guide to some pre-existing landscape. Indeed, the map has a particular place in this tape as the colonists' device, in contradistinction to the Aboriginal art that creates a different sense of place and spatial relationship by melding concerns of kinship and myth into the records of journeys made. As broadcast, *Night's High Noon* develops into a critique of television's obsession with the touristic other, the native of exotic spaces, the recording of Disappearing Worlds. It flaunts the impossibility of relating it back to its home territory: broadcast as exile.

It is clear also that the piece is in exile from somewhere, that it makes its distance from origin (and the fragility of origin) a new element of the work as it is shown, bending television to the video status of playback, pure distribution. At the same time, though, the relative crudity of the drawing and its reliance on easily available sources is immediately suggestive of a productive role beyond simple negation of TV. After a viewing with the artist, my students began to discuss what images of Liverpool you would use to make a similarly complex statement of the city and its representations, and realised how dense and contradictory the imagery of their city is. They could as easily have discussed the ways TV's attempts to represent Merseyside betray an anthropological interest in mapping its culture, or where to get hold of a games computer they could make their own piece on, or how to contact Aboriginal rights organisations, or a hundred other things. The breadth of the work is itself enabling, in a way that most broadcasting is not: this addresses modes of production; that speaks only to novel ways of consuming. Pleasure remains a consumer good until we recognise intelligence as a pleasure, the intelligence of making. Sometimes, you hanker after a culture that you don't have to disagree with to enjoy.

So a productivist emphasis gives us a different reading of the viewer relationship. Certainly TV is in the home, and intimacy is one of its most enduring hallmarks. But that presence is not a given: it is a product, in this instance of a journey. The productivist stance

emphasises the journey made, the difference between presence here and now, and the absence of the place or time of making. A broadcast item that takes this on board is likely to be a more powerful and urgent, ultimately a more pleasurable and meaningful piece of television than those programmes – quintessentially Live Aid – that seek to annihilate the space between production and consumption by reconstructing consumption as an intimacy with the production process. Divorcing form from content, TV can afford to allow some statistical pressures on the latter, in order to reaffirm the solidity of its grip on the former. Making that divorce the centre of broadcast video is, if not to weaken, at least to grasp the importance of that tension.

What is more, it can give us a clearer and sharper perspective on the importance of the ethnography of consumption. It would be a logical extension of the arguments made here to say that television, in its concentration upon the forms of segmented temporal continuity, exercises a single, univocal pull on audiences, one based not on its content (the familiar 'hypodermic needle' model of the effects of programmes on experimental subjects) but on the impact of flow as such. At the same time, though, this extrapolation goes too far: the functions of both flow and of programming are more complex than this, and we need therefore the detailed work of ethnographers to understand what differences emerge between different uses of flow, and the impact of different contents. To do otherwise is to return to the fatal givenness of television, and to be driven to the fatalism (however optimistic or pessimistic) of a Fiske or a Baudrillard. For instance, TV represents itself as present, but that presence is always presence *to*, presence within, a specific social conjuncture or a specific history, including the micro-history of living rooms, bars and classrooms. To this extent, broadcasting is (as video is) always engaged in a dialectic of global and local, simply because its mythical presence is always within an actual here-and-now. Into this nexus plunges the detail of programming, the specificity of different forms of production. Thus the continuing Romantic status of the author in British TV drama calls up a different set of responses from those evoked by general flow: watching programmes rather than watching television. Likewise the kinds of productivity engaged by prestige series like Alan Bleasdale's *G.B.H.* and Denis Potter's *Blackeyes* are functions of the peculiar position of authorial discourses to authorise departures

from dominant television forms. To claim either that these produc-
tivities are ultimately recuperable within the form of flow, or that
they are ultimately the same as all other television, is to defer forever
the moment of determination. As Althusser himself observed of the
theory of last instance determination by the economic, the last
instance never comes, and yet it is the last instance. We have,
'ultimately', to deal with what is here, now. And that must include
not just the mainstream, but the opposition.

 Such, I believe, is the rationale for continuing to explore the
problematic of art within the consistently cultural framework of
television. Art is not, *per se*, any more (or any less) autonomous and
elitist than sex or technology or televisual form but, like them, it
needs to recognise the historical condition which it occupies, and to
use its particular contradictions in relation to those (more success-
fully institutionalised and administered) of other hypostatised
domains of social life. So Callas, to circle back, reworks his 1989
tape Neo Geo: An American Purchase in the 1990 installation, the
Fujiyama Pyramid Project, where the terms of the tape (looking into
the Pacific Basin face-off of Japan and the USA) are transmuted
into a room whose central element is a pyramid, opposing faces of
which are painted to refer to the masonic Great Seal on the dollar
bill and the view of Mount Fuji on the 5000 yen note. Perhaps it is
the figure of Fuji that so attracts me here: Mount Fuji as first shown
in the Long Beach Museum of Art, California, and subsequently at
the Bluecoat Chambers, Liverpool, England; Mount Fuji as the
sacred locale, transported in homage to its transport on that most
transportable of commodities, the bank note, and the new journey
undertaken at the historical moment in which we believe ourselves
to be witnessing the end of the banknote and its replacement with
digital credit transfer. This magnificent hereness of the installation,
the eye of the US pyramid winking at the spectator in welcome,
celebrates its arrival, announces its departure, speaks of and to the
internationalisation of finance even as it occupies this space, this
time. Does money abolish space? Or does this tangible presence
abolish our always-fragile faith in money?

 In the end, the problem with Fiske is not that he believes too
much in the audience, but that he believes too little. In his need to
find a resolution for the contradictions of contemporary cultural
life, he provides a discourse of the audience characterised by faith
but without hope. The critical moment hinges upon the notion of

productivity: the thesis of 'active consumers' needs to be met with questions concerning the degrees of activity and apathy, the functions and uses of passivity, the pleasures of meaning as much as the meaning of pleasure. And most of all, the shape of engagement with television needs to mark critically the position of television as a given. In this Fiske, like Baudrillard, acquiesces in television's own assessment of its ubiquity and self-replication. The function of productivist theory and practice is a negative one, at least in the first instance: to criticise that 'givenness', and in criticising it to open the terms of change for future theoretical and practical production. Gidal's purism may relegate avant-garde practice to the status of minority form (though we should never mistake small numbers for lack of importance), and the rigour of his arguments may debar forms of practice that I would like to see worked through in their fullest potential (including many popular TV and cinema forms). In particular, Gidal's refusal to exploit the human body by representing it risks handing the business of representations of sexuality over to the dominant media, where the play of presence and absence is only too easily transferred into oppression in daily life. In its own way, Gidal's theoretical practice fails to live up to the revolutionary potential of his film work. Space and time are only comprehensible in their materiality, in the ways that they are occupied; the specificity of the medium deployed in a given instance has to take second place to that.

7

Sound: Video, Noise and Music

Media theory, it is no longer a novelty to say, has a problem with sound. Film and television theorists have, until recently, rarely set themselves the task of understanding the soundtrack, and even more rarely the does the problem of articulating sound and image come up. This is less a product of intellectual laziness than a reflection or refraction of the mind/body distinction we have begun to isolate as a major cultural phenomenon. Sight has become the dominant sense, the medium of surveillance, the measure of truth (for example, 'I'll believe it when I see it'; 'Seeing is believing'; 'Eye-witness Reports'). Sound and music have been relegated to a lower status, and increasingly, especially in dance music, associated with the 'lower' bodily functions.

The problem becomes acute when we look at music videos, which set themselves the unusual task of illustrating the soundtrack: the purest example of 'radio with pictures'. The video album *Seal* (ZTT/Warner, 1991), by the artist of the same name who swept the boards at the 1992 Brit Awards, combines elegant, understated studio recordings with more familiar special effects videos, of which at least two are among the most technically accomplished of their kind. Throughout, there is the familiar concentration on the image of the singer, which is not only a vital marketing tool but a nearly obligatory reference point for the recorded song. After the scandal of Milli Vanilli, sold on their good looks without singing on their records, the importance of authenticity as an ideology of pop can no longer – if it ever could – be doubted. Especially the case with the Black voice – virtually synonymous in music writing with the authentic sound of pop – the presence of the singer to the song is

110

almost the most central formal element of the music video (and is redoubled in Seal's authorship or co-authorship of all the songs on the collection).

However, that kind of authenticity is put into an interesting ambiguity in the two key tracks, *Crazy*, directed by Big TV, and *Killer*, directed by Don Searll. In the former, Seal is shown in multiple reduplications, each one acting autonomously but each choreographed with the others. At certain moments – on the words 'fly', 'sleep' and 'you my friend' – the actions are anchored in the words, but for the most part the visuals operate on a metaphorical acting-out of the song's theme, borrowing multiple images for multiple personalities, and the iconographic image of a derelict holding a dove in the snow as the inspiration for the gently crazy persona of the song. In *Killer*, Seal is placed in an M. C. Escher-inspired virtual architecture, behind and within which various real-time shots of New Age imagery – forests, waves, static electricity, flame – are mapped, while computer-generated bhodisattvas and dolphins flicker in and out of existence. Seal himself is overlaid with computer effects, the everyday miracles of music video. In both tapes, the actuality of the performer is thrown into question, and the technologies and aesthetics of recording made central to the concept of the tape. Noone could relate these Seals to even a single performance, let alone the 'real' Seal. On the one hand, both *Crazy* and *Killer* return us to the central issue: the industrial 'property' Seal, whose existence guarantees the authenticity of the recording, its emotional and ideological heart as well as its prime economic function. But on the other, the power of *Crazy* in particular comes from its ambiguity about the anchorage of the music in a single person, an ambiguity it articulates through the disjuncture of Seal's breathy singing style, with its promise of personal communication, and the effortless reduplication of Seals in the vision track.

The centrality of metaphor to this, as to many other music videos, might be explained in Lacan's analysis of metaphor, which he sees as the relation between discourse and subjectivity. It is impossible to deduce a single image in *Crazy* from those that go before it: the absence of a necessary relationship, then, suggests that the visual system cannot give shape to the singing subject on its own. Singing presumes an actual singer, but cannot give us the complete person, so that the song pursues his subjectivity, the completed Seal, down

the lines of melody, and the vision track likewise tries to fill up that missing place where the singing comes from. Each successive image interprets and reconfigures the one before, each signifier then a metaphor of that absent centre, the singing subject. In pursuit of the myth of full and self-sufficient subjectivity, music and image alike chase endlessly down the stream of signifiers. Crazy. But something else is in play in the utopianism of pop: a search for a healing moment of the rift between sight and sound, mind and body, the visual – so tightly bound to a few square inches on the front of our faces – and the sonorous, which like touch is experienced (and expressed) through the whole body. The mystique of the star derives precisely from this perpetually absent, perpetually sought after, recombination of the image with the physical.

When John Cage visited the soundproof room built by NASA, he discovered that he could still hear not only his heartbeat but also a high-pitched tone and a lower whooshing sound. The engineers explained that these were the sounds emitted respectively by the central nervous system and the bloodstream. Quite apart from suggesting the origins of perfect pitch, these observations also serve as cognates to the Goethean discovery of the eye as a source of light. If the body is itself a sound source, then it is possible to think of the sound world in terms much closer to Merleau-Ponty's conception (1968) of the visible as a field in which subject and object alike share in the recognition of a mutual relation in which seeing and being seen, hearing and being heard, are inseparable. If the course of modernist art has classically maintained the division of the two, music and soundworks have assiduously addressed them together. Sound media, like concerts, radio and recordings, can moreover continue to be enjoyed without demanding absolute attention simply because sound continues even if we do withdraw attention or close our eyes (a fact exploited by composers from Stockhausen to Eno). The culture of distracted attention, so recently unearthed in television studies, is almost the most obvious factor in sound. The body maintains its general perception of sound even when we are not conscious of its action.

The body is, of course, far more obviously a source of sound through the voice (as well as the range of percussive effects it is capable of). The semiotic chora of which Kristeva writes (1974) is easily identified with the endless productivity of prelinguistic sounds of which infants are capable. That babble is as founding of music as

is the nervous system's involuntary production of tones. When we speak, then, of music as ordered sound, it must be in the same way in which we speak of the ordering of looking into regimes of vision like perspective and maps. The ordering of sound through melody, harmony and rhythm is a profoundly social one: you only need to note the reactions of listeners to an unfamiliar musical vocabulary like gamelan or Egyptian nightclub music to see how the offence against cultural norms takes the form of an almost physical disgust. The achievement of formal music in the twentieth century has been not only to foreground this socialisation of the sound world, but to make genuinely alternative forms of organisation widely available. The sound of random tunings of shortwave radios may be in itself perceptually baffling, but its aesthetic is clear: the world is constantly producing sound, and to recognise only one form of its organisation is to be voluntarily deaf. The multiplication of media for dabbling in sound – cheap instruments, cheap tape decks, cheap synthesisers – is proffered in this tradition as a means towards a utopian goal. For Cage as for Beuys, everyone is an artist.

However, sound is not freed of its socialised construction simply by wishing it so (though utopianism is a legitimate element of the critical-negative function of art, one that, it can be argued, music in particular is fitted to play: cf. Attali 1985). To return to the issue of film projection raised in Chapter 5, we saw there that Metz argues a correlation between psychic projection of desires and cinematic projection of images. Now film can be argued to be the oldest of the visual arts, if we imagine its roots in casting moving shadows on the wall. There, in a myth of origin, we can imagine a primeval scene where the body and the visible are at one: culture as the body's involvement in the environment. But in the idealised cave of the cinema, the projector is precisely not at the back of the viewer's head: that would cast a shadow, and thereby admit the body's conspiracy in the production of vision. Cinema enacts the socialised, historical division of the body from the visible in order further to concretise vision. The video monitor, on the other hand, is a light source, so that light is distinguished forcefully from the viewer.

Several artists, notably Maria Vedder in her work *Sparkle and Fire* (1990), Simon Biggs in his installations *Der Golem* (1988) and *Alchemy* (1991) and Judith Goddard in *Descry* (1992), make the connection between this separation of light and body and the mediaeval understanding of light as 'the shadow of God', a physical

metaphor of the deity. Though relatively few video works use video projection as an integral part of their aesthetics, there are on the other hand a large number deploying the light from monitors to illuminate the bodies of the audience. Illumination here can be taken as a religious metaphor, placing in or filling with light, enlightening. Unlike the meticulous secularism of broadcast, video works are as happy as musical ones to deploy the 'spritiual' when it is needed. Returning, or attempting to return, the sacred aura to the mundane world of familiar TV is itself a negative act, and one that, in its own way, addresses the great lack left by the modernist process of secularisation, Nietszche's Death of God. In these works, video's illumination is a profane cry against the human world left derelict by God's withdrawal, the more pitiful because they inscribe on the bodies of their viewers the last trails of light from the departing divinity. The light from the video monitors illuminates an emptiness that occurs when, cast back on their physical beings, people must become producers of their own history, even though that history appears to them as if external, beyond their control. It is not, as in cinema, that the images seem more full than the ordinary subject feels him/herself to be; rather, in these and similar works, the very light itself takes on a mythical plenitude. This is the property of video deployed in that strange slippage between mystique and mysticism at the heart of fan culture, the metaphor of the star as a source of light, so powerfully and touchingly worked through in the dialectic of presence and absence in the music video. The longed-for and impossible physical presence of the star is expressed in disembodied light.

In the age of recording, divorced for the first time from the site of its making, sound becomes likewise divorced from the productive role of the body. Headphones, which like Metz's projection give the auditor the sense that the source of the music is in her own head, increase this movement towards the reification of sound, and its paradoxical externalisation, as the body's own musical productivity is supplanted by commodity-form recordings. The aura of the sacred so avidly sought by Messiaen and the late Stravinsky, the Eastern mysticism articulated by Stockhausen and Cage, is conspicuous only by its absence: like the light of video monitors, the holiness of the voice, its affinity with nameless longings is relentlessly secularised, but in a social organisation which denies the

profundity of those longings and replaces them with commodities and services that are supposed to satisfy them.

If the logics of musical modernism have opened up the world of music, the growth of the recording and broadcasting industries have closed it down again.This at least is the thesis vividly argued by Adorno, himself a pupil of Berg and a practising composer and music teacher. Continuing his analysis of the culture industries, Adorno argues that jazz (which he uses both specifically and as an umbrella term for all popular music) is a symptomatic performance of a timelessness projected on to technologies and cultures by capitalism. Like Kracauer, he believes that the mechanical rhythms of jazz replicate the alienated ordering of time in the newly mechanised world of Fordist factories and Taylorist bureaucracies. The enthusiasm of the jazz fan is a product of successful techniques becoming canonical, and feelings then being attached, almost wilfully, to the hypostatised technique. Jazz aestheticises politics, celebrating subjugation to the yoke of the mass, as it is understood by the European dictators. It is 'the false liquidation of art – instead of utopia becoming reality, it disappears from the picture' (Adorno 1989, p. 209): the very ubiquity of the popular engulfs art as difference, dragging even the inventiveness of the serialists into the maw of a self-replicating, self-perpetuating industry of conformity (and one might wish he had gone on to note the ways in which atonality had been taken up in the movies). As in the case of headphones,

> The particular effects with which jazz fills out its schema, syncopation above all, strive to create the appearance of being the outburst of caricature of untrammelled subjectivity – in effect, that of the listener ... But the method becomes trapped in its own net. For while it must constantly promise its listeners something different, excite their attention and keep itself from becoming run-of-the-mill, it is not allowed to leave the beaten path: it must always be new and always the same ... Jazz, like everything else in the culture industry, gratifies desires only to frustrate them at the same time. (Adorno 1989, pp. 203–4)

Jazz's specific techniques, allied to its rapid distribution technologies, thus contribute to massification, even as they appear to speak to and on behalf of individuality and desire. Desire itself is

mobilised, as all culture must mobilise it, but only in order to be attached to and equated with its technical manipulation at the hands of the culture industries. In this closed circuit, the critical role of art music is lost, and the carnival conducted to the metronymic beat (which Adorno says derives from march time) of an objectified cultural form. We should add that it has abandoned the materiality, the sensuousness, and the critical potential of the body in so doing, replacing it with an ossified, mechanical version of its own spontaneity. Productivity is reduced to reproduction, and reproduction anchored in the heterosexist reification of desire.

One problem here is that, lacking a sophisticated theory of subjectivity, Adorno can contemplate this process as a wholly successful one. Yet we have argued above that subjectivity is never a completed process, and that the actual, historical human subject is unhappy precisely because of the ill-fit between instinctual drives and the socialised forms available for their expression. As the contemporary Hollywood cinema approaches the aesthetics of the music video, for example in the 1986 film *Top Gun*, the 'wall of sound' production of stadium rock is used to stitch together the disparate edges of editing, where the viewer is most at risk of going astray, of leaving the organised narration of its desire for some more personal project. In doing so it ties the fragmenting elements of the psyche together into a unity predicated on continuity across the edit underwritten by the music. The bludgeoning emotiveness of stadium rock enforces coherence both through volume and by filling as much of the audible spectrum as possible with sounds, all of which are subordinated to the main theme. Rather in the manner of headphones, it reverses the traditional hierarchy of image over soundtrack, so that sound is reprivileged historically as the more totalitarian medium. Perhaps this sits in a dialectical relation with Kaja Silverman's observation, citing Flugel's 'Great Masculine Renunciation' of beauty in clothing since the 1750s, that 'over the last two centuries, the male subject has increasingly dissociated himself from the visible, attempting thereby to align himself with a symbolic order within which power has become more and more dispersed and dematerial' (Silverman 1988, p. 26).

Male pleasures of fetishism and voyeurism depend on the removal of the looking subject from the field of the visible, so that the gap between representation and reality can be foreclosed. When that is done, the further function of the sexual organisation of looking can

be carried forward: to erase the evidence of sexual difference and thus the anxiety it causes (in psychoanalysis, castration anxiety is rooted in the child's first observation of the physical difference between sexes: the visualisation of a fault in the plenitude of the visible world). Erasure of sexual difference is itself the gateway to the restoration of a sense of wholeness to the adult, a sense lost since the first entry into the worlds of sexual difference and the Symbolic. The fetishist and the voyeur – the one by displacing desire on to parts or performances of the body, the other by assuming a position of power over what is watched – manage their fears of sexual difference by denying its existence. But that erasure is effected in accord with the broader social formation, where sensuality is objectified as sex, and sex split into a binary opposition of two unequal sexes.

So the representation of women in cinema is often said to be a representation of women as lack: as the entity missing from a story in order to make it go, for example. We could read this as a procedure in which representations of women are made in such a way as to fix the concept of lack, in order to forestall recognition that both masculinity and femininity are lacking, that the social forms of life which each sex acquires are marked by their perpetual incompletion. If we recognised that radical, endless process of lacking, we would find it productive, in the sense argued for in the previous chapter. Instead, incompletion is fixed to the body of the woman alone, hence acquiring the status of an absolutely given fact of the world, and thus freeing masculinity of any such constitutive incompleteness (the spectacle of the 'incomplete' homosexual man, masculinity avowing its own lack, is presumed grounds in our culture for violence, even murder). The position of women as lack underwrites the position of masculinity as whole and entire, a status (ironically) underwritten by the cinematic techniques that lead to infantile senses of wholeness. So we can get some sense out of Freud's argument (1977, pp. 351–7) that the fetish object stands in for the non-existent maternal phallus: in some sense, every mainstream representation of a woman is a fetish object, proving the universality of a putative phallic ordering of the world. Thus women are hypostatised as spectacle, while masculinity is hypostatised as vision, and the separation of the two from one another is once more founded on the removal of both from the field of bodily productivity.

Film soundtracks, especially those deploying stadium rock, tend to further this process by using a totalitarian musical style in which, since all the areas of the sound spectrum are already full, there is no place for the listener's productivity to begin. Sound engulfs the gaps between scenes, the differences between moments of vision and spectacle, at the points (like edits) where we might begin to investigate the incoherences of the image track. The wall of sound reorganises masculine/patriarchal spectator positions as totalised and totalising, whole, entire, coherent, monolithic, absolute, given. The Wagnerian themes used to accompany battles and space flights in films like *Star Wars* (1977) and *Star Trek: The Movie* (1979) accomplish a similar purpose: to establish the absolute coherence of the (implicitly masculine) spectator as a prelude to, and necessary condition of, male mastery and power over the audible and visible worlds. If the dispersal of instinctual pleasures in looking between voyeurism and fetishism is the visible organisation of male desire, then the stadium rockers' wall of sound (like the Wagnerian *Gesamtkunstwerk*) is the audible organisation of patriarchal desire as domination. Within such a regime, some musical forms will also connote femininity (as romance, as sexuality), as Gorbman (1987) and Kassabian (1991) have argued, and further extensions into the oppositions of modal and tonal (cf. Tagg 1989), of major and minor (cf. van Leeuwen 1988) and rhythm and melody (cf. Middleton 1990) need further development in the field of audio-visual media (cf. Brophy 1991) But this fundamental conclusion is inescapable: the ordering of sound in soundtracks objectifies the sound world, establishes a series of (gendered) binaries through which it works, and deploys these resources in the interests of a homogeneous and coherent patriarchal subjectivity.

Which leaves us with the problem of the speaking voice, or more particularly of recordings of the speaking voice. Here we need to take on board Lacan's suggestion concerning the displacement of the phallus as the privileged signifier of (male) desire. The phallus is precisely that which is not shown, certainly never in dominant cinema: that is how images of women can become signifiers of the phallus, representatives of male desire. Lacan argues that it is not the parental phallus as such that works on subjectivity, but the name of the father which takes its place. Authoritative speech in patriarchy is, then, the prerogative of the phallic male. The heroic self-confidence of a Clint Eastwood character, whose speech is

measured out parsimoniously but is always a mark of the hero's control of both himself and his situation, is an example of the father's name in action: a speech which is precisely patriarchal. It comes from the real man within: its power and truth guarantee the fullness and coherence of the patriarch. As star, Eastwood speaks the lines, and even with the very voice, of the narration of the film. His words are true, his perceptions correct, his orders obeyed and backed by the power of his machismo. All the other men are judged by his standards, and their distance from the truth demonstrated by his identification with it, just as their weakness is demonstrated by his strength. So the male star, in this instance at least, speaks with the authority of the film itself: it is the voice which enunciates the truth of the narration. The filmmaker's truth is spoken by the hero (even if the hero has to learn that truth in the course of the plot); or, as apparatus theory would have it, the filmic apparatus speaks with the hero's voice. To this extent, the voice of the hero, like the wall of sound, organises the film's moments around a single point of view, one that has all the power of patriarchy within it, and which, on the basis of that power, can voice the ideological projects of the film as sharing the absolute givenness of coherent male subjectivity. A great deal of the narration of mainstream films is about getting women to voice their acquiescence in the truth voiced by the man. Again, the lack of authority in actual male voices, the incompletion of speaking, that never-ending pursuit of a complete statement, the process of lacking, is displaced on to representations of women's voices which, like the images of their bodies, are hypostatised as lack: silence, hysteria, misunderstanding, the inarticulate groan of sexual pleasure. As Silverman argues, 'in the final analysis it is the male viewer's own exclusion from the site of filmic production rather than the spectacle of woman's anatomical "lack" which arouses such anxiety and fear in him' (Silverman 1988 p. 30).

There are a whole series of consequences here: the fullness of the hero's speech is the site of identification for the (male) spectator, but it is so as an imaginary fullness, making up for an actually lacking completion of masculine subjectivity. While the cinema hero's speech provides a gratifying fantasy of authority, power, truth and coherence, it also debars the viewer from engaging in inventive, productive entries into the narration of the film, closed off by being already fully occupied by that meticulous construct of fullness. This kind of speech also provides us with an idealised (and idealist)

version of language as the product of the individual speaker. While the hero's voice carries the weight of the cinematic apparatus, it simultaneously elides the production processes that have gone into it, leaving us with the impression that it is Eastwood that speaks, that it is on the basis of individuality that language achieves this fullness to itself, the fullness of truth. The materialist conception of language as social (and of subjectivity formed, in large part, by the processes of socialisation that go with language acquisition) is disallowed. With it goes the notion of language as an ever-unfolding process, one characterised both by the lack of finality and completion, and therefore by its endless productivity. In pretending to fullness, this patriarchal, heroic language buys its own completion at the cost of attributing to others a failure to speak coherently. Nowhere is this more apparent than in the Hollywood representation of Native Americans, Africans, Arabs, South and East Asians, all of whom speak the same non-language. Mastery in this extreme case is possible only through the acquisition of the hero's language by a 'tribal', or by massacre. The hero's voice not only speaks authoritatively: in Silverman's words, it 'captures and coerces' the speech of others (Silverman 1988, p. 31).

It is interesting in this context to speculate concerning the authenticity of women singers' voices in music video, and to see in what ways video fails to abide by cinematic codes of authority, so moving beyond binaries of cinematic viewing as discussed here. Music video seems to be far more caught up in cinematic codes than artists' video, yet it too is subject to a different mode of viewing and listening. To some extent at least, what we hear is the voice, far more than language, and in the culture of rock 'n' roll, we are invited to recombine the experience of song with the experience of the body, especially in dance. Our response, then, is not one of cerebral truth, but of a reformed sensuality, albeit one subject to Adorno's critique of commodification and mechanisation. In consequence, the use of 'truth' as a dividing line between masculinity and femininity is no longer an available strategy. Music video is a curious hybrid of music culture, cinematic technique and video distribution, its reception an amalgam of each of these formations. As a result, it can be seen to occupy a threshold position, at the brink of the kinds of complexly narcissistic modes of viewing (pre-Oedipal and so pre-individual, thus pre-gendering and pre-'truth') evoked by computer

imaging, with which it increasingly shares a vocabulary, and which is looked at in more detail in Part II.

In an intriguing deployment of the qualities of filmic and televisual sound, Adrian Piper's installation *Cornered* (1990) uses a direct address to camera as a confrontational device. She speaks, in sync, and her first words are 'I am Black'. Cinema has deployed sync dialogue as a means of asserting the fullness of its protagonists – like Eastwood – to the image, to assert the completeness of its fictional identities. Piper uses the same technique, but displaced into video, where the fact of recording is always apparent. Her assertion, here, carries a weight that it could not in the cinema: the 'I' that speaks lays no claim to completion, but bids for an identity. A major strand of Piper's work deals with the fact that she does not 'look' Black, but that, as a woman of mixed descent, she identifies with African America. The opening claim, then, addresses a perceived disjunction between the visual and auditory tracks, announcing an identity that, in any case, is hard fought for, hard won. The announcement of Blackness is not, therefore, an assertion of the fullness of individual identity, as would be the case with an Eastwood character: it is a claim for identity, itself a moment of the struggle for a Black identity. So the filmic technique, in other hands, in another medium and for other purposes, is transformed. Interestingly, Piper had initially opted for a rapidly cut, 'advertising' style of presentation, opting eventually for a single long take with direct voice to camera in her own character (interviewed on *The Late Show*, BBC 2, 11 February 1992). That single take, and the installation's *mise-en-scène*, which has Piper wedged between a table and the corner of a room, is determined by a metaphor of a cornered creature: cornered by the assertion of 'negritude', the Black woman turns to counter-claim her identity as Black. Identity here is not an ideological-technical construct but a field of struggle, between the imposition of a false identity (Blackness as the lack of whiteness) and the assertion of a new identity (Blackness, like all identity, as a process founded in a common lack of completion).

In film's soundscapes, however, the mainstream can be argued to replace lacking with lack, productivity with product, sociality with individuality, and to focus, through music and heroic speech, the plurality of its signifying processes on to a single, monolithic and patriarchal form of subjectivity. At the same time, it moves sound

from the interplay of inner and outer towards the objectified pronouncements of a screen apparatus posing as the internal monologue of the viewer. And scarcely a noise gets by that is not someway or another deliberate: heroic speech and the wall of sound deny the contingent, the risky, the opening up of sound worlds. The regimes of sound in television are more loosely organised. Because TV is itself an endless process of production, and because it is typically situated in the home, where it must compete with the actual social conditions of living to an extent rarely experienced in the cinema building, it deploys a far less rigid hierarchy of sounds.

Rick Altman, in one of the few essays devoted to television sound, lists six strategies adopted by television sound in the USA, each of which in one way or another is directed towards keeping channels open to a distracted, intermittent audience. In the action replay (also one of the most obvious moments when TV's liveness is interrupted by the transparent use of videotape: cf. Morse 1983), he sees the soundtrack announcing what it is about to show, rather than anchoring, as film does, the presence of the actor in the speaking of the character. In this forward displacement of the fulfilment of sound into the future, he reads a relationship between play and replay that recapitulates the relationship of present and representation:

> Formless, uninterpreted, lacking in direction, the present takes on meaning – its 'for-me-ness' – only in the process of representation ... By bringing a specially made image together at this specific time with a spectator especially desirous of seeing that very image, the sound has succeeded in involving both the spectator and the image in the discursive circuit it directs ... Charged with calling me to the image, the sound track uses every weapon at its disposal ... But the ultimate argument, as well as the final goal, remains the notion, fostered continually by the sound track, that the TV image is manufactured and broadcast just for me, at precisely the time that I need it. (Altman 1986)

So TV sound operates a little like continuity editing, which creates a desire to see, and then magically fulfils that desire. Yet Altman also ascribes to it the power to create form out of the formlessness of the present, albeit by deferring the plenitude of the soundtrack – its realisation in the image – until the viewer has come back into the room to get to the full version. By which time it is already past,

objectively, but subjectively more present because desired, with a desire initially mobilised by, in this instance, the shouts of the sports commentator on the elegance of a pass.

Much of the repetitiousness of TV can be sensibly ascribed to this procedure designed to stitch the distracted viewer into the TV flow, and though some of the patterns of viewing and broadcasting he describes are specific to North America, much is generalisable into European TV. This industrial-technological apparatus finds its homology not with the concentrated look of the cinema-goer but the wavering attention, formless because present, of the listening ear. If in its endlessness television is closer to Lacanian models of desire than film so, in its deferral of the fullness of meaning till the viewer has had time to look, it is closer than film to a Derridean notion of differance.

Derrida's complex arguments about the status of speech in what he describes as the Western metaphysics of presence need not detain us here. What we need from it is simply his criticism of idealist theories of consciousness, based in the notion that the subject is the source of meanings, while language, especially speech, is a mere material form of this internally generated ideal. Derrida's critique is based in the materiality of the sign. He suggests that, though speech is used as a metaphor to support the idea that the individual produces unmediated meanings, in fact the processes of signification are deeply mediated even within an individual consciousness. So much so, in fact, that what for Husserl was the presence to itself of consciousness, within which perception and meaning were simultaneous, must be understood materially: there is no presence, because the process of moving from perception to signification is always already delayed. So it is that Derrida prefers the metaphor of writing, always chasing after the event, always clearly distinct from it. It is this difference between the event and its signification that he sees as founding, not the self-presence of idealist philosophical subjectivity. Motivated by a purely instrumental need to maintain its grip on audience numbers, TV as insitution involves in the TV apparatus a far more productive mode of subjectivity than that embraced by film.

It may also be true that television is only a more sophisticated manipulator of its audiences: an apparatus more attuned of necessity to the actualities of daily life (Altman calls this 'household flow'), which also needs, in the USA, to keep the sets turned

on, since that is the source of the Nielsen ratings which, in turn, are the measure of their success in delivering audiences to advertisers, and therefore the prices of their advertising slots. British TV uses many of the same techniques, especially during programme breaks where any concentrated viewing will be dispersed, and the sound is needed to bring the viewers back to the screen. But the power of discourses of quality in the politics of broadcasting in the UK are still felt to be as necessary as ratings, certainly within the industry, and certainly in the longer term (for example, in discussions on the future of the BBC). Quality in these terms might be defined as living up to sustained attention on the part of viewers: the kind of attention which we might give to a timeshifted programme on video. Powerful here is the notion of an authoritative voice, be it an Attenborough commentary to a wildlife series, the presence of leading politicians in debate programmes, or the privileged position of authors in the marketing (if not always in the production) of TV drama. Yet it is also true to say that British television entertains a wide variety of voices and modes of audio address, and that it is far more likely than cinema to provide authoritative female voices.

What it cannot afford to do, however, is to give up its unyielding task of organising a common identity among its viewers. Sound must organise the meanings of images (for example, of news reports) it must identify both programme types (as in the very different uses of incidental music in British and American soaps) and segments within and between programmes; it must act as the guarantor of TV's continuous presence, even when we are not looking; it must, in short, be both the internal audience for television itself, commenting on and anticipating the flow of screen events and simultaneously the address to the viewer that hails us into its construction of meaning. In this way, we come to the conclusion that sound on broadcast is used to confirm our pursuit of subjectivity (though, unlike cinema, rarely producing a completed subject position) by encouraging a pursuit of endlessly deferred meaning. So TV, a hugely centralised system of distribution, encourages a relation which, according to Margaret Morse, 'can be summarised as one in which a medium structured to prevent dialogue with the other in our society has developed a fictional form of dialogue; television cannot satisfy our desire for subjectivity, but it can displace it' (Morse 1985, p. 15). Where cinema presents us with the image of completeness in the enunciation of truth through the heroic voice and the wall of sound,

TV recognises the necessity of continuing to hold our attention day in and day out by displacing that fulfilment into a deferred space of the future. TV, therefore, is a teleological medium. Even when films are shown on television, they are framed with the discourses of incompletion (including visual ones like 'letterbox' format for cinemascope films), and are even interrupted, so that they too become television, and are subsumed within the overarching project of continuity.

TV continuity, though, is clearly of a different kind from cinema continuity. The latter is pitched at completion around a dominant patriarchal subjectivity, and organises the overall sound design to that purpose. The former allows more play to heterogeneous voices, musics, noises, but does so within a delimited and hierarchised system of sound. Delimitation of the range of voices tends towards the exclusion of certain other voices (such as children, peoples of the 'third world', or Sinn Fein, for example) while the hierarchy defends the high ground of patriarchal subjectivity against all comers; another description of the TV apparatus would be as a game in which anyone can play, so long as all recognise that the referee will win in the (always deferred) end. In its use of direct address, TV invites us to play the game: to set up oppositional negotiating stances *vis-à-vis* both its messages (for example, with phone-ins) and its model of (future) subjectivity. To keep us interested – us in this case being a far more widely dispersed and differentiated audience than that presumed and produced in cinema – regression is no longer a viable option, certainly at least not the sole or even the major one. TV already represents itself as a far more negotiable medium than film, though it does so within a global logic which presumes that all competing messages and subjectivities are ultimately subsumable within its own. TV then reveals itself as the typical medium not of postmodernist fragmentation and radical difference, but of liberal democracy. This is at least a step forward from the totalitarianism of cinema.

Neither film nor TV, of course, approach, in their most familiar forms at least, the openness of the sound world addressed by Cage and Stockhausen. Film and television sound, like the transmissions of short-wave radios, need to become the content of a further set of representations: they need to be treated as signifiers which can then be re-represented within further compositions in order to meet both the modernist fascination with music as sound (a fascination shared

by popular music) and its negative-critical project. But it is not enough to be critical. In some ways, TV is itself self-critical, not only within certain programmes (*The Media Show*, *Max Headroom*) but in the way it invites specific voices into its discourses, the better to target audiences defined purely instrumentally by lifestyle or status. As Morse points out, this is a process of bringing the outsider inside, a process of homogenisation. Yet she also argues that this need to renovate the repertoire of voices should also be exploited: 'Changes in shared fictions, values and beliefs occur over the long term, slowly and incrementally, not merely because once shared values are discredited or may be no longer viable, but because alternative values and their constituencies have laboured to mark themselves in discourse' (Morse 1990, p. 215). If British television is marked by the sign of the TV personality, it is as personalities – as discrete individuals – that new voices appear, yet the new voice is part of an ongoing struggle over and within TV. We should not give up this struggle for innovation inside the belly of the beast, the positive struggle for reform.

At the same time, we should worry if this becomes the only form of struggle, and if other routes are allowed to atrophy, as has been the case in the UK's independent film and video scene through the Thatcher–Major period. The shift of emphasis in funding institutions from off-air to broadcast is important to the reform of television, but that is only part of the work needed to build a living audio-visual culture. Since art follows its internal logics with greater rigour (more autonomy) than TV, it has tended to allow more radical questioning than transmission will allow, especially in the realm of sound, where the functional uses of the soundtrack need no longer be subordinated to the economic and political functions of broadcast institutions. Film sound is religiously anchored behind the screen, even in stereo-equipped cinemas: it is geared towards underwriting the here-and-now-ness of the cinematic image. TV sound is more of a vector than a creation of screen space: it drags us towards looking, but it also constantly refers us forward towards that ever-absent completion that broadcast lures its audiences with. Video is cheerful deploying both sorts of sound, but can, especially in the forms least like film and television, create other sorts of possibilities, perhaps as yet quite abstracted from the rest of the everyday world.

Commissioned in 1991 for installation in the atrium of Mercury Court, a city-centre business development in Liverpool, Chris

Meigh-Andrews's *Streamline* is a sculpture made of nine video monitors, seven of them flat on their backs, with one at each end tilted on its shortest edge, while a small bridge crosses this 'stream' in the middle. The monitors show a stream of water on which a small paper boat floats with the current from one end of the installation to the other, and then back again as the flow is reversed. At each reversal, a pair of female hands accepts the boat, and a male pair relaunches it. The action is accompanied by the sound of a babbling brook. The installation sits below an arbour which is part of the decor of the atrium, a smart lunchtime spot, its babble mingling gently with the muted hubbub of conversation. To some extent it conjures up impressionist images, especially with the bridge modelled on the bridge in Monet's late oils of his garden. Meigh-Andrews writes in the flyer for the piece that the paper boat can be seen as 'symbolic of attempts at communication' (Meigh-Andrews 1991, n.p.), so that the piece combines a development of landscape art with a meditation on the nature of communications.

Stream, channel, flow: these are the aspects of television recapitulated in the piece, spatialising television's temporal flow by getting the image continuity to operate not only over time but through the space of the nine monitors. At the same time, the monitors are linked by powerlines, suggesting further that TV flow and the flow of the electricity supply are in some way cognate. What draws it back into landscape is the act of reversing the flow, simple enough with electricity, more difficult with television, where the flow is not only temporally determined but, crucially, is not reversible. TV's fiction of itself is of dialogue with the audience, but effectively that dialogue, even on the rare occasions when it occurs, is utterly dominated by a flow from the centre out. It is no more possible to conceive of television as a communicating apparatus than it is to think of it going backwards. The image of backwards TV is itself a fascinating one for TV at its most self-questioning: Monty Python's 'déjà vu' sketch, the backward-speaking actors of *Twin Peaks* and the reversed speech of Gary Hill's tape *Why do Things Get in a Muddle?* (1984). There's a disturbance here, though, in *Streamline* in that the image track is reversed, but the sound is not.

As it happens, the sound was recorded separately from the image, which despite its naturalism is in fact a set, and one whose sound envelope simply did not match the rural quality demanded by the images. The gap between sound and image then is understandable as

a spatial metaphor: the boat moves between sender and receiver, but the stream, though reversible in terms of communication, is still part of an endless onward flow. To make the kind of critical point that I want to make, I would have to intervene in the making of this piece, and argue that the sound too should be reversed: that we should hear the babbling brook played backwards, so that its recordedness is more apparent, and to match more clearly the spatial reversal of the images.

The sound has here to fulfil another role, however, one almost unheard of in film and television: a sculptural function. Sound in this instance has not only to relate to the image but to occupy the space within the atrium, to form the given place into a sculptural space. Michel de Certeau distinguishes between place – the location where a thing is – and space as an effect of the events that occur in a place. To this extent, he says, space is to place as a spoken word is to the word as such: it adds multiplicity, the contingency of the specific moment and context of speaking, so that place as space is not only modified but becomes modifiable (de Certeau 1984, p. 117). Stories, he argues, operate a set of shifts between space and place, and we could extend this by arguing that typically cinema sound organises the anonymous but story-filled space of cinema into the place of its fictions. TV moves between the two, for example in talking about 'your home', a word with both an ideal and a real referent. The sculptural use of sound turns the geometry of a social architecture into the home of a specific practice, shaping the acoustic place into a formal structure. Such sound structures assume a polyvocal quality that send us both towards the image portions of the sculpture (and the monitor boxes, the leads, the bridge) and through them to a further set of represented spaces, the space of representation itself, virtual space. This motion of sound in video sculpture between sculptural and virtual is a dialectic which television by and large does not allow itself. The uncertain status of video's more clearly recorded sound, its distance from its original, combined with its constant reference back across that insurmountable gulf, and its presence as an occupation of space; these factors drive beyond the delimitation of time and place in television, multiply the vectors where TV has only one. *Streamline*, simple as it is in design and execution, renders far more complex commentaries on communication than the flow of TV can: excluding itself from direct address, yet it is by that far more open to dialogue than the fictive dialogue of

TV's self-presentation. Here after all is an example of the artist as producer, making an addition to the repertoire of effects, opening a way for new inventions in the electronic medium. In announcing its own illusionist effects, especially in that most illusionistic of all, the soundtrack, *Streamline* presents an alternative version of communications: one subject to all the vagaries and dangers of the channels that it uses, that recognises the fact that there are channels. At the same time, though, this is a discovery of the pleasures and productiveness to be found in just those problems: the chances of misunderstanding are also the possibilities of understanding anew, of making new understandings. The lack of a pure, translucent, noiseless medium is no lack at all but a gain. In place of the monolithic, self-fulfilling presence of the authoritative, unhindered by the material of speech, we gain the material itself, the stuff of which meanings are made, the stuff which, unalterably social, unavoidably historical, is the productivity of language, visual, verbal, aural. As sculpture, this material stuff enters into the everyday world, turning place into space, a space in which our bodies also are.

The sound world needs far more analysis than we have room for: work on sound design, acoustics, the techniques of recording and editing, the histories of sound, the relation to the cyborgs that engross us more and more in cultural and media studies, the singing voice on record and in performance, the impact of digitisation, the relation to other spheres of the social formation and so on. What I propose, however, is to draw upon some of these themes, as well as others begun in previous chapters, in performing some analyses of particular video works. That will be the business of the final section of this book, in trying a practice of writing against practices of video to see where the theories break down, and new ideas are needed.

Part II

Practice

Now that the errors which have hitherto prevailed, and which will prevail forever, should (if the mind be left to go its own way) either by the natural force of the understanding or by help of the aids and instruments of logic, one by one correct themselves, was a thing not to be hoped for, because the primary notions of things which the mind readily and passively imbibes, stores up and accumulates (and it is from them that all the rest flow) are false, confused and overhastily abstracted from the facts...For while men are occupied in admiring and applauding the false powers of the mind, they pass by and throw away those true powers, which, if it be supplied with the proper aids and can itself be content to wait upon nature instead of vainly affecting to overrule her, are within its reach.

(Francis Bacon 'Proem to the Instauration' in *The New Organon*, New York, Bobbs-Merrill 1960, pp. 3–4)

8

Magnetic Memories: Truth, Power and Representation

Cinema, after all, came rather late. Photography gives us the most apt descriptions of the phenomena of the opening of the twentieth century, especially the globalisation of the city. The photograph is not only the possibility of identification, of identity constituted through the disciplines of policing; it is also the possibility of anonymity, of interchangeability between all the images in the archive. It is far closer to universality than cinema too, on the global scale: if not defining, it is the characteristic medium of our century, the one that is coming to an end.

The airmail artist Eugenio Dittborn (cf. Cubitt 1990/1; Brett and Cubitt 1991) uses in his work 1930s mugshots of young criminals. These complex images evoke, among other things, the station terminal of Santiago de Chile where the peasants of the hinterland arrived looking for whatever they were looking for, and where they found their brief fame as criminals instead. In their faces you seem to see the look of those who have just discovered, after half a lifetime, that they are Americans. Their crimes are now forgotten, along with the lives they left in provincial towns. They have no names. They are only Americans, and wanted by the cops. That mix of anonymity and identification, clothed in the borrowed bravado of Warner gangsters: that is the notion of photography I have in mind.

We might say that in the history of photography, film occupied for a time an institutional apex. Like Dittborn's gangsters, the pinnacle of the circulation of photographic images came in the cinema. In the Hollywood star system, particularly, the traffic in images found, say, between the mid-1920s and the late 1940s, a

133

heartland around which lighting, framing, tone, emotion, intelli-
gence and beauty could be gauged. Photography, a technology
slipping between many media, cannot be limited so easily to a
single discourse: it must be seen as a field of mutually interacting
but relatively autonomous discourses and practices which, however,
relate systematically with one another. And in our time that means
hierarchically. At the top of the hierarchy of photographic practices
– journalism, family albums, passports, postcards, billboards, and so
on – cinema most of all fulfilled a dream of photography: to number
every seat, and to throw their occupants into the dark. Rendering
anonymous is the first stage of producing an identification for every
viewer, and making thereby every identity the same in the inextric-
able interweaving of seeing and being seen.

The shift from analogue to digital recording of images (and a
corresponding understanding of older technologies from a digital
perspective) destabilises this neat hierarchy. Television threatens
both the magazine and the cinema as pinnacles of communications
hierarchies, and begins the struggle to invent its own. Following
Ulmer, I would argue that '"Television" then is best understood as
the name of the institution that has arisen to manage and distribute
the medium of video' (Ulmer, 1989, p.x). To expand this apperçu:
television (as broadcast distribution medium) is the pinnacle of an
institutional and discursive hierarchy of video practices. Preview,
festival and classroom screenings are subordinate practices, as are
facilities houses, timeshifted recording, rental and sell-through tapes
and, at least till now, computer games and graphics displays. Most
of all, from a systemic point of view, television, characterised by its
aura of liveness, its (segmented) flow, is more important in the
hierarchy than the occasion of viewing: more important than the
design of the monitor, than the quality of reception, and finally than
the social specificity of actual, historical viewing. No single instance
of television is as important as television itself (just as no single film
can sum up the 'experience of cinema').

We have, then, a new hierarchy of visual communication. The
production, distribution, marketing and sales of film and print
media have changed to meet the new situation. Just as cinema
altered the design, contents and consumption of print, so video has
altered the patterns of previous media. We need, however, to
complicate this conception with a second one, concerning the
position of sound recording in the twentieth century. Like photo-

graphy, recorded sound moves between media and enters into complex relations with each one it touches. In some ways, the recording of sound has run ahead of developments in visual media, establishing a sly bridgehead in everything from literature and fan culture to performance and film. The shift in emphasis on sound between film and television is in part at least a product of the advances in sound technologies. Sound can be said to add a pledge of authenticity to film: in video media, the image adds guarantees to the soundtrack. Yet a great deal of sound continues to lie below the threshold of perception in normal viewing, and much is designed to do so (for example, the incidental music in American soaps, or the complex 'ambient' soundtracks in their British equivalents). Relations of sound and image form a fascinating material on which to base a discussion of the power relationships evolving in video.

I will want to argue, in addition, that the issue of power must also be addressed in terms of the technologies of production. The digital sounds and images generated without either microphones or lenses which now occupy so much of our media culture are widely hailed as opening up unlimited new vistas for eye and ear. Yet Metz presciently warns us, in a discussion of future film technologies, that adjustments to the apparatus will continue, but not in any regular fashion. By analogy with political development, he argues that 'there are not endless possibilities to choose between, and of those that are actually functioning, each is a self-contained machine which tends to perpetuate itself and is responsible for the mechanisms of its own reproduction' (Metz 1982, p. 92). Though Metz here intends films rather than machines, the argument holds good of new media technologies. Such technologies do not emerge by accident or without recourse to society at large. They do not become important without major financial backing – that is, they do not survive on their merits, but because someone has an interest in their survival. And having come to prominence, there is likely to be a period of friction when any new technology arising threatens to oust an older one. In the current unstable situation in media technologies, this field of struggle produces monsters, allows extravagant experiment, but also gives birth to orthodoxies. That the orthodoxies are as yet competing, both between themselves and with older pretenders, merely makes the situation more important to engage in. The hegemonic hierarchy in the media apparatus of the immediate future is being built in the 1990s. Analysing power relations within

and between these competing media therefore becomes an urgent political and cultural issue.

There is a further reason for writing on power. The period of my involvement with the moving image culture since 1980 has been the period in which the dramatic flowering of new cultural forms, from Rock Against Racism to community computing networks, has been the victim of what appears from inside the culture as an orchestrated attempt to close down all avenues of experiment and innovation that are not consistent with certain key factors in the dominant constellation of ideologies. That these ideologies take their style and rhetoric from economics does not alter the ideological significance they take on as dogma in cultural policy. Most of all, the rhetoric of cultural investment, cultural capital and cultural product has introduced an expectation of short-term returns on processes and practices that cannot turn around a profit in the terms or the timescales demanded by policy structures dominated by an outmoded managerialist notion of efficiency. It is one of the strengths of capitalism in general that it encourages (cannot structurally fail to encourage) the rapid evolution of new techniques and technologies. Yet it is caught in a double-bind in which the free experiment of capital in the abstract must meet with the standardisation required by actually-existing, transnational, corporate or monopoly capital. The crisis of independent media practice is perhaps already only history. Yet, in its ruination at the hands of dogmatic monetarists and cultural apparatchiks, we need to understand what it is that the field has been cleared for. What is the video process which is being standardised, and what is its status?

The lens, after all, is only one of the technologies available to video for generating images: by now the majority of images on television are created by the electronic manipulation of previously existing images, whether produced by film or graphics. Even if the manipulation of the image is as simple as a telecine transfer from film to tape, we still have to register that this represents an image of an image, and the broadcast image then is one further remove from the real world whose light first activated the photosensitive molecules of the film strip. And as every film buff knows, telecine operations are notoriously inaccurate as representations of films, Cinemascope suffering most, but all common film formats failing to meet the standard aspect ratio of the TV screen. The consciousness of recording which video adds to television gives a further layer of

removal, a further difference between the world and its electronic image, and one that is redoubled by our growing consciousness of the use of computers to treat images.

This awareness came to a head in a recent case in the United Kingdom, during which the accused party was arraigned on the evidence of a surveillance videotape. Since the quality of the image was of insufficient resolution to identify the perpetrator with absolute certainty, the police had used an image-enhancer to produce a clearer image, one that approximated to the physiognomy of the supposedly guilty party. The court, quite rightly, held that the treated image was no longer acceptable as legal evidence of wrong-doing. This, on the one hand, raises the question as to whether any electronic images can be treated as evidence since, as any undergraduate on a semiotics course will know, in representing, media (electronic or otherwise) always alter the object to which they refer. At the same time, it is perhaps the sheer professionalisation of the police use of video that leads us to suspect them. The famous Zapruder film of the Kennedy assassination, or the more recent take-up of amateur footage of a racist police assault in Los Angeles, are instances of the ways in which we accept far more readily the witnessing offered by bystanders than by professionals, just as we found with *You've Been Framed.*

Even so, there is a tendency to assume innocence in the bystander which is not shared by all political cultures. When news footage of the *Intifada* was clearly being tampered with by Israeli authorities, or censored and contemporaneously being used as police evidence against Palestinians, the *Intifada* barred all Western news crews and produced (as they still produce) their own footage of events, in competition with those Israeli and Western crews who film from the standpoint of Israeli patrols. Likewise, the underground in Chile under Pinochet also produced startling video footage of socialist, pro-democracy demonstrations and their brutal suppression. In what follows, the importance of video as counterdocumentation, as an alternative to controlled news flows, and as an active intervention in dominant news and legal practice must not be forgotten.

Material reality does not cease to exist because media enter into new relationships with it: indeed, media add their own materiality to the stock of what is real; and a treated image adds to the world something that an untreated image cannot. The common ground

between these issues is surely, again, that of power: the power accruing to the concept of truth. Video records of anti-Arab attacks produced by SOS Racisme in France, Gunther Walraff's undercover tapes of fraud and exploitation in Germany, footage smuggled out of South Africa documenting oppression and resistance: these are not isolated incidents, and neither should they be seen as fruitless attempts to staunch the submersion of reality under the tyranny of images. But the truth to which such works lay claim is the truth of struggle, truth to the needs of the moment of their circulation. Like Piper's articulation of Black American identity, such work doesn't claim the status of absolute. Though many pitch themselves at a Western concept of natural justice, they do so as a technical or formal device. What is important is not that they speak truth, but that they are aimed at change.

Such work has a clear purpose: to demand solidarity and support. All other claims, epistemological, aesthetic, ethical, must be subordinate to this imperative. 'This is how things are', they say, but only in order to add 'but they cannot be allowed to remain like this'. Until forced to capitulate in the undeclared war waged on them by the USA, the Nicaraguan Sandinista TV mapped the struggle not in the search for truth, but because understanding, analysis and basic education were fundamental to their claims to a future. In such work, truth is not a teleological goal, existing in pure and abstract state beyond the world, waiting to be brought into it. Instead we need a concept like 'correctness', as in Mao's essay 'On Correct Thinking' (1967), which claims the roots of correctness in social practice. A correct representation is one which serves the needs of the social dynamic, which hastens the processes of history without necessarily defining their goal. In this sense, the video of resistance has a profoundly negative relation to philosophical truth, since its major motivation is the critique of things as they are, not their acceptance. As such, their correctness belongs not to all time, but to the moment of their circulation, the moment of use. Correctness, ultimately, is not a function of the video, but of its audiences, and the ways they create the next moment of the future.

When we turn to the dominant modes of video media, the status of truth as a medium of power is unavoidable, rarely more so than when we investigate it not as a general term, but in its privileged position in legal discourse. What is so surprising is the relative status of video as evidence and video as a record or transcript of the legal

procedure. Unlike North American courts, the British judiciary will not allow photographic or electronic recording of events in the courtroom. Newsworthy judgments are represented on television screens through pen and wash drawings, 'artist's impressions' of personalities and moments of drama. Names and addresses of suspects, witnesses and courtroom staff may be published, and footage of suspects and witnesses outside the courtroom: there can be little defence of the practice on the grounds of safeguarding the innocent. What is in fact at stake in this division between video as evidence and video as record is the dignity of the legal process itself.

Since video can be accepted as evidence, its status as fact is not at issue. The interpretation and validity of the video as evidence can be queried, according to the procedures set down in the laws of evidence, as happens frequently when children give evidence on video in abuse cases. But questions of fact are separable in law from questions of interpretation, and if a fact is given in evidence, it is simply a question of whether it can be believed or not. The status of truth, then, is relatively clear: a truth exists; a statement of that truth is provided (on tape); the status of the statement may be queried on the grounds of, for example, the trustworthiness of the witness. Video is a partial witness to a pre-existing truth which it is the business of the court to reveal and to judge. The concept of truth, itself, is not open to question: this is a defining characteristic of legal discourse.

Why then does the court not permit a 'truthful' record of its own deliberations? Print media – court stenographers and law reports – are permitted, as is the use of drawing (a far more mediated medium than electronic recordings). There are two points to raise here. First, a record claiming accuracy as to the conduct of the participants in court must throw itself open to the same queries concerning partiality and trustworthiness as video evidence but, since the findings of the court are presumed to be the very truth itself, there can be no room for further deliberations. Justice must be done, but if we were to see justice being done, we would automatically have to interpret that sight. On the one hand, we would judge tones of voice and body language; on the other, we would be able to read the processes of truth-seeking and particularly the announcement of its uncovering as texts: texts which are notoriously polysemic, multivalent, unstill. In short, the truth of a video text is not that of the legal discourse. The law works on the spoken word, asserting the

primacy of speech and assessing truth according to the contiguity and continuity of the act of witnessing, both witnessing events, and witnessing to events. That a speaker knows is not in doubt: that a speaker speaks what she knows may be. But both the truthfulness and the accuracy of the evidence is held to be assessable on the grounds that the speaker is there, before judge and jury, and their demeanour and character in the act of speaking are held to be inherently indicative of the quality of the evidence. Recording removes that immediacy: the validity of the recording needs to be determined by a further act of speech, identifying a piece of writing or a tape as legitimately part of the legal process, the legal discourse.

The court's dignity, then, is founded on the way in which its proceedings, while they *may* be questioned, *must not* be. Contemporary societies do require legal sanctions. Yet contemporary cultures find the notion of an absolute truth discoverable in any discourse less than totally credible. This is the fundamental contradiction that makes itself felt in the differential status of video inside and outside the courtroom: beyond the court, there is no validating discourse to guarantee the truth of the video record. Custom and practice allow a transcript, transcripts which themselves acquire legal status as precedents, partly at least because they are underwritten by procedures used to verify their accuracy before they are made public. It is the very instantaneity of video, its very proximity to speech, that allows it its standing as evidence, and debars it from acting as transcript. Like speech, video can be interpreted: truth is not perceived as an inherent property of video in the same way as it is of legal discourse. On the one hand, the 'truth' of video evidence must be subordinated to the 'truth' of judgement in a hierarchical ordering of truth claims. On the other, in this procedure of evaluating the strategic powers of each form of truth, the status of truth itself is made doubtful: both the specific truth of a specific case, but also, and more important in maintaining the dignity of the judiciary, the nature and therefore the status of legal truth. Unlike writing, with which it shares the quality of occurring after the event (if only by nanoseconds), video is transparently manipulable, and since it is also rapidly copyable in a form indistinguishable from the original, its proliferation of images of judgement is almost impossible to police as written transcripts are policed. The only way to stop the flowering of dozens of video versions, dozens of edits and interpretations, is to halt the flow at source, to ban the electronic

media from the court. The voice of judgement retains its disembodied, absolute presence at the heart of the law.

The law is also a machine, however, as Kafka knew: a machine for producing truth. Deleuze and Guattari assemble an argument concerning *les machines désirantes* which seems relevant here (if not quite so generally as they argue):

> Every machine is, in the first instance, in relation with a continuous material flux (*hyle*) which it slices into. It works like a machine for slicing ham: the cuts take samples out of the associated flow. Thus the anus and the flow of shit; the mouth and the flow of milk, but also the flow of air and of sound; the penis and the flow of urine and of sperm. Every associated flow then must be considered as ideal, the infinite flow of an enormous joint of pork. Hyle designates effectively the pure continuity that a material possesses when conceived of as an idea. (Deleuze and Guattari 1975, pp. 43–4)

In law, we see a machine dedicated to the flow of truth, and for the purposes of the Deleuze/Guattari argument, we need to allow for an idealised concept of truth as an endless flow, as endless as the speech that accompanies a public trial. The purpose of interrupting the flow is to establish categories – of relevance or credibility, for example – which will in turn guarantee that the flow of truth concerning a particular set of events can be finally interrupted in the great cut of judgement. The further risk, with video recordings of trials, would be that the flow is not finally staunched, and the processes of evidence-giving and interpretation would go on for ever. As Aristotle wisely observed, 'a whole is that which has a beginning, a middle and an end', adding that 'An end ... is that which naturally follows something else either as a necessary or as a usual consequence, and is not in itself followed by something' (Aristotle, tr. Dorsch, 1965, p. 41). Yet we are aware of few things, outside the realms of fiction, that are truly not followed by something else, save only death, a finality which, mercifully, is no longer part of the legal repertoire in the United Kingdom. An ending, then, is both a fictive construct and an act of the discursive machine. The judgement that terminates a trial is the moment beyond which the legal system recognises no 'afterwards'. The flow is staunched. Yet that moment is precisely the moment at which the system dispenses justice: the

moment of power. Or, to put it just a little differently: power flows throughout the trial, in every direction, according to the channels constructed discursively for it; but the moment at which that power is localised and monodirectional is the moment at which the machine cuts off the flow. The exclusion of video is the insistence that there is no afterwards, no further debate or discussion: a moment of utter, though fictive, power. The legal system, like a good story, works because we believe in it. Video recording threatens to undermine the grounds of that belief by foregrounding the story-telling, narrational aspects of the law.

The point, then, of the discursive production of endings in the law is to abrogate to the law itself, as discourse, the totality of things to be said about a specific kind of event. Its authority derives from the ability to interrupt the productivity of language, to end the story, to stop the spread of rumour, misinformation, propaganda, legend: to call a halt. One of its major tools in doing so is to insist upon the pre-eminence of place in legal proceedings. Only in the sanctioned arena of the courtroom can justice be meted out, and stories concluded to the satisfaction of the law. This hallowing of specific ground for the enactment of justice allows different legal systems to be compared without, as they say, prejudice. The legal system of the United States allows video recordings of courtrooms: so be it. Since the systems are identifiable by their geographical validity, there is no important disturbance of either system caused by comparison with its opposite number. The geography of the nation state, which is in many ways the dominant geography of our world even in the era of transnational corporations, defines the limits of a judicial system, and elaborate protocols surround the ambiguous areas of wrong-doing that occur across or between borders. Again, video threatens such clear distinctions and common respect for each others' laws that help ensure the mutual ratification of legal systems. Video does shift across boundaries, demands interpretations of the ways in which justice is delivered, provokes questions as to the universality of the natural law which is said to underpin all actually existing systems and discourses. I am thinking, of course, of injustice, for though we rarely share, between individuals, let alone between cultures, a common sense of what is just, we do share a sense of some actions at least which appear to most people as fundamentally unfair. Indeed, we are experts at judging the professional foul in sport, or the malignancy of fate in the arrival of illness or the deaths

of the innocent. Yet even so, distance inures us to injustice, a distance crucially measured in national boundaries. For the boundary interrupts, as the judgement does, the extent to which we can participate in the processes of a particular discursive formation, and this is separate from the familiar elimination of compassion that arises in peoples of the industrialised world when confronted with the enormous injustices of famine and tyranny as they occur in the Third World.

Though speed in communication characterises relations in the First World, and affects us at fundamental levels, geopolitical distances become physical ones in other cultures: a fact learnt well by the government of apartheid in South Africa, whose homelands policy has instigated a judicial and political series of breaks, cuts and interruptions in the flow of power between peoples within its boundaries of a most radical and dangerous kind. In a work made in the late 1980s, Africa Word + Image address this issue critically in such a way as to reopen the issue of power as it relates to video.

Not that the work, *Mseleni Tales*, was actually originated on tape: this might stand as a simple instance of the interdependency of media in the contemporary scene. Shot on 16mm film, transferred to tape for broadcast, distributed on cassette (the format on which I viewed it, though it is also available on film), the work begins to proliferate, to take on new tasks as it leaves the site of production and becomes itself the pretext for new texts: teaching sessions, screenings, discussions, images and sound from which new sound and video texts are easily made. It is a text without closure (unlike the system of justice which governs the doings of its subjects). *Mseleni Tales* recounts stories and journeys, stories told on and of the long journey from the urban employment centres of South Africa to the Mseleni district in the north-east of the country. The stories recount and enact the resilience of traditional culture in the face of the massive disjuncture of urban and rural, White and Black, rich and poor, storing and developing the old tales, but also reinventing them and adding to the repertoire from the experience of a century of European encroachment. Unafraid of the benefits of education, medicine and transport, the stories are still powerfully aware of the inequalities of their distribution in South Africa.

At one point in the tape, we hear old men recounting, reframing, the experience of colonialism within the tale-telling culture: as one speaks, the others nod or grunt approval. You feel the protocols of

interruption, without necessarily understanding precisely how they work. You understand, watching in a house in England, the workings of popular memory in a foreign place, and the dignity which that requires and inspires in teller and auditor alike. Later we watch a woman telling a tale to the young children under the shade of a tree. They don't concentrate; they wander; they seem unsure of the purpose of the tale and of how they should respond to its telling. Refraining from commentary, the tape doesn't inform us as to whether this difference in reaction is a common and familiar thing among the people of Mseleni, or whether it is evidence of a cultural gap between generations brought on by the rigours of their exploitation and the blandishments of metropolitan media. Certainly what it suggests is that the tales need to be remade generation by generation, and that perhaps for this youngest generation the urgency of remaking is particular and startling. As the tape itself refuses the status of truth-bearer, of authority, of anthropological power over the people it describes, while observing the complexity and difficulty of 'traditional' societies, so we can learn something fundamental concerning the relations of video and power: power is not quite the *hyle* boasted of by Deleuze and Guattari. Truth and power are not natural flows, ideal and ceaseless cornucopias. Like the tales of the people of Mseleni, they must constantly be remade, even as they are constantly interrupted. If interruption is the constitutive moment of power, still that moment requires a prior one, in which the flow itself is produced. There is no natural, endless source of truth and power: each must be made and remade, by generations, almost by the hour, the minute, the 1/25th of a second it takes to scan an electronic image.

However, narration, the act of telling, isn't quite reducible to elements in the way traditional media theory can find the element of the moving picture in the single frame. The 'narrateme', the smallest unit of a narrative, is in any case a temporal entity, and to some extent narration can be understood, like music, as an organisation of time. In *Mseleni Tales* and in its subject, the question of power and truth can then be read as gravitating around the issue of temporal organisation. There are three time scales involved: the time of the film, a calibrated, scientific, as it were objective time of exposures and edits; the time of the tales, of their plots and of their telling; and the time of the journeys that take the workers to and from their communities in Mseleni. In the time of watching, these different

times are not reconciled or explained: their mere observation takes on its own particular gravity, a well into which three stones are dropped. Yet the viewing has too its own urgency, for in the clash of these three times, in the echoes they set reverberating, emerges the urgent question of history. Whatever is not natural – where there is no *hyle* or natural source of truth and power – there there is history. History has this double meaning for us: both the events recounted and the manner of their telling. Both senses are apposite to this clash of times retold. At stake again is the truth, with the added urgency of a political conjuncture in which a people cannot shirk the business of making their own history, with or without philosophical cogency.

In Woody Vasulka's 36-minute *Art of Memory* (1987), some of the Western twentieth century's most treasured icons of apocalypse and of progress work across one another in a complex net. An Icarus figure, whom I always read as the recording angel, becomes Benjamin's angel of history, the wind out of paradise caught in his wings so that he is blown backwards, while the ruins of history pile up higher and higher at his feet (cf. Benjamin 1969, pp. 257–8). The landscapes of Ford's westerns, birthplace of the white American myth of origin, become the site for a translation of Christo's Canyon Curtain into a complex of screens over which Vietnam, Stalingrad and Guernica scroll. A digitised Robert Oppenheimer, father of the atomic bomb, intones gravely the line from the *Bhagavad Gita*: 'Now I am become Death, the destroyer of worlds.' On to Monument Valley are mapped the images of the Nevada nuclear test sites. Images of Franco and Durrutti play under Hemingway's commentaries on the Spanish Civil War, the songs of the Condor Legion on the soundtrack, fasces traversing the West's sunset. Revolutions and Stakhanovite statuary appear ghostly in the landscape under banner upon banner made up from the photos of the great revolutionaries, many of them – Goldman, Sacco and Vanzetti, Gramsci, Luxemburg – assassinated or incarcerated. Atrocities, destruction and waste are mapped over against the impassive sky, the unmoving mountains, seemingly innocent of human crime, though the crimes of victims and perpetrators alike echo in their virtual distances. Vasulka in interview (*White Noise*, Illuminations/BBC2,1989) speaks of Cicero's mnemonic art, registering each topic as a pillar in a temple. Vasulka lodges each theatre of war in these mythic landscapes, until he closes with the dancer (Merce Cunningham?),

seeking flight from inside his closed box of monochrome light. Images, treated electronically, take on the shape of fantastic architectures, shifting in value from the utopias of science fiction to the triumphal arches and sarcophagi of tyrants and invaders.

The art of memory is not only the work of Mnemosyne, the historian's muse, spirit of the archive: the art of memory is also the art of forgetting. The logo of UFA, the German national film company that was to become a central part of Goebbels's propaganda machine, comes up after the titles, treated so that its elements are separated: on the one face of a die, the logo itself; within the die itself, the spinning globe over which the shadow of the logo is cast. In the cinema, it looks as if the light of the projector is casting the shadow: treated for video, it is as if some virtual light source is casting the shadow, as if there is something in the world responsible for that gloom. Or perhaps it is the globe itself which is gathering the darkness into shape, projecting its own darkness out into the solidified form of the UFA letters. Remembrance gives form and apportions blame, but it is as if that blame, that evil is complete already within the world, that it is a metaphysical evil merely waiting for some historical actor to walk into a part already written for him. This scene gives way – the screen splitting horizontally from the centre as if a great eyelid were opening within the image – to the furrowed frown of a sixteenth century sculpted head, archetype of the Renaissance man, the perfectible, if not the perfected; is it stern? Or worried? It is directed, in any case, towards the future which he faces with resolve or trepidation, as you care to interpret the bunched musculature around those piercing stone eyes. But the monuments of our century are of less durable stuff: the photographs and films that make up the bulk of Vasulka's visual quotations.

The UFA logo returns, but twisting in an invisible electric breeze, floating away into space, while the soundtrack runs through permutations on a Nuremburg rally. Distant and alone, the recording angel surveys the unstill images as they roll and tumble, ossify and divide, stretch, tumble, slither. An actor, a kind of Everyman, tosses stones at the angel to get his attention, then tries to take a snapshot, to seize the moment, in evidence perhaps, or to exercise some kind of power over the angel, to record the recorder. But the sky suddenly rains static, and a wing of images sweeps him to the ground. I want to say that for all their poetry and poignancy,

when we log experience on to film, we do not remember; in fact we forget, but it is the power of our new media to aid and abet forgetting that the tape struggles against, certain that it is more important, leaving the twentieth century, to look backwards than forwards. As sound and image are disassembled into their digital components, as the fearful inward glance of Oppenheimer replaces the fretful forward gaze of the Renaissance, there emerges a kind of ethical imperative: to search out the evil in order to remember it, when the power of evil is redoubled because we forget that it has occurred.

Faces have lost their names, protagonists in conflicts whose parties we have erased from memory, songs have been stripped of their symbolic potency, and voices of their power to impassion or command. The endless rollcall of the dead and the damned, victim and torturer scarcely discernible the one from the other in the embrace of imagery. The machinery of suffering – in which we must include the moving image – stretches out across the darkling land bent into the shape of highways always leading into vertical screens, like giant drive-ins, every journey ending in an image, every architecture built of pictures. In the final sequence, against land-scapes with water – clouds, snow, lakes and shorelines – that make the previous desolate scenes seem even drier than before, two archive performances that might be Merce Cunningham and Lenny Bruce enact the absurd enormities of both remembering and not remembering. The sun is in the angel's wings, and for a moment he seems closer, but at last a strange, half-stone and half-organic thing spins slowly down another canyon as the copyright sign and the acknowledgements to funding agencies roll up. It is the colour of black and white photographs, the colour of bone.

Since it is a recording medium, video is also a medium for erasing. Perhaps what we notice and recall, what we witness, is the appearance of disappearance, the oxymoron that is relished in *Art of Memory,* where what is erased has nonetheless its part in the story, along with the act, the active process, of forgetting. Magnetic recording, thus would represent the possibility, likelihood, even the probability that what is recorded will not remain. In the achieve-ment of economy, we have lost the permanence of the form cut into stone, the monument: in the architecture of light, like the pillars Albert Speer erected out of searchlight beams for the Zeppelin Field at Nuremburg, the greatest virtue of high technology is the economy

of means. It is too feeble a signal to maintain itself for long; archives fade into the radio snow of universal magnetic fields. And in the nuclear flash, the first thing that will disappear, not under erasure but with its authors, are magnetic memories. Is video the Alzheimer's Disease of the West, the disorder of the synapses that produces a meticulous derangement of the senses? In the senility of European culture, is there a risk of canonising a beatific, Rimbaudian dissolution of memory, building instead the art of the present moment, as it is so frequently celebrated in pop songs? Do we know, as the senile know, that we are forgetting?

Wittgenstein closes the *Tractatus*: 'My propositions serve as elucidations in the following way: anyone who understands me eventually recognises them as nonsensical, when he has used them – as steps – to climb up beyond them. (He must, so to speak, throw away the ladder after he has climbed up it.)' (Wittgenstein 1961, p. 74). With such a procedure, we turn forgetting as a function into forgetting as an art. The hermetic secret of Vasulka's art of memory is that it is the same as the art of forgetting: memory is the ladder that must be thrown away after it has been climbed. For the *Art of Memory*, the ladder's steps remain both present and not present, necessary to an understanding of why and how we came to be where, now, we are; but, with their distortions and reduplications, contingent too. The fading noise of marching songs speaks to us both of the necessity of marching and of its wilful randomness. All soldiers, if we are to believe their songs, their speeches and poems, find the justification of their actions in a future that will remember them, but the dreadful secret that is kept from them is that, barring a generalised nostalgia, their memories do not outlive their comrades who were spared to march to cenotaphs, anonymously.

If Vasulka's tape has a problem, it is in the ease with which it organises its sections about the Second World War as if the Russian Revolution and the Spanish Civil War were of a kind in establishing the grounds on which it would be undertaken. Though I understand why a Czech who moved to the USA in 1965 at the age of 28 would read the year 1917 as the birth not of socialist hope, but of Stalinist despair, still the differences between the two wars are as important as their similarities, and the military suppression of the Spanish people teaches, if it can, a different lesson from the hijacking of the Russian. It would be too easy to read off from the tape a message about all wars being acts of tyranny, all tyrants being the same, and

'dictatorship' a political term that elides all differences between state capitalism and corporate fascism in the interests of democratic pluralism and transnational capital. In the *White Noise* interview, Vasulka speaks of the evil that characterises the modern world as a metaphysical quality. It is too easy to read that metaphysical evil as the mass politics of the mid-century.

What saves the work from the fate of truism is the skill with which he insists on the materiality of his medium, without making that opacity a goal or a binding limitation. As in some of Léger's late canvases, he makes the colour strain against the design, linking the unlikely, differentiating between the similar, intimating another order, another mnemonic, beyond the chronological catalogue or the monuments of power. These curtains and banners of library footage have an ideal role: to let another light shine through their interstices, another way of looking at the world that does not yet exist. This is a praxis of erasure, tremulous counterpoint between the vanishing of the past and the becoming of the future. A past that is both here and not here, there and not there, passively vanishing and actively being forgotten, but always held in that process of vanishing and forgetting, 'present' to us as a fading away, whose very fading is constitutive of what we now can do or become.

In the theories of power associated with Michel Foucault, the problem to which the theory constantly returns concerns the possibility of resistance. Foucault himself is criticised (Dews 1987; Habermas 1987) for failing to account for the existence of that resistant behaviour to which, in any case, he lent his lifelong political support. But if the inference I am arguing from the practices discussed in this chapter is correct, then resistance is a product of the exercise of power itself, or rather of the internal contradictions of the exercise of power. One of Foucault's great insights is that power is not only exercised through mediating discourses and institutions, but that it is actually constituted in them. Yet power's constitutive media are themselves unstable, perhaps more so now they are so entirely enmeshed in the commodity form (the bit of information in calibrated time). Foucault argues that 'It is because contradiction is always anterior to the discourse, and because it can never therefore entirely escape it, that discourse changes, undergoes transformation, and escapes of itself from its own continuity. Contradiction, then, functions throughout discourse, as the principle of its historicity' (Foucault 1972, p. 151). But the upshot of this

chapter is that contradiction is not anterior to but enmeshed in the procedures of discourse, be they the discourses of law or story-telling or history, by the very fact that all discourse is already mediated. So, while accepting Foucault's subsequent principle that contradiction is the principle of the internal dynamic of discourse, we can add that it is also the principle on which the holes in discourse, the divorce of any one discourse from another or from an interlocutor's experience, the trailing edge where dogma no longer applies, all become apparent.

Vasulka's tape allows us to rethink the ways in which video can address its audiences through challenge to the structuring of memory. Legal discourse privileges the eye witness, and bases its construction of truth upon the presence of the witness to the event. But in the case of Rodney King, the defence had to argue that the event wasn't really like the tape of it. And audiences reacted with serious differences of opinion. In the United Powers public house in Liverpool, a broadcast that showed the tape three times over, along with legal and expert arguments over its validity, led to an hour or more's discussion of what amounted to a practical aesthetics of video, including forceful comparisons between it and the reconstruc-tions of crimes on the police phone-in programme *Crimewatch*. The consensus was that amateur video was less likely to be phoney than professional, especially when there was no issue of identifying the protagonists on the evidence of the tape. On the other hand, some argued that the use of domestic video in Kuwait to provide false evidence of Iraqi atrocities showed that you couldn't trust even grainy VHS images. In retrospect, the difference between the two tapes, the Los Angeles beating and the Kuwait hospital, was that the latter was by far the more coherent, its coherence, paradoxically, marked by its use of in-camera edits: manifest technique.

The King tape gains in credibility, like the Zapruder film of the Kennedy assassination, from its handheld tremble, its lack of edits, and, even more paradoxically, because it is quite difficult to discern the action as it is replayed. Vasulka seems to work against this kind of credibility, and to bring it to the point of crisis, by his flamboyant technical bravura and by the very clarity of the archive images. Such clarity can only be, we cynically discern, the property of a staged or restaged event. Clarity and certainty may be a criterion for truth, but it is truth itself that the audience fail to believe in television, especially after their immersion in video culture. It is to Vasulka's

credit that he can deploy this uncertainty without making it the central function of the tape: we look to the moving image to tell us what we really saw – for example in a sports arena display – but we recognise that the record is never the same as the event. If such micro-memories are in question, how much more deeply so are the constructions of the great European dictatorships? Coherence, too, is part of the discourse of truth, and both make us suspicious.

Political video, operating on the principle of correctness, does not need to strain for coherence (in fact it should avoid it) since that would imply an ending, the absence of a future. But the dominant discourses of law and history, miming their own coherence, enact their inconsistency, and the more they seek to shore up their truth with evidence, the more that evidence becomes permeable, friable, malleable. One telling of a story may be cogent: seen in the context of multiple retellings, its partiality becomes more than a motor for improved discursive performance; it becomes the ground on which whole discourses are, historically, pulled down. It is as if faults and fracture lines were a constitutive part of crystalline structure: in the very instant in which they are formed, the crystals of discursive truth are ready for shattering.

9

The Monk and the Maenad: Science, Dialectics and the Video Apparatus

There comes a time in which discourse makes itself felt in history, in the real. We live in such a time, when the regimes of power touched on in the previous chapter, and others like them dedicated to the pursuit of truth, begin to enforce their discursive presence (the word is deliberately chosen) on the web and the weft of the world. If a single discourse has become hegemonic in the 1980s, it is the discourse of management. As that discourse is beginning to feel its way into its new found supremacy, it is entrenching itself, not just among people and their institutions, but in the very machines through which it will make its wishes known. Few texts have made this so apparent in the last few years as the special issue of *Scientific American*, volume 265, number 3, September 1991, entitled *Communications, Computers and Networks: How to Work, Play and Thrive in Cyberspace*. How influential this publication may be, or how symptomatic I know not. But it sold out in my home town within days of arriving, an unusual occurrence in Liverpool.

By and large, articles address the exponential development of computer power and computer networks within and between corporate entities. Several note that a major impact of networks has been to loosen hierarchical structures, and to enforce a movement of decision-making to lower echelons in management. Many articles speak of the competitive edge gained by corporations adapting to the new communicative possibilities of computer technologies. Rare indeed are the mentions of any other possibilities save only in the domain of privacy and, closely linked with

it, the domain of the hacker, the subject of two essays in a short section on policy. More typical are articles concerning the infra-structural needs of the developing information economy (including one by Senator Al Gore), arguing with technical delight about the possibilities of a global information gridlock, and about the hard and soft solutions that might be necessary or possible. Other articles, fired with a visionary zeal that is quite captivating, argue that the computer is too visible as a medium; designers need to embed computers into the human environment so that they become as invisible as print or photography, constantly there, constantly used, but never experienced as a difficult or frustrating bridge between message and meaning. Several pieces argue the need for a reformu-lation of managerial attitudes in the evolving workplace, where computer-enhanced communications are seen as providing the impetus for a shift from hierarchical to *ad hoc* management structures. As a magazine with a major sales base in the executive sector, it is unsurprising that several articles end with calls to management to avail themselves of the opportunities presented. The address throughout is to decision-makers, whether the calls be to altruism or to self-interest, enlightened or otherwise.

In one of the most telling papers, Nicholas P. Negroponte lambasts facsimile technology as wasteful and limiting, arguing that electronic nets are better used transmitting more compact and usable computer information than photographic representations of text. He concludes:

> The fax, a dumb terminal par excellence, perfectly represents the services that result when we do not focus on the intelligence of the network and its ends but instead rely on the lowest common denominator of transceiver. Making such mistakes grossly limits the quality and originality of the products and services that can later arise. Let us not make them again with broadband networks: networks present real opportunities for liberating us that are much too enticing to forfeit. (Negroponte in *Scientific American*, 1991, p. 83)

In this brief paragraph, Negroponte has encapsulated some of the most important issues in contemporary video media. On the one hand, there is the question of the 'intelligence' of the network, that profound belief in the autonomous development of technologies

which we analysed in Chapter 5, yet at the same time there is an awareness that human decision-making has a major role to play in that evolution. He observes a common phenomenon in the growth of new media: the devolution of a system towards the cheapest option; the one which also most closely reduplicates the familiar devices of the previously dominant media – in this case print, photocopying and telephony – and which does so by arguing its user-friendliness. This is so like the rise to dominance of the VHS format (and the virtual elimination of D-MAC more recently) that the parallels must be more than fortuitous. There exists a power in the world which consistently fails to lead us towards the most flexible and adaptable systems of technology, which consistently downgrades our expectations of a new medium and which, far from evidencing progress, demonstrates a reluctance to strive for the best. Instead, this mysterious force races to market with the minimum necessary to attract a buyer, and actively seeks to swamp the marketplace in the effort to ensure that no new rival has a chance of developing a better technology. It will come as no surprise then that this force, which Negroponte is unable to name, is not a mysterious cabal of necromancers, or even a misinformed class of decision-makers, but capital itself.

Since, in the pages of *Scientific American*, he is in no position to offer a critique of capital, Negroponte is unable either to analyse this facet of the impoverished design of electronic nets, or to propose a genuinely alternative route towards that liberation which he quite rightly sees as a potential within new media. As is clear from most of the other essays in the issue, 'the machine is a means for producing surplus-value' (Marx 1976, p. 492). There is little interest in lightening the burden of toil on the average worker through the inventions with which we are so familiar: their purpose is to increase productivity, the rate of production of surplus value. The computerised supermarket check-out is not there to ease the mental labour of counting, but to remove that skill from the old white-collar retail worker; to increase the throughput of transactions; to manage, without expensive human skills, ordering and stock-taking; and to monitor the accuracy and speed with which the worker produces income for the company. If this has removed some of the tedium of driving an old cash register, it has only been at the expense of the older skills of talking to people that have had to be reinvented, in the crushingly banal discourse of managerialism, as

'customer services' and 'personal skills'. In another article, a cheerful caption tells us that the computer-networked 'back room' of Rosenbluth Travel enables 'connected firms to respond to the market more effectively and profitably than can isolated agencies' (*Scientific American*, 1991, p. 94). The accompanying photograph shows row on row of terminals, for all the world like the Dickensian counting houses of the late nineteenth century, each worker isolated from her neighbour by baffles and headphones, and all but one of the discernible faces is female. This is the distressing reality of the wired-up world: the function of these technologies, historically, is not to liberate but to enslave us.

This is why Negroponte's call to arms rings so hollow: there is no 'we' for whom his cry rings true. Either 'we' are beneficiaries of the system, and see no need to change it, or 'we' are not, and feel ourselves incapable of making it change. Of course, there is the possibility of an enlightened reader with corporate clout demanding the 'quality and originality' Negroponte promises, but it will always be within the framework of profit. There is, however, another readership for this kind of publication: the computer buff. The hacker has a place in this culture as a mythic figure, but also a position as saboteur. Even if hacking is simply made up of playing games on company time and company machines, there is a kind of tactical refusal to knuckle down. The network, though, seems to offer a way of making even this a part of the management culture, as Sproull and Kiesler demonstrate in the same issue (pp. 84–91). The conversational appeal of E-mail can be harnessed to emerging management philosophies of devolved decision-making (leaving management to decide 'where to draw the line on access'), and though the authors can speak of democratic organisations, they are quite clear that 'it is up to management to make and shape the connections' along which that democracy will function, so harnessing precisely the creativity which Negroponte yearns for to the goals of transnational capital.

The points raised in this issue – and there are many more – induce a series of questions concerning the emergence of video media. Differences between home and workplace seem likely to diminish further, as they already have for senior executives and others who keep an electronic office at home, or carry lap-tops and cellnet phones from place to place. If that means that the day of the corporate headquarters is over, so be it. If it means a downturn in

use of the commuter car, all to the good, and if it allows more carers to take up employment, tremendous. But quite apart from the further dereliction of the inner cities that that would entail, quite apart from the increasing efficiency of the extraction of surplus-value, quite apart from the threats to workplace organisation and socialisation, what of the intensification of pressures on home-workers to eliminate the spaces between work, leisure and domestic duties? Video media are not simply either informational or recreational, leisure or work oriented; they partake of both forms.

There is a tremendous utopianism about proselytes for electronic media, one that comes as readily off the pages of *Scientific American* as it does those of *Science as Culture* or *Ten:8*. Undoubtedly, the enormous potential of such media is for a new mode of democracy, one intimated by the networks in which research, games and gossip are exchanged on a global scale already. But since these media are very precisely designed with profit maximisation in mind, their design is itself a matter of concern. Whatever the technology in general is capable of, in the particular, in the instances which we have to hand, those capacities are being framed, contained and limited by decisions that have nothing to do with any production of the future. They are to do with the maintenance of the status quo, or rather with the extension of the status quo. Marx's central argument in the chapter on machinery and large-scale industry in *Capital* is that a crisis emerges when the development of the mode of production outstrips the limitations placed on it by the means of communication and transport (Marx 1976, p. 506). We might want to argue that the obverse is also true: that when the means of communication outstrip the constraints of the society in which it has evolved, we again reach crisis. The purpose of much computer design is to minimise this risk; rumours even circulate that the computer viruses which dog the networks have been deliberately placed there to hamper the free flow of information and ideas. My contention here is that the video media are likewise tending towards a state in which opportunities are being closed down as rapidly as they are being opened; and that the evolution of the new form is hampered, perhaps permanently, by hardware and software design solutions, or rather the problematics which give birth to them. In the context of video media the work of computer artists becomes particularly important, because it is to them that we must look to

indicate the contradictions between the capabilities of the systems they use and the constraints that are placed on them.

William Latham's work uses algorithms to generate virtual objects in virtual space, usually shown as three-dimensional quasi-organic forms hanging in empty blackness. Work shown in 1991 uses a small video wall, and specially-composed music also using some mathematical principles in its composition. Latham's work has generated some controversy, much of it of a banality so complete that it deserves attention here. The most familiar question to arise, as has been the case with electronic media since the 1960s (if not before) is 'Is it art?' This, of course, is at the heart of Latham's practice, for the felt need to ask the question at all is part of the fundamental dialectical history we are beginning to trace: that in which art and science are estranged from one another in an initially emancipatory gesture which, however, returns historically as a fundamental problem in the relations between the two, just as it impacts on the development of each.

In one way at least, the question is easily answered: Latham's work appears in galleries and is available for sale in the form of Cibachrome prints and video tapes. As such, it partakes of the art world's mode of circulation and distribution, and so it is art. On the other hand, Latham's card describes him as a computer artist, and gives his address as IBM United Kingdom Laboratories Limited. Working in the laboratories of the world's largest computer company (indeed one of the largest corporate transnationals) makes him not merely a scientist but, more specifically, places his work within the movement of positive science towards an instrumental role. However radically intended, art and science alike, so defined, are indubitably and equally implicated in the reproductive cycle of monopoly capitalism. Latham's own apolitical presentation of his work reinforces this sense that, while it may be art, these pieces are modernist in neither of the artistic senses explored in this book. Perhaps they might be understood as practical explorations of the capacity of his computer laboratory to generate complex and colourful shapes, suitable, perhaps, for general entertainment purposes such as laser-discos. The implication, in other words, of the question 'Is it art?' is that it is not art, where art is considered as a term endowing the objects or practices described with a particular value.

The second banal observation is that these virtual objects are ugly, monotonous, moving wallpaper. Once again, this is a judgement based on values that relate in more interesting ways than is first apparent to the problematic relationship between art and science. Beauty ceased to be an active, essential ingredient in art practice and criticism in the processes of development of the Duchamp legacy, and we would not expect a reviewer, let alone an art historian, to reject the work of current heroes like Anselm Kieffer or George Baselitz on the grounds that it is not beautiful. On the other hand, the word and even the concept of beauty have become increasingly familiar in scientific and popularising texts, where for example one of the qualities of the quark, along with charm and strangeness, is beauty (a complex mathematical descriptor of its behaviour) and where the beauty or elegance of mathematical argumentation is frequently remarked upon.

Unusually, Latham is actually working with at least one of these 'elegant' figures of mathematics, the fractal geometry now most regularly associated with the ubiquitous Mandelbrot set, one of which graces the screen of the machine on which this book is being composed if I leave the keyboard untouched for too long. Fractals elicit gasps of admiration even from non-scientists. The elegance, which they express in graphic form, of the mathematics of undecidability evokes both the wonders of the organic world, especially of morphogenesis and growth, and the lure of chaos theory as that has been taken up in New Age trends of the late 1980s and early 1990s. In the graphic geometries of phase space and n-dimensional spaces, New Age seekers after wisdom find the appearance of a synthesis of art and science, of abstruse and popular culture, of the eternal and the present. Surely, then, it is not too much to ask that they look too for the less simply charming products of such processes, and be ready to accept that the viscera too are organic creations too, though less to our taste than flowers and snowflakes?

The lure of beauty, though, is strong. There is so little of it and, however cynical, we prize it above everything except sheer survival and immediate need. A great deal of the modernist endeavour was premised on the refusal of beauty and aestheticism: on uncovering the ideological oppression operated under the guise of prettiness (William Carlos Williams wrote of 'the fascist stomp of the pentameter', Laura Mulvey of the need to destroy beauty if women were to be freed from an oppressive visual regime). Has the time

come to return to good, old-fashioned values like beauty? Is that the mission of the new computer arts? Can the synthetic production of graphics based on the algebra of growth return us to a synthesis of the old opposites of science and art, mechanical and organic? The computer, after all, is a popular medium, never more so than when deploying graphics for games or flying logos: surely no instrument is better for transcending the divisions between high art and popular culture? We would be rash to dismiss the claim out of hand. First, however, we will need to look, albeit briefly, at the notion of beauty again. What is it that we might find beautiful in Latham's works, for example?

I would suggest that the answer would have to begin with their mobile symmetries. Something pleases us in order and its variations in these virtual objects, something concerning their ability to centre our attention on wholeness and ordered alteration. When they are described as 'organic', there is a tone of approbation in the term, deriving from an aesthetics of the organic unity of the work of art propounded in Romantic criticism (and usually there placed in opposition to the merely mechanical addition of parts). This sense of organic is a central term in the Romantic critical lexicon largely because it can be placed in opposition to the mechanisation of the Industrial Revolution. Organic, then, in this sense refers less to the biology of organisms than to an idealised, validating touchstone of criticism in its dogmatic mode, an organicism associated with wholeness and order assimilated to an overarching concept of Nature as that great Good from which we have become alienated. Latham's work is beautiful in this sense, then, only if it has in some way authentically re-presented to us the founding unity of humans and Nature. It would be possible to argue that he has achieved this, and in three senses: first, the virtual objects seem to demonstrate patterns of growth and change that we associate with natural processes; second, they exist within machines, so demonstrating and acting out a reunion of the alienated terms of the organic/mechanical dichotomy, and finally, because they raise to the status of beauty even those elements of nature which, traditionally, we find ugly, such as the internal organs of large beasts, or the larvae of smaller ones. In the virtual world made possible by the electronic arts, the veil of unreality allows us an unalloyed enjoyment of those elements of the organic world that might otherwise disgust us: beauty, in the New Age, assimilates even the repulsive into its

synthetic embrace. The 'beauty' of this work therefore emerges from its ability to overcome the dialectical oppositions of organic and mechanical, natural and artificial, art and science.

Such an account of Latham's work restores it to the cultural domain at least, if not to the artistic one as that has evolved in the twentieth century. From the point of view of both science and art, as two opposing poles, it is something new: something that emerges from each and moves towards a synthesis in which their opposition might be ended. But it can also be argued that this is precisely the weakness of the work for, in our urgent, emotional and intellectual need for beauty, for an end to these splits and contradictions in our culture, we are only too ready to leap prematurely at the first potential solution to come along. I want to argue here that such a response to Latham's virtual sculptures, while of a more interesting order than the simplistic ones that have characterised its reception to date, is itself characteristic of an emerging set of discourses clustered around the idea of a New Age, and that that set is typically sentimental, wilfully ignorant and ultimately destructive unless it proves itself capable of developing its own negation.

The need for beauty is a real one. It emerges from the complex interplay of subjectivity and history, as the internal dynamics of the fragmented subject work through the material of a fragmented and dynamic social situation. On the one hand, we respond to change and process with delight, revelling in contradiction and tension, finding profundity in the irreconcilable conflicts of individuality and society, the fullness of living and the proximity of mortality, just as we find them in the interplay of light and dark, sound and silence. But on the other, there is a yearning for quiet, for respite, a final shelter from the storm of living: this Freud refers to as the death instinct or the Nirvana principle, identifying it with physical processes of entropy and stasis, of the tendency of all physical systems towards a state of rest. Such, I would suggest, is the goal of our simple contemporary yearning for beauty; it is associated with symmetry and order because that is a good approximation to stasis and rest (though maintaining enough activity to remind us that it is best understood as a response to the difficulties and complexities of living). So two actively 'aesthetic' emotions coincide in the human heart, the one rejoicing in conflict and flux, the other seeking symmetry and calm. Elsewhere (Cubitt 1988, 1991) I have tried to argue that these two are differing faces of the same coin: desire leads

us into the maelstrom, while anxiety tends to seek safe haven, the former centring on the ever-absent object of desire, the latter on the losses experienced in every prior attempt to reach it. There would be no need to concern ourselves with the relative merits of these activities or their relationships with one another if we were only individuals: the roads of the Maenad and the monk would not be contradictory if they never met. But of course they do meet in the social interaction which is constitutive of humanity, and therefore in the internal dynamics of each individual psyche.

In Latham's work, then, we are offered yet another mode of synthesis: one in which the attractions of the unstill are combined with the sense of order. These objects maintain their symmetries while evolving, and so they gratify our desire for change while assuaging our anxieties about loss and disorder. The very replicability of the virtual objects, their existence as electronically-stored programmes, allows us to believe in their permanence, even as we revel in their movement and change. So they speak not only to the dialectic of art and science, but to a more personal sense of the reconcilability of desire and anxiety, freedom and rule. And because they are virtual objects, they attain to a conjunction of permanence and presence to which real objects cannot. Entirely dependent on the machines that are needed to create and play back their construction, they yet assume a kind of autonomy from their carrier media, one largely based in their mathematical genesis. We assume the permanence of the language of mathematics as system (the mathematical *langue*) as we assume its full presence in the enunciation of these forms (*parole*). This full panoply of mathematical underpinnings forms part of the 1991 displays, in which elements of the written programme are screened along with the virtual objects, encouraging the viewer to recognise the immanent algorithms within the present sculptures. Yet another reconciliation is effected here between the eternal verities and the actual devices they produce, just at that historical moment at which the adequacy of mathematics to physical processes is being questioned. The ultimate rationality of classical maths and the strangeness of the physical world come, again, to synthesis.

The final synthesis proposed by Latham's virtual sculptures is the greatest of them all: the overcoming of the opposition between subject and object. The suggestion that is hard to ignore is that in this thoroughly mediated technology of production, subjectivity

itself, the artist's subjectivity, is assimilated into the machine in the form of the programme. Here at last is a world in which the will can be perfected as the instrument of creation, a world in which mind and matter meet not as opposites, but as partners in the business of creation. Where the histories of art and science have shared a preoccupation with moulding materials to the human will, with the resistance of matter to the intentions of the mind, here they come to fruition in a world that can be made with the lineaments of the mind. We do not need to rage against the recalcitrance of nature when nature itself can be remade in the form of the mind, and the intellect in the forms of nature. The obstinacy of reality is overcome, as is the recalcitrance of the mind, in the generosity, the sharing, the resolution of conflict in hyperreality.

This resolution of the dialectics of the modern in Latham's sculptures – the drawing together of art and science, subject and object, mechanism and nature – produces such banal criticism because it has removed the need for critique. There is no further place for criticism in this hyperreal domain in which all oppositions are annealed. Neither dogma nor theory are necessary in a space in which both come to their logical conclusions. Theory's anti-foundationalism is completely justified in a world in which any foundation can be laid and its processes explored equally with any other. Dogmatic concerns over the demand for utopia are healed in the presentation of just such a utopia as indeed present, here and now. Latham is, in this perspective, quite right to present his work apolitically, for it represents an abnegation of politics if that is understood as the art not of the possible, but of opposition, criticism and negativity. Taken on its own terms, the work sits at the further end of criticism and of politics, assimilating the motives for their existence into the hyperreal synthesis, a truly synthetic art.

But.

Taken on its own terms, the 1991 work begins to destabilise its own formal symmetries through the emergence, with the addition of sound and of sculptural space in the use of the video wall, of the virtual into the real. When we are lulled to rest by the calming of all opposites, into the porches of our ears sound pours its leprous distilments: that sense which cannot be separated from the physical motions of the material world allows in the poison of doubt. In taking on music, Latham's work immediately inhabits a soundscape, a space defined by physical proximity unnecessary to the experience

of visual virtuality. Looking into a monitor to see these shapes metamorphose in harmonious symmetries, we can believe that the objects exist independent of the monitor: that the programme will run on another VDU, perhaps is doing so simultaneously, and that the programme will run independently of our knowing that it is running, or of our being able to perceive its graphic expression. But sound, that physical vibration of the air, requires that there be a source and a listener, and in that physical separation of subject and object mediated through the moving air, the original sin of dialectical relations re-enters the pristine world of the virtual. And at the same time as we become aware of the gallery space as an aural landscape, we notice the gallery installation. The large Cibachromes are now not objects in their own right but arrested moments from the evolution of forms (The Evolution of Form) that play in what, anchored in sound, becomes real time on the video wall. Simultaneously, the video-wall becomes the focus of a sculptural or architectural construction of the gallery, taking on, in addition to the internal space of the monitor, the real space of a room off Piccadilly on a real November afternoon. In short, the act of installation makes us aware, in sound and space, of the way that these images are images, events taking place in a material world, in history. This has a twin effect: on the one hand, the virtual objects take on, again, the mantle of reality, of real events in a social space; while, on the other, they reopen themselves to criticism.

Close by, the Ritz Hotel. Five minutes' stroll away in one direction, the Arts Council of Great Britain; in the other, Tower Records. A lunchtime walk from the Connaught Brown Gallery, the centres of British broadcasting. This sort of space comes very expensive in London, even in recession; the space taken up here can be measured in square footage and business rates, the equations of space and time marked in capitalism as rent and taxes. If before we were entertained by the escape into virtual space, the installation of a video wall makes us newly aware of the material infrastructure of display, the ways in which even algorithms are not innocent of the business of the world. At the same time, though, we should be aware of the occupation of space by a show whose goals are almost entirely defined by the aesthetic and/or pure science. A show whose spatial repertoire, while real enough, has also that dual role of presenting an entirely mathematic, virtual alternative to the countable, accountable space of capital. That dual occupancy of space, oscillating

between the cost-effective and the innocent, is itself a dialectical and critical one, regardless – or indeed as a result – of the refusal of these virtual objects to say anything actual about the real world. Their mere existence as inhabitants of this history and of their own makes their internal perfections an immanent critique of external imperfection. What's more, this unstable relation of the virtual objects to the infrastructures of their presentation gives back to them the instability on which any further evolution must be premised: there is, after all, somewhere else for Latham to go which is not condemned to the silent absorption and negation of history.

If the work itself becomes critical of the world as it is, and if it also opens up its self-enclosure to the instabilities on which future growth can be premised, then it opens itself up to criticism, criticism which (one hopes) will only help the work to unfold further the dynamic possiblities of the interplay between the virtual and the real. Such a criticism might then unfold along two lines: the one engaging the formal properties of the installation as sculpture, playing through the dimensionalities of the virtual, the sculptural, the sonorous and the temporal; and the other engaging the interplay of that whole relation with the historical situation in which it takes place and time. The second line of enquiry I want to leave to the next chapter. But the formal concerns which we have learnt to interpret from the Duchamp–Beuys–Warhol legacy lead us directly into the heart of Latham's practice since it presents itself as, and is perceived, debated and reviewed in terms of, its standing as a computer practice. The importance of Latham's work to IBM is akin to the work of the Media Lab at MIT and the Pixar studios of John Lasseter in the United States as a research tool into the relations between computers and creativity, a hot business issue as we have seen. At the same time, these practices raise questions concerning the emergent apparatus of electronic imaging. If I am correct in arguing that computer graphics are to be at the centre of corporate developments in multimedia, then we need to recognise the detailed shapes that these graphics functions are taking.

The advance of apparatus theory over most technological determinisms derives from its ability to raise the question of whether the technological arrangement of video discourses and institutions can be said to have some ideological or epistemological effects prior to or in addition to the historical specificity of the moment of viewing. Asked in these terms, the question retains a

sense of the materiality of viewing, of the unique coordinates of each individual moment of interpretation, while still requiring an understanding of what there might be that could be common to all such acts within a given cultural formation. Crucially, since these are days of rapid change at both state-of-the-art and Western consumer levels of video viewing practice, can it be argued that technological developments are in some way in pursuit of a new kind of subjectivity – perhaps of the kind suggested in the analysis of Latham's work – by trying to keep up with an emerging New Age 'personality', or actively producing it, or creating the possibility of its existence? Is there, in other words, some element of common historical experience on which each fragmented act of viewing is premised? Is there a history of the viewing process in general? And do the formal shifts represented by Latham's single-monitor and installation pieces represent something new in that history?

Can an analysis of the social organisation of spectatorship in the Connaught Brown Gallery give us an insight into historical shifts in the organisation of video as an apparatus? Video, we have already argued, is not a single mode of practice, yet it is possible to consider it as a field in which TV flow is dominant, as I argued in the previous chapter. If we take these increasingly rare 'pure' examples of television, then we do find some examples of practices more common there than in photographic media. For example, the traditional overlighting of video shoots leads to a flattening of the image unusual in film outside the domain of cell animation or of Greenbergian avant-garde work. This flattening gives a sense of the picture plane on TV as a common and recognisable quality of the medium, a quality which has been the subject of a great deal of experimentation since the early works of David Hall in the UK or Bruce Nauman in the USA, and which has had an impact on the look of films like *TRON* (Steven Lisberger, 1982, US) and *Prospero's Books* (Peter Greenaway, 1991, UK).

However, it is also part of the argument of this book that there exist challengers to broadcast television's discursive hegemony, and that they are themselves in states of internal reorganisation. The issues of the management of change raise questions concerning the formal organisation of Latham's – and indeed of any future – videographic work (defined simply as imagery not primarily produced using lenses). Metz's arguments concerning the limitation on options and the self-reproducing tendencies of media technolo-

gies raise again the question of management, the instrumentalisation not only of human reason but of machine intelligence, if such a thing exists, as well. If, then, we interrogate current practice for an emergent hegemony (currently only growing into the power that it wishes to inherit) in videographics, we will find that some practices remain marginalised, while some are already assuming a currency that looks like an insidious orthodoxy.

Latham's work shares with other influential current work the use of the polar coordinate system, which replaces the Cartesian x, y and z axes of three-dimensional geometry with a combination of distances and angles measured from a point of origin. As a system, it is a usefully simple one, responding better to intuitive grasp of space than the Cartesian. This system, though, tends to be used in conjunction with a concept of the virtual camera, a single point from whose perspective the events of polar space can be displayed. Again the system responds well to intuitive understandings of three-dimensional space. This is the space and the perspectival system adopted by, for example, most of the more sophisticated games graphics, by NASA and European mask-and-glove virtual reality kits (slightly modified to emulate stereoscopy), by Lasseter's well-known narrative animations such as *Luxo Jnr*. (1986), *Tin Toy* (1988) and *Knick Knack* (1991), by the widely-admired showreels of the Moving Picture Company, one of the UK's major facilities houses, or by music videos such as Don Searll's *Killer* for Seal (discussed in Chapter 7). It is, in addition, the standard system for computing the familiar flying logos of a hundred TV generics and advertisements, as well as electronically-generated still images from Tokyo to Tucson. My initial problem is with the predominance of the intuitive in the making and marketing of user-friendly videographic systems. While not wishing to deprive as many people as possible of access to the new media, the central role of a replication of existing spatial orientation seems to baffle the one thing that these media perform so much more readily than their photographic forebears: the manipulation not of objects but of space itself. Too many options are foreclosed when we decide to disseminate only the centuries-old single-point 'monocular' perspective system, to build only that into the systems from which we learn the possibilities of virtuality.

'Intuition' doubles as a mode of the natural in English, and it is this sense of the naturalness, the givenness of this system of

visualisation that most powerfully masks its ideological construction. One of the central attributes of the monocular system is to lend its represented world a kind of coherence. It is notable that Latham has recently begun to use edits in his work. The relative paucity of edits is characteristic of the monocular perspective system, except where there is a transition between videographic and photographic images. Even then, the tendency is to use fanciful effects such as flips, rolls, tumbles, flying fragments or lap dissolves. Other, related, processes are the subject of major investment of technological and human resources. Crucial among these are anti-raster (which removes the jagged lines characteristic of diagonals drawn on low-resolution screens), rendering (increasingly sophisticated libraries of surface textures and programmable light-sources are available) and cushioning (accelerating and decelerating objects at the beginnings and ends of motions; the 'soft object' is the Holy Grail of videographic animators). The predominance of such technophile solutions to perceived technical problems typifies a search not so much for perfection as for completion, for the self-enclosure of these virtual worlds. These surfaces are surely sexually and libidinally charged. Certainly the iconography is sexual. The imitation of a tactile world within a universe that is increasingly coded in its visual vocabulary as unified and coherent: this is the core of the historic shift that is on offer in the emergence of videographics and virtual reality. We need to go on to explore what this might mean in terms of subjectivity.

Before leaving close reading of Latham's work for a broader consideration of contemporary practice, it needs to be said that, again, *The Evolution of Form* as an installation undercuts the very processes of subjectivity which it so powerfully engages. For there remains a sense of the alien in Latham's world, deriving from his use of spots and scales, coils and shine. This unified, cosseting world on offer, while it lures us with what I would argue is a conspicuously sensual appeal to the longing for infantile fulfilment, nonetheless also calls up a sense of infantile revulsion. The magic of virtuality is that it is so whole, so entire, so full, so coherent; that it unifies the viewer with the world of plenitude from which we were exiled when, as infants, we began the long and painful series of losses and splits that constitute our adult subjectivity. But Latham's work is much more interesting than most because, simultaneously, it evokes that disgust with which, in the process of transition from purely bodily to

the socially defined, we viewed the evidence of our materiality. For Kristeva (1980), this disgust is part and parcel of the longing for lost unity with the maternal body: we long to return to that sense of warmth and safety; at the same time we fear it, fear being smothered, reabsorbed into an undifferentiated world in which we would have to surrender the thin construct of selfhood. The power of the work is that, at the very moment at which it becomes technically possible to enjoy the sense of a return to that now fictive past, it urges upon us a sense of the price demanded by a refusal of selfhood. It is as if we guessed, seeing these coiling shapes, that lurking just within their pristine surfaces there lay the sheer negation of plenitude, utter emptiness. The innards of the machine offer no utopias.

Summing up his work on the ethics of psychoanalysis and introducing his seminar on Plato's *Symposium*, Lacan describes the human *ethos* as created *ex nihilo*, bootstrapped into existence on no foundations but out of the unnameable and impenetrable void that precedes the human subject. He blames Plato for projecting on to this void, which persists as the core of our being, the idea of the Sovereign Good (Lacan 1991, p. 13). This move on Plato's part is superstitious: it enshrouds in mystery, and makes the foundation of a metaphysical system, the formal negative on which humanity is founded. At the same time, such a step elides into the realm of mystery the complex emotional whirl that surrounds this black hole of subjectivity: the longings and the disgust that surround origin, the *inter faeces et urinam nascimur* of Augustine, the 'Love has pitched his mansion in the house of excrement' of Yeats' Crazy Jane. Latham's work, too, is a fantasia of origin: his virtual sculptures are generated on a model of organic evolution, tracing the becoming of form from the virtual void of the computer. Yet it is characteristic of his works that they project on to the empty space of origin the Sovereign Good of the artist: form.

It is in this sense that single-monitor pieces like *The Evolution of Form* and *The Process of Evolution* can be read as metaphysical. Over the grinning void of origin they project a kind of ambiguous loveliness. Yet that loveliness takes the form of a kind of good: the more so since, in place of processes of 'natural selection' appropriate for the organic world, Latham employs a process of aesthetic selection to guide his evolutionary algorithms. Revulsion and terror are legitimate emotions in the face of origin because it is precisely

without form, and that as such it recognises no Good. One might perhaps make an argument for its marking that boundary or edge at which beauty is transformed into the sublime, yet even this, marked with the approbation of a particular mode of aestheticism in the late twentieth century, becomes a moral good, a marking of unity over against the emptiness which denies it. These membranes stretched over nothingness take on the lineaments of necessity, logical outcomes of the processes of *ex nihilo* creation itself. Their processes take primacy over the non-entity upon which they are founded, negating the founding emptiness to make it appear always already full, replete with form, with the elements of meaning.

In itself, there is no problem with this: you cannot blame an artist for failing to imagine the unimaginable. But it is the way in which this imagination of origin, of the primal processes of life, is embodied in a profoundly socialised visual regime (that of monocular perspective), rendered coherent and ordered and subsumed within processes of aesthetic taste which are again profoundly social it is the very precision of Latham's objectification of virtual objects which gives them the gloss of eternity, denies the fundamental instability from which they emerge. Their powerful symmetry gathers about it the empty space on which they are mapped in ordered rationality. Drawing together the dispersed and divided oppositions of science and art, machine and organism, this ordered virtual world establishes its diegetic coherence as powerfully and suggestively as any Hollywood film, suppressing that primal difference on which it is premised in the same movement as that in which it establishes its internal unities. Neither are those unities themselves innocent, but made upon the model of a renaissance perspective that has become the touchstone of visual realism. As another of Latham's titles has it, this is more a *Conquest of Form* than a tracing of its origins: the resolution of historical and artistic dialectics in the subordination of form to an aesthetic intentionality masks itself as the working-through of an inhuman logic.

However, just as the dialectic of high and low culture can be read as the most productive aspect of art/cultural practice over the last century, so conflicts over the status and possibility of knowledge have been the condition of the most productive scientific and philosophical work of the same period. What is always to be feared and most strenuously criticised is the attempt to bring the historical process to a premature end, the creation of machineries of, in this

instance, intellectual gratification that would stem the development of knowledge, however contingent and short-lived its claim to truth.

It is such a premature closure of these great historical debates that seems to be offered in some contemporary computer-generated videographics. It is to Latham's credit that his work does address such major issues: art, culture, science, business all jostle towards an interpretation of the works. Yet, for all its own contemporary impasses, the absence of critique as an active, negative component to the work leaves it open to the criticism of naturalising its particular strategies. As critique lurches towards dogma, or feeds upon its own theoretical entrails, it is understandable that an artist would decide to leave well alone, and perhaps select precisely this medium, as yet scarcely trammelled with theoretical debates, to move into. But the mere avoidance of negativity does not resolve the problem of unrelieved positivity. Why should this bother us, though? What is at stake? Surely only a few minutes of videotape? My concern is two-fold: on the one hand, we are witnessing now the birth of a new medium, and its best practitioners therefore deserve a more informed discussion of their work than they have received thus far; second, this body of work seems symptomatic of some of the large social and intellectual movements of postmodernism, notably those that proffer a conclusion of history or an end to change, setting up in their place a quasi-mystical New Age. To his credit, Latham propounds no such metaphysical nostrum, yet to some extent his work depends upon one, that metaphysical membrane over the void that derives its force from covering over the unnameable difference, the fundamental instability of the human world in which, after all, the virtual must share. So far, the work has only begun to explore the interface of virtual and sculptural (social, historical) space: when it does so in earnest, when it moves beyond mere display and becomes an integral part of the works' functioning, then the dangers of spiritualising the new artistic and cultural domains opening up to us can be avoided.

If the weakness of Latham's work is that it seeks a premature reconciliation of mind and body, science and art, internal and external, subject and object, its strength is that it recognises a need for such a reconciliation in the first instance. The beginnings of a renewed address to sculptural space returns us to that other query concerning the relations of video media to work and leisure. We are so used to a cultural division of the two that the emergence of a

medium or family of media which once again blur them causes concern, and not entirely without reason: we are right to be suspicious of the resituating of capitalist work practices in the space we have come to know as that of leisure. The use of sculptural space, the siting of work of another kind in a space of another kind, raises the question of the geography of work and leisure, that separation which has created the suburb and the motorway. The question is not what is the VDU, but where is it?

10

Allegory and the Crisis of Signification

Where is the VDU? We can break this question down into two or three more: where is the video image? Where is the monitor in relation to the viewer? Where is the monitor in geographical space? Where are the actual monitors? And where do they presume that the viewer is? To start with the question of the distribution of VDUs, video monitors are most prevalent in the industrialised world and the Gulf States. In the rest of the world, monitors are clustered in the great cities. For the agrarian poor, video is still a remote, as yet scarcely used medium dominated by state monopolies of broadcasting. But if timeshifting and playback are still comparative rarities, video as a production medium is beginning to extend its role in the developing world, especially since the advent of chip-based cameras, far more resilient to humidity and dust than their tube-based predecessors. Video hardware is still overconcentrated in the Northern hemisphere, and both broadcast and cassette distribution favour heavily the products of its increasingly centralised communications industries. The democratic potentialities of video are thus severely hampered by its bonding with the dominant economic forces in global capitalism: little equipment is available for African, Latin American and South or South-East Asian video production and playback, and even less of what is made gets shown in the West.

One aspect of this bonding to dominant patterns of wealth and poverty, power and oppression, is that it enables video practice to be devoted largely to the replication of familiar Western modes of perception and story-telling: the culture is impoverished by the dearth of practitioners outside the metropolitan centres. When the

Togolaise video drama *La Tortue qui chante* (Hantz Koffi,1987) was shown on British television, it seemed to open an aesthetic scarcely touched on even in the Third Cinema. *La Tortue* uses the device of a marketplace storyteller to frame a mythological tale which is made to bear directly on a fictional local power struggle, raising in turn much more general issues of the ethics of development. Songs, dances, poetry, satirical comedy and dramatic performance style are drawn from traditional sources and reworked for the camera. In this it is not so unlike the cinema of Ousmane Sembene, Suleymane Cissé or Med Hondo. What marks out its difference from Third Cinema (as is also the case with other work in similar vein from Tcheik Tidiane Diop in Senegal or the Warlpiri experiments with television in Western Australia) is the dramatic use of the intimacy of the relation between video and viewer. Third Cinema has a tendency towards epic – the writing of history, since that is the urgent need of the peoples for whom it is made – often drawing on small-scale events to sketch out the larger historical implications they carry. But Third Video, if it's appropriate to use the term, is characterised by the small-scale interventions it makes, the intimacy of its address, the local quality of its speech and techniques, and its ability to address the local through history rather than history through the local. Third Video makes the opposite movement to Third Cinema, drawing the weight of history to bear on the scale of local decision-making.

Unlike the documentarists of the *Intifada* or the Chilean video underground, such fictional products move the ground from the urgency of communicating with the outside world to the problems of communicating within communities. They can therefore rely far more heavily on the local styles and local references that characterise the rural community. But unlike Western TV, they can deploy this intimacy not at the level of individual address to which we are condemned, where TV flow is used to produce the endless meta-phorical flow of images that underwrites and renews Western individualism, but by addressing the group. In *La Tortue*, the storyteller cracks his jokes and sets his scene in call-and-response mode with an audience of actors who then take on the roles of the animals and characters of the myth. Likewise the viewer is invited into a group production by songs, by questions, by suggestions that s/he recognise the types involved in the tale: people are addressed as a group members, not as individual. This group address is reinforced

by the typical situation of viewing, which is communal rather than individual. According to Roy Armes (Armes 1987, p. 45) there were only 250 cinemas in the whole of Francophone Central and West Africa in the 1970s, and those were again concentrated in the cities: the importance of communal viewing to the production of video drama in this context is enormous. The intimacy of the medium is redoubled in the intimacy of the viewing, and the effectiveness of the medium to intervene in that small-scale set of human relationships particularly emphasised. From such work we can learn the potential for turning what is in many determining ways a domestic format, anchored in suburban culture, into a medium for carnival.

For us, in Western Europe and North America, the VCR is still largely an adjunct to broadcasting, though that relationship is weakening. But though we buy more sell-through videos, timeshift more programmes, playback more home movies and do more basic editing (if it is correct to see fast forward, freeze-frame and similar functions as modes of editing), our relationship with the monitor is still that most powerfully developed for the television set in the late 1940s and early 1950s: the electronic hearth of the nuclear family (cf. Spigel 1988, pp. 11–47). Far from organising viewing around community and group interaction, TV historically organises it in the domestic context, centred on the family as the central economic unit of consumption, the site of reproduction of labour power, and the core of conservative discourses of social stability. Video has emerged as a further step towards a devolution of even this social unit into an interaction of individuals. One typical use of timeshift is to allow an individual member of the household to pursue a personal taste without having to negotiate with the whole family (cf. Gray 1987; Morley 1987). On the other hand, some uses, especially among diasporan communities, tend towards the affirmation of group identity through group or extended family viewing of programming from the home culture (cf. Gillespie 1989), a fact that must lead us to surmise that there is nothing fixed or determining about the technology: it is the cultural practice within which it is situated that is central to its meaning. At the same time, these can be seen as variants on the 'home theater' model discussed by Spigel, in which 'the private activity of watching television was made pleasurable precisely because one could remain alone in the living room, but at the same time sustain an illusion of being in the company of others' (p. 32). But, as Spigel goes on to argue, this leaves the viewer in a

complexly ambiguous position, one in which the sexualised gaze is domesticated, but which puts wife and TV at odds for male attention; in which fantasies of TV looking back at the nuclear couple are frequently articulated; in which the visibility of the home as the sign of status (and, we might add, as a relatively new public space of entertainment for visitors outside the family circle) is at odds with its role as site of an externally-directed vision. In short, the space of domestic viewing is circumscribed by its socialisation as living-room furniture, and the same is true of much video viewing, especially as the infrared remote control has returned the viewer to the armchair, after a brief period kneeling on the floor next to the deck.

Nonetheless, video has begun to disperse viewing in time, if not in space. The TV set becomes more versatile, and its flows and promise of an eternal present more vulnerable to the interjections of recorded images. The illusion of transparency, of broadcast as a gaze uninterrupted even by natural obstacles, is troubled by the sense that what is seen and what we see do not share the same moment in time; viewing and the viewed are separated. We can therefore no longer (if we ever could) believe in the screen as a medium which puts us in contact with some shared community of viewing. At the same time, we lose the imposed unity of a space of viewing underwritten by a shared time of viewing in the home: watching at different times – even when the same material is viewed – no longer allows for a negotiated mode of viewing, negotiated agreement over the value of a programme. In a related movement, the development of large-screen displays and video projection have shifted the role of the screen in public spaces by extending the living room into, for example, the family shop. Instead, we have an increase in public viewing, notably of sports, music video and home-culture viewing for diasporan communities like the Turks of North London, or the South Asians of West London. Video media, then, multiply the modes of viewing practice which can be engaged in; but even so, there is by now a deeply ingrained sense of a correct distance from the screen, marked by the dimensions of the domestic.

It is in these interruptions of transparency that we can understand the development of a certain strand in video practice. Perhaps it is precisely the interruptions made available by video recording that made it possible to think of the opacity of the image, its materiality as signifier, and to make that the core of some of the major

interventions in both theory and videomaking. Art historical and film theoretical discourses alike, as we saw above, tended towards an understanding of the visual as a plane, a flat surface on which the illusionism of realist practice had to be, could only be, disrupted by a concentration on the materials of which they were made: pigments, light, time. In the search for a purity of means, these discourses and the practices associated with them reached a moment of crisis in signification. The signifier, material 'substrate' for Saussure, became dissociated first from a 'real' referent, then from the mental/ conceptual signified. Avant-garde practices anchored in work on the signifier found themselves unable to work on the signified, unable to deal in meanings, but only in the matter of which meanings are made. This Greenbergian impasse not only informs the early interventions of vidéastes in the circulation of TV; it returns again ('the second time as farce'?) in the dogma of hyperreality that haunts postmodernist discourse: the sense that there is an unbridgeable gulf between signification and reality, between the material of signs and the material of the world, and that we are now consigned to an infinite limbo of signs that have no sense and no direction.

A particularly potent exploration of such preoccupations and presuppositions is Susan Hiller's installation *Belshazzar's Feast/The Writing on Your Wall* (1983–4). On multiple floor-mounted monitors, images of flame stretch towards the purity of pixels, while separate loudspeakers play back what at first sounds like white noise. Apart from some printed matter on the walls, there is nothing to tell us that we are other than in the presence of pure sound, pure image, pure sign. But the flames have the fascination of all fire: the way they attract reveries of faces and forms moving and dancing, so that although we begin by seeing only a play of light, we are soon enmeshed in the screens as attractors of fantasy. Hiller's fires pun on the TV as hearth, but do so by suggesting that the power of the screen is not to deliver messages, but to trigger dreams. And the sound too begins to gel: like the paranormal recordings quoted by Laurie Anderson in her *Example # 22* (on *Big Science*, 1982), there are messages hidden in recordings ('Your sound', sings Anderson, 'I understand the languages. I don't understand the languages. I hear only your sound'). Incorporated in the installation are documentations purporting to be of paranormal or extraterrestrial messages received through the TV set, warnings of impending doom or new

utopias, prefigured by the Biblical tale of Belshazzar, at whose impious feast appeared fingers that wrote upon his wall MENE, MENE, TEKEL, UPHARSIN – God hath numbered thy kingdom and finished it; thou art weighed in the balances and art found wanting; thy kingdom is divided and given to the Medes and Persians (Daniel 5, 25–8).

This is a quite different understanding of the domestic familiar. On the one hand, the monitor gathers to it the investment of fantasy. On the other, it is the medium for messages from worlds beyond. What we think of as the significant content of television is unimportant: what matters is the way its materials provide a space for an unconscious set of processes relegated to the outer edges of communication, but which nonetheless draw us back over and again to the flickering screen and its clouded soundtrack. Beneath the opacity of the screen lurks a new transparency, but one which is scarcely conscious, scarcely touches the patriarchal domains of the Symbolic, and which most of us, consciously, find funny, at least quaint, possibly hysterical. We hear in such 'evidence' symptoms, and Hiller has carefully derived her quotations from women recipients, assembling these paranormal experiences into the domain of the Kristevan semiotic chora or Irrigaray's speechless domain of primal femininity and privileged access to the psychoanalytic unconscious. What is at stake is not meaning, but its necessary conditions, the processes of semiosis that antedate language, that undifferentiated space in which inside and out are not yet separate, in which the body enunciates a language more ancient than articulated speech. The utopian condition of this vision of video is that it need not wait for content to justify its fascinations: prior to the organisation of visual pleasures into perspective, voyeurism or fetishism, there exists a more fundamentally physical communication via light and sound, though it be one we experience as adults with something close to dread. As a whole, then, the piece revalues the physical experience of viewing, that passivity we bring to watching TV when we are too tired or bored to bother with its messages. The truly passive viewer can obliterate the monodirectionality of TV, projecting fantasy on to it as it projects its prelinguistic flickering lights and sounds on to her. TV, she intimates, imposes a rule on to what cannot, finally, be ruled: 'These incoherent insights at the margins of society and at the end of consciousness stand as signs of what cannot be repressed or

alienated, signs of that which is always and already destroying the kingdom of law' (Hiller, quoted in Iles 1990, p. 41).

The domestic living room is privileged in common political parlance as the place of true humanity, the place where you can really be yourself. But the self, especially in a place which is also the privileged heart of sexual reproduction, is a fragile thing, and has to be maintained by just that 'kingdom of law' of which Hiller writes. As Spigel (1988) argues, few places are more heavily policed, in the sense that we have a clear understanding, underwritten by innumerable discourses on home and marriage, of how we are to behave there. That fundamental relationship of distance between the viewer and the domestic screen is one of these. We encourage our children to sit back from the screen, and do so ourselves, out of a set of social obligations (not to block others' sightlines, for example) and aesthetic presumptions (the best place to see from), but also because, if we get too close, the coherence and therefore the transparency of the image disappears, taking with it the hierarchical organisation of viewing space and visual pleasures. In their place the opacity of the image becomes unavoidable, the play of pixels which might unravel the precarious order of the self as it is founded in the kingdom of law. Correct distances (to use a phrase of Mitra Tabrizian's) are necessary to the maintenance of the domestic law: sexual difference, sexual division of labour, ultimately the very foundations of the individual as, increasingly, the unit of social stability which is taking over that function from the nuclear family. Postmodernist critiques, like that of Fiske, are still celebrating this shift of emphasis from the family to the individual (especially in the ruling and middle classes). Materialist videography needs to understand it, as Hiller's work in some senses demands, in terms of the moments of a dialectic that is far from over.

That the process is continuing is apparent in one apparently mundane observation: the distance between viewers and monitors is decreasing. Though dominated in early years, and still to a great extent, by the domestic television, home theatre model of viewing, with its underpinnings in the nuclear family, inch by inch video media are freeing themselves from that relation, just as TV freed itself from the pure theatricality of cinema and vaudeville in becoming domestic. More recent video forms began life in the workplace, replacing typewriters, linotrons, Steenbecks and moviolas, cash registers and ledgers. Much of their design was based in

analogies with bookkeeping and books, or with the craft professions like typesetting, architecture, product design, magazine layout and film editing. As they moved into the home, games consoles and high-resolution VDUs stayed at the same distance from the user, something in the region of 18–24 inches. That proximity to the screen makes an enormous difference. For one thing, it allows the screen to occupy a far greater proportion of the field of vision, minimising distractions, increasing concentration (presumably one reason why the desktop format evolved as it did in the open-plan office context). For another, it still evokes the culturally-validated practice of reading: it is far rarer to find parents complaining of their children's involvement with video games than with the television. We evoke instead the sense that working with a VDU, however silly the content, is a legitimate skill, just as reading is valuable regardless of the idiocy of the book being read. So the new proximity produces a kind of respect for the user that is still not the case with viewing on TV monitors, where even the most dedicated research is likely to be interrupted because it doesn't look like research. And that respect is, to some extent, internalised: even game-playing on the VDU feels more legitimate than watching a tape on the TV screen. And for a third thing, we get the vertiginous impression of sitting at the edge of a vast internal universe of which we can hold on screen only a small portion; a universe, moreover, that is open to our manipulations.

We still relate to the screen as image, even if that image be of typed pages or spreadsheets. But it is already, in all video, an image that we believe we can intervene in or alter. More even than that, if the dream of the big screen was to impose an identity on every viewer, that of the small is to impose the viewer's identity on everything that appears on the screen. Perhaps that is too harsh a description of the way the monitor attracts our fantasy, invites us to project on to the monitor, and we will in due course have to correct the overstatement by re-emphasising the productive nature of the medium itself. But these increasingly familiar video relations, in which we sit right up against the screen, driving the image with mouse, keyboard, joystick, touchscreen or edit controller: surely these are the accoutrements of a profoundly novel relationship, one which finally escapes the controlling format of the living room TV, even if it is only to deliver us over to another mode of determination. This new relation is frequently described as obsessive (cf. Turkle 1984) but observe also your own readiness to spend abnormally long

hours at the controls of an edit suite or personal computer. The high-resolution screens of contemporary PCs make it worthwhile sitting close, even peering into the screen to trace a detail. This gesture of peering in is at the heart of the new relation, far more even than the increasingly precise manipulability of images on VDUs as well as, at great distances, through the use of infrared remotes. The interaction that counts is less that of actual power to change the image than the particular sensation of power that accompanies the new, concentrated gaze which seeks to discover the minutiae hidden in the bowels of the machine.

This relation of looking inwards is a profoundly new experience for the modern world. In place of a transparency allowing us untrammelled vistas of the present moment extended infinitely through space suggested by broadcast; and beyond the avant-garde and later postmodernist understanding of the screen as absolutely opaque, rendering only an endless play of signifiers without referent or concept, another and more disabling form of the eternal present; in place of these we have this inward extension of the gaze, which, coupled with the power to arrest the image into stillness and so perpetuate the instant, produces a new kind of present: one into which we can enter as explorers. A sequence from Ridley Scott's *Blade Runner* (1982) gives a strong visual impression of what I mean: the detective Deckard is searching for a clue in an old photograph. Scanning it into a computer, he magnifies the image over and over until he finds what he is looking for. Imagining an image that can be explored in near-infinite detail entrances us, lures us on into the technological future; it is the same lure as the worlds within worlds of the Mandelbrot set, logo of the New Age mystics, the lure of an inside to the flatness of the screen display, an inside to the opaque signifier. But in the *Blade Runner* version, there is more: Deckard is searching for a clue concerning the human or android identity of his intended victims and, as the plot makes clear, he is himself unsure whether he too is an android. The search is then for a clue to origin. We have a sense of the parting of veils when we look inward into the machine; but we also are drawn in, as Hiller's fires draw us in, by inviting us to project our fantasy on to the picture plane, into the machine. We call this relation 'obsessive' because it is exclusive. As it excludes, by proximity, the outside world, so it draws out from us an extraordinarily narcissistic response, a response of entirely selfish involvement with what we nearly understand as images of our self.

In place of the world (ordered and organised around dominant ways of looking), in place of the blank wall of signifiers, we gaze inwards to the Imaginary source of signification, the pre-Oedipal, infantile semiosis. Perhaps, as the psychoanalysts would say, this too is an imagination of return to the first relation with the Mother, prior to paternal Law, a return even to the interior of the Mother's body. It is certainly, I think, a self-involved relationship with the screen so intense that the foundations of individuality as a social phenomenon, of individuality as socio-historical product and agency, are threatened with fragmentation.

This is the kind of relation exploited by Latham and Lasseter in the works analysed in Chapter 9. Such works, I argued, draw a skin over the quivering tendons of what lies prior to identity, that fearful, shapeless interior where form, order and law have no place. But there are many other modes of relation ready to be engaged in, explorations that challenge rather than seek to heal the rifts in the individual psyche. Where an earlier avant garde practice – one which in many ways parallels Latham's aesthetic – identified the gap between signifier and referent and made its home in working along the line that divides them, this new aesthetic begins the work of analysing the grounds on which signification is possible. The premise on which it is based fits the narcissistic movement of video as it gets physically closer to the eye: it is a research into the relationships between and within the individual and the screen. It is also remarkable that so many contemporary works rely on allegorical terms: the case with works by Biggs and Hall discussed above, and with recent works by Biggs, Gillman, Cox, Dion and others. This issue of the uses of allegory resurfaces at a point at which work on signification collides with the need to signify and, as in the great flowering of allegory in the baroque, it will raise questions of the relations between subjectivity, meaning and the social.

To begin with, however, let us look at three tapes made by Terry Flaxton which work together, and are part of an ongoing project called *The Colour Myths*: *The Inevitability of Colour*, *Echo's Revenge* and *The Object of Desire* (1991–). Flaxton's starting point, according to a 1992 treatment for the whole project written for Channel 4's commissioning editors, was a reaction against the disabling politics of signification of Jean Baudrillard. In place of the 'death of meaning', Flaxton proposes an identity between perception and

meaning: 'that we are that which produces meaning, and are therefore responsible for its production – should we so choose'. Allowing that this premise is arguable, he asserts that the point is to establish the conditions for argument: conditions which, if Baudrillard is right, are not permissible, since arguments are only circulations of meaningless signifiers. Jungian archetypes provide a kick-off point: pre-existent faculties pursuing their fulfilment in the match between world and mind. Jung, it should be said, is a prevalent figure in British video culture, perhaps precisely because the theory of archetypes provides an architecture within which some internal consistency for allegorical work can be generated, and perhaps because of the match between his theoretical framework and the mythopoeic imagination of Robert Graves, whose collection of Greek myths and interpretation of mythic thought in *The White Goddess* have been deeply influential here. The specific architectonic device for the project is the myth of Echo and Narcissus, where Narcissus is equated with vision, mind and masculinity, Echo with sound, body and femininity. Like the works of Jung and Graves, the tapes build from a problematic of the historical division of mind and body in modern culture, and play through variants on their dialectic.

Longest of the completed pieces, *The Inevitability of Colour* immediately links sound and image, then distances them from one another. Over black screen, a male voice says 'Let there be', and on the word 'light', a lit candle appears; but a woman's voice quotes part of Magritte's title, 'Ceci n'est pas une ...' ('This is not a ... ') as the word 'Candle' appears printed on screen. Magritte's painting is of a pipe, with the words 'Ceci n'est pas une pipe' ('This is not a pipe') written below it: even a realistic painting is still a painting, and a painting of a pipe is not a pipe but a painting. When this figure returns later in *Inevitability*, it is with the same hiatus in the voice, but with the word 'Television' printed on the screen by the candle. After each appearance, one of the tape's two male voices asks, 'Do you feel its warmth? Does it light your path? Have you seen this *image* too often? Has it lost its meaning for you?' The first time, the questions ask about the status of representation, much as Baudrillard's eventual thesis must begin in scepticism about signification as necessarily linked to reality. But the second time, the questions address Baudrillard's theses on the opacity of the image. Is this television a hearth, a lamp in the darkness? Does the very opacity of the image itself become a meaningless feature, one that we no longer

find inspirational? Is TV itself, as an object, losing meaning, just as Baudrillard sees it destroying all other meanings but its own existence, dedicated to its own auto-reproduction, the entirely self-sufficient self, the complete Narcissus, including in its self-reflection even the hapless viewer? It is a thesis brought out visually when, as the second male voice speaks of 'the world filled with images, both of serendipity and of our own construction', a globe composed of flecks of TV colour revolves against a background of smoke. Everything beyond the self-enclosed world of images is mere smoke, but the image world is itself locked into an internal self-regard as bereft of meaning as it is of reference.

Flaxton's voices accept this as description, but refuse its projection on to the whole of the future, that future which, we are assured, no longer exists. Such assurances belong to an 'I', here mapped as masculine, which the treatment links to the sixteenth-century 'empirical materialist' philosophers, by which I believe is intended the sceptical tradition from Descartes to Hume. It's probably a minor correction to suggest that it is in Kant that we find the most commanding isolation of the thinking 'I' from its sense perceptions, the most absolute distinction of mind and body. With his isolation of the a priori concepts of the transcendental subject, Kant reformulates that fundamental Idealism so characteristic of Western culture for a new era, just at the moment when Hume was about to anchor thought in the human relation to the real. With that distinction, and the consequent distrust of sensual data and privileging of the mental, the grounds for profound distrust of signification are laid; for what faith can be placed in signifiers which are, of their nature, material, sensory, perceptual? It is on the grounds of this distinction that Kantian aesthetics are formulated, and on that ground too that abstract art becomes conceivable: the investigation of the proper grounds of sense perception, derivable from concepts, expressive of a newly remote divinity in things, or revealing the resistance to the entirely human of the entirely empirical. In Kant the only response to solipsism must be the grounding of mentation in the transcendent, which all minds share. But his philosophy is itself historical product: the grounds for the industrial subordination of nature must include the divorce of the human reason from natural involvement, and that in turn demands the separation of people one from another, since each must be the owner of a full complement of rationality independent

of material intercourse. Flaxton traces another derivation: Lucifer announces his claim to bring knowledge under the proclamation 'I am that I am', and in his fall, the 'selfless act', becomes shards of light, each one a self-conscious existence (marked on screen as multiples of the letter 'I' spinning out of a cloud of pixels, each mind an avatar of that transcendent ego). But each ego is trapped within a solipsistic world of images within which, like Narcissus, it can see only its own image. Baudrillard's postmodern individualist is a function of just such a transcendental ego. It is the business of *The Colour Myths* to unravel this mystical solidity of an ego that has grown so great it has erased reality.

Echo's voice speaks to the spinning ball of images, adding to the accusation the list of those voices that are excluded from the world of meaning by this narcissistic egotism. Such a world cannot be stable if it excludes so many. At the same time, the clouds of smoke fade, and the ball spins against a background of its own objectless images, freed from the gravity of their centred spinning. By seeking to include everything, this transcendental ball excludes much, and in excluding cuts itself off, like those mystics quoted earlier in the tape who amputated all the organs of sense in search of a truth more fundamental than perception. Yet the rain of perceptions goes on, and our senses, and the imagination that informs them, goes on projecting meaning, even in their absence; colour is inevitable, even in a darkened world, because we will always produce and project meanings, even in the void. The woman's voice, Echo or Pandora, tells us as much: 'That straining to hear is in fact the ordering of things to project the meaning implicit in ourselves. In listening to the silence we will hear the crying in the wilderness – it is our own voice returning to us.' The image track plays water rising in a tank over a sweet, air-blue background in which blurred flowers of white light maintain their indefinite shape through the refracting medium.

Inevitability treats its voices as sound, running audio effects on the recorded dialogue and adding sounds, musical and otherwise, to the mix. It deploys a series of images of great beauty, staged for the camera and computer generated, assembled for their evocations. As the message of the tape is anchored firmly in the spoken word, we strain to hear as well as to listen, so that our levels of concentration fluctuate, and it is only after several viewings (or with the aid of the script) that it is possible to unpack the whole argument. Yet that is part and parcel of the tape's method. What we could, but do not,

understand becomes a kind of music, working at a preconscious level halfway between awake and asleep, reason and dream. Likewise the vision track draws together images that seem to cluster into groups whose meanings just escape comprehension: falling crystals, petals, fragments of images, rising flames, smoke, bubbles, rippling cloths and liquids, liquid-filled, smoke-filled or image-filled globes, a dark sky dotted with static, bubbles, stars. Between these realms, the image of a cord, umbilical perhaps, joins and divides what is above and what is below. Evocations, imaginations, intuitions, intimations of meaning, never meaning itself, whole and entire. The joining and dividing cord can itself become fragments, fluids, flame. Like Plato's demons, charged with joining the two halves of the universe, that of the gods and that of men, the cord that joins the dialectical relations of *Inevitability* is itself subject to desire.

Echo has the last word in *Inevitability*: no longer 'I' but 'You', reverberating into an empty screen. There remains the gulf between consciousnesses, between unconsciousnesses. The second tape, *Echo's Revenge*, explores the divorce of sound from image, in a critical dissection from an (as yet) non-existent tape. We learn that this tape will have a montage of images, and will address the opacity of those images as signifiers. But the male voice who speaks this description is also trying to command an appropriate soundtrack to a female voice; both speakers are shown in profile against a dark backdrop. The sound is to be subject to the visual image, but the woman refuses to defer to his demands, frustrates his planning, quizzes his rationalism. We are unsure, after their images have burned into our retinas, of how far apart they are: whether they have been taped in a single shot, for example, or shot separately and montaged together. The space between vision and sound, mind and matter, is animated as allegory.

It is *The Object of Desire*, however, which will ultimately come sixth in a series of seven sections, which most closely tracks the narcissistic relation of viewer and monitor. Many of the images from *Inevitability* return here: black waters of sleep, blue waters of hope, the cord, the flames, the liquids, fragments and smoke. But now we see them from Narcissus' point of view, his and our hand stretching into the image, vainly trying to grasp what is no longer there, the hand itself crumpling into pixels, as the section titles of *Inevitability* had rolled and flickered into and out of existence. We are invited into Narcissus' world, disembodied and unanchored, while the

soundtrack moves between the temporal organisation of music and chaotic, twittering electronic noises. *Echo's Revenge* spoke of sounds of jets over mountains, wind, the sound of an SLR shutter: are these sounds, we wonder, derived from those sources, their microtonalities hiding untold wealths of harmony, disharmony? The beauty of these images derives not just from technical perfectionism, or even from their powers of evocation, their power to call up from the viewer sets of responses that we maybe never knew we had. Like Latham's, they work on our perceived antithesis of nature and machine, organism and mechanism. But most of all they accept the postmodern diagnosis: we live in a world of opaque images, although we need not believe that we are trapped therein. Their beauty derives from their transience, their delight in all that is changing. These are the images, bereft of faith, that speak of hope: a politics of the unconscious.

For Flaxton, it seems, that politics, the politicisation of the audio-visual, must take place via a common unconscious formed around the archetypes evoked by his core metaphors: voice, sound, vision, writing, the four elements, the geometries of the line, the globe and the octahedron. For now what is important, as he says himself, is not the argument itself, but that it be possible to argue. And I would argue that the grounds of that possibility derive from the inwardness of the new video relation. Whether in our internal investigations we find the void, the archetypes, some interstellar dust, 'the foul rag and bone shop of the heart' or a hard-edged octahedral shard of ego from the fallen Lucifer, we must recognise that we are looking for a soul, but that for all that we do not find one. Or more precisely, that what we find is, in any case, not one but many, not fixed but changing. If humankind still has souls, then they too have changed, as we have changed. It is as if, with our new proximity to the screen, we had exchanged the televisual metaphor of the telescope ('television' derives from Greek and Latin roots, meaning to see far) for a video metaphor of the microscope. What was an instrument for the investigation of the external world has become one for exploring the internal. But what we find inside is not a unitary, coherent whole, but a plethora of different lives, a microbial zoo of sensations and unborn concepts, a chora of inarticulate sound and unformulated visions. For me this explains something of the sense of vertigo these tapes provoke, the sense of peering into a well where echoes are produced without visible cause, echoes of

some primordial event which only conscious work can mould into the shapes of meaning.

This fragmentation of self and of meaning that occurs when we try to trace their common origins seems, too, to explain to some degree the prevalent use of allegory. Flaxton's technique is to try to restore the magical sources of symbols, to unearth a kind of wholeness in the oldest signs, where meaning and signifier seem, for sheer antiquity and ubiquity, to be inseparable. I am arguing that irreversible historical actions have worn away the cord that linked the symbol and its magical powers of unification, just as Maravall argues in his history of the Baroque that the 'technification of political behaviour ... was not expressed in mathematical formula [*sic*] but in symbols. These symbols may have been of very remote origin, but from Machiavelli to the individuals of the baroque they underwent a process that divorced them from their magical references, turning them into a conceptually formalised language' (Maravall 1986, p. 65). However, it is also true that allegorical figures have a quality unlike that of more personal symbolism: an allegorical figure can take on a life of its own. Once constructed, an allegory, like that of the *rosa mistica* in the Middle Ages, or like the television screen in our own time, can be used and reused. It ceases to be the property of its originator – if indeed such rich figures ever have single inventors – and becomes the property of all. The allegory exists not because it is innate in the mind, but because it is profoundly social, and it becomes popular because it speaks not only to what we are conscious of loading it with, but to those pre- or unconscious formations to which we have been addressing ourselves. Water, for example, is not of necessity linked to femininity. But it is so simple, so universal, so precious, so tantalising to the senses that it gathers around itself our deepest feelings: waters of Lethe and of rebirth, waters of purification and of sensuality, waters of dream and waters of Maya, waters of the storm, the cove, the drink, the tear. The importance of allegorical figures is precisely that they emerge exactly at the moment at which we most want to anchor meaning to some fixed point, but that at precisely that moment and no other they take off, blasting that fixity apart with the profligate showers of their associations.

Allegory is the hinge point where everyday, communicative systems of meaning are articulated with their moment of crisis. With the allegorical figure (and I believe that some key figures

addressed in this book, like the figure of the surface and the figure of the screen, are just such allegorical instances), we are invited to gaze upon the fixed centre of a system, only to find that it has become a shifting, violently productive, exploding zone of mutually contradictory meanings. The nineteenth century erected the mythological women analysed by Marina Warner (1985) to symbolise their highest aspirations: statues called France, Justice, Empire, Victory, Trade. One reason must have been the uncomfortable role of women, at once excluded from public life, yet charged with the reproduction of the family on behalf of that public realm. But as soon as these figures began to proliferate in earnest across Europe, then precisely the can of worms explodes, most characteristically in Freud's unanswerable question '*Was will das Weib*?', ('What does Woman want?'). In allegory since the Baroque, the mind/body duality is brought into a realm where it can be managed and administered, but it is precisely then that it destabilises itself and those around it.

Modern allegory is a mark of the difficulty of being an individual. The attempt to create a common zone of anchored meanings characteristic of administered, bureaucratised societies, beginning with the Baroque, reflects the reluctance of meaning to serve. Meaning is too prolific, will always 'say the wrong thing', crack jokes in front of our most hallowed shrines, notice the pigeon shit on the equestrian statue. The value of *The Colour Myths* is that the tapes exceed the maker's intentions precisely where there is the greatest risk that he and they might have become servants of the allegory of pure signification. If, like Latham, Flaxton has attempted too rapid a resolution of the intense dialectics that he addresses, the saving grace is that the formal devices and sheer studied beauty of the images, abjuring polar perspectives and fearless symmetries but aiming intuitively for the unstable and unformed, crack open the surface of the screen. So they open up space for projection of psychic needs, but without the formal closures that would make this just another postmodernist hall of mirrors, another *mise en abîme* where we are supposed to lose ourselves in the endless present of our own image.

When Deckard instructs his computer to home in on a detail of the photograph in *Blade Runner*, he does so verbally. This is another shift in our relations with the VDU; we used always to talk to the characters on TV, or to yell at the programmes. But now we talk to

the computer itself, addressing the machine as a colleague or a (recalcitrant) ally in the pursuit of knowledge or the perfect score. Strangely, the movement seems to be towards a more intergated relation between spoken and visual languages, in which we expect a form of dialogue in which the machine 'responds'. On the other hand, we are quite aware that those responses are entirely due to the commands we give through the technical manipulation of the machine's peripherals. Language is being lifted, slowly, towards the disembodied level of vision, and the relations of speech are becoming vital to the perception we have of our internal lives. Throwing a spanner into that mode of relationship is a further way of destabilising the developing standardisation of the human/ computer interaction. It involves a new relationship to speech (and recorded speech) that dares to go beyond the perceived limitations of spoken language in the wake of Derrida's grammatology. Unlike many of his contemporaries, Flaxton is unafraid of words, so that the sound and image are not only constantly at odds, but make outrageous demands on our attention, neither explaining nor accounting for the other, doubling up the hiatuses, faultlines and chiasmuses through which hope, which is what links us to others and to the future, can creep in, drawn all unwilling from within our solipsistic, postmodern souls.

11

Inconclusion: Electronic Ecology

Liberation from the tyranny of representation is a terrible responsibility.

The moving image – along with photography – has been freed of the necessity of capturing or interpreting reality, itself an awesome burden, a century later than happened in the more traditional crafts of painting and sculpture. Unlike them, it has the hundred years of experience in those media to draw upon as new possibilities are forced upon it. That experience derives from and lives out a history of separations and splits, some of which I have tried to pencil into this writing: rifts that tear art from life, science from art, exchange from use, production from consumption, psyche from soma, conscious from unconscious, senses from one another, media one from another; and any understanding of the politics and aesthetics of video must take this experience into account. Neither should it attempt to soften the blow with premature resolutions, as I accused Latham of doing in his work to date.

Video media are at the cutting edge of this dialectical history, notably in the field of virtual reality, where the separation of mind and body is at its most extreme, and where, consequentially, the focus on the powers of sight are most intensively developed. The search is on for virtual touch experience, usually through electromagnetic feedback in the glove, or more fancifully using similar techniques in an allover body suit (glamourously posited as the heart of teledildonics, virtual sex). But this is a sense that will be subservient to the primary one of sight, which is the cybernetic governor of virtuality. The separation of sight from the body is an achievement that one might have thought already achieved in

cinema, even without the need for IMAX or OMNIMAX systems elegised by Virilio (1990): in virtual reality kits, the point is less to isolate vision than to subordinate the other senses to it, in the same way that music is bolted on to visual footage as a mere preventer of silence, rather than as a functional part of the work in many computer-generated works.

Thus the 'total' experience is in fact one in which the senses are separated from one another and then organised hierarchically. The commonest clincher of arguments about the impact of virtual reality on users is that it gives a sense of vertigo (so it must be convincing).The sense of balance, which we have come to use as a metaphor for the integrity of the individual, is manipulated through visual technologies in virtual reality, suborning it to vision. Perhaps most conclusively, with video, in closed-circuit systems and in mask-and-glove virtualities, the viewer's own body is reduced to an object of vision (unlike the OMNIMAX, where, as in cinema, it is dematerialised in the process of becoming the source of vision). The relation this bears to the arguments on perspective in Chapter 9 should be clear: the fetishisation of sight is accomplished through the organisation of looking into very specific forms and regimes of visuality (Foster 1988, pp. ix–xiv) such as point perspective, the Mercator projection or the familiar Hollywood pairing of fetishism and voyeurism (Mulvey 1975). It is in such hypostatised scopic regimes that (what passes in any historical moment as) the *hyle* of vision is constructed, through a series of schemata and interruptions, as a modus of rule.

This separation of senses impacts on the division of media one from another. Greenberg's plea for a painting that was not poetry or sculpture, Pater's claim that music represented the highest aspiration of art: these are modes in which the division of media has been conducted, largely along boundaries marked by hierarchical organisation, internally and externally, of the senses. The singular mission of video media in this is, I think, through their impurity, their lack of essential properties, to muddy the clean cut between, say, painting and sculpture, music and drawing. In doing so, they call into question the clarity with which vision itself is defined in our culture, demanding instead a concern for the relationships between estranged faculties and senses. Such relationships, dialectical interchanges where perhaps we might imagine a prior unity, are the key to understanding video, and very particularly to writing about it.

Video is a medium only in the sense that it mediates *between*: people, fundamentally. But to begin with what we actually have before us: video mediates between senses, between media and, at an even more profound level, between technologies.

Not that this is a reassimilation of the dispersed members of some originary whole body. Virtual reality mask-and-glove kits disperse elements of the body into instrumental bits – hand and eye, the technofetishised organs of manipulation – and not even the feely suit can restore integrity to the dispersed body; in fact, quite the opposite. Centrally this is because, if ever there existed a whole body, it no longer exists as such for us. The division of mind and body experienced in the Christian West is only the beginning of a dialectic which has alienated the parts of the body from one another – for example in the fetishisation of specific parts of the body for sexual interest – and then further alienated them internally from themselves according to functions, gestures, costume, health, and the other clustering discourses that batten on to the body and the mind as separate, isolated entities. That historical construction of alienated bodies is experienced on a daily basis: in our day, specifically as something to work on, as in working on your triceps, your tan or your algebra. When the body works well, we treat it as an object to be worked at, using all the metaphors of engineering common throughout the managerial culture. When it doesn't work so well, we treat it even more as an object. Increasingly the same can be said of the mind, in the age of designer drugs and virtualities that, dispensing with masks, promise to imprint images directly on the retina with safe lasers, or even, in the proprietary brands of alpha-wave generators, skip vision entirely and go straight for the brain's biochemical energies. Our bodies and minds are assemblages of dispersed elements which we treat as mechanisms, objects, somehow separate from the governing 'I'.

It is only in moments of crisis that we can see the figure of a primal body, unified and coherent, return as a major figure in the culture, although minority beliefs have often held a central place for it. As moral panics serve less to ward off foreign threats than to reconvene popular belief around the defence of 'our' culture, so AIDS has been at the centre of a discursive strategy, from the *Daily Star* to *Scientific American*, which centres less on the virus than it does on the reconstruction of a pristine body which it invades. Each discourse sets up the figure of a prior, coherent creature which must

be defended. But that coherent body never existed; it is a dream which calls us, and which I would argue is related to the narcissistic pull of coherence in virtual worlds, the memory of a pre-Oedipal state before these divisions and dialectics. That primal self before selfhood dawned – constant figure in mystical beliefs, especially in the New Age culture – is a recurrent figure in the discursive structures of the media and our daily lives. It is a powerful shaper of those metaphors of invasion which have proved so brutally persuasive in the twentieth century. And both the defensive panic generated about AIDS and the narcissism more general in the culture operate together towards the production of individuality as the centre of the new social organism, replacing the fading authority of the nuclear family.

However, I have to argue that the purposes of video culture are at odds with this discursive construction of an integrated human. This is hard to say because, like everyone else, I am part of a culture in which the reintegration of mind and body, the feel-good lifestyle, are deeply entrenched. Yet dialectical thought, materialist philosophy, demands this difficult acceptance of unpleasant actualities. We cannot simply go back to an infantile state; if it were possible – as some mystical techniques seem to make it – it would not be desirable. These internal divisions within the human organism are painful, but they are also necessary. We cannot, as a species, exist without our technologies, and we cannot clean up after ourselves without some rational awareness (the awareness which, as Lovelock (1979) argues, was needed to make us aware of ecological crisis in the first place). To deal with this dialectically demands identifying first the state of affairs as they are, then negating it and only then finding synthesis, rather than ignoring the problem in the first instance. This business of negation is, I believe, the ecological function of video at this stage of our cultural evolution. Only on these grounds can we hope for a synthetic future.

AIDS, too, provides us with the metaphor that more than any other overlays our days: the metaphor of the virus. The computer hacker culture analysed by Ross (1991a), especially in North America, where conspiracy theories are an everyday cultural entertainment (and may even have some role in political life) spawned the notion that computer viruses were first hatched by the Pentagon in an effort to stop the growth of the networked counterculture. But it is argued too – notably by the *Processed*

World Collective – that the viruses, although they eat away at the instrumental uses of computers, are genuinely subversive in that they insist upon an anarchistic playfulness in dealing with the new machines while refusing to accept business domination of the new medium. The playful aspect needs to be understood ecologically too: this kind of play is purposeful in that it creates diversity in the computer environment, and it is in diversity that the possibilities for new development are germinated. So we need to think of these viruses not as alien invaders but rather in the sense of William Burroughs's great phrase: 'language is a virus from outer space'. From the point of view of language, we are the parasites, creatures who only exist in order to pass on the words and the stories. And so we should think of ourselves not as coherent, defensible positions locked inside our epidermises, but as spaces traversed by dialogues from other sources. Just as the molecules of dinner become us for a while before leaving to become something else, so language, art, culture, perceptions and ideas traverse us, make us what we are, then go. There is no integrity to being human, but a constant state of flux. That constant interchange of dialogue, like the messages on computer networks, is the content that is also the condition of our existence. What we have by way of identities is a patterned set of changes.

This is not, of course, an entirely innocent proceeding. Between humans and within each of us, there are stoppages, faultlines, breakages; the places where power is in operation, where conflict arises. Crucially, we are riven by contradictions, by the dialectic of mind and body, the splits between senses. All of these things are both deep within us and at the same time profoundly social, produced in that production of the human creature as a site where dialogues not only arrive and transfer, but where they are reworked by a language-producing creature. The great historical contradictions are precisely and specifically located in actually living human beings. Our processes, physical and mental, are those of history. The central effort of hegemonic forces in the new media is towards the construction of a watertight individuality. In doing so, few strategies have been as powerful as the return to infancy except, perhaps, the forging of an exit from history in the guise of the sexual act.

Pleasant though it is, as Pound observed in a letter to his father, far too much poetical mileage has been gleaned from the failure of

the twitching of abdominal nerves to secure a lasting Nirvana. Much of the structuralist aesthetic has now been cast aside as 'modernist', yet this fetishisation of *jouissance* remains, a kind of mental expropriation of the body. The necessity, the obligation to orgasm which anchors Western culture is reproduced even in the halls of the academy and the avant-garde: not just sex, but transcendent sex, better orgasms, the right kind of orgasms, ones that erase everything else, that simultaneously escape from, cure and validate history. Too much is invested in the humble orgasm, a tiny proportion of the body left to carry all that sensuality, all that meaning, while excluding and even obliterating all the rest. The emergence of sexuality as an all-but-unquestioned centre of cultural and social life has little to do with Freud, and a great deal to do with the appropriation of psychoanalysis to back up the sociocultural construction of sexuality. This is a very specific historical formation which we live out daily. Like the alienation of labour power analysed by Marx, bodily processes are set apart as processes over which we have no control: as, indeed, technologies. At the same time, however, they are reconfigured as the final justification of life. The presexual libido, coursing through every aspect of the body, is first centred on a single organ, and then idealised culturally – and indeed conceptually in many postmodernisms – beyond what is possible for those poor nerves to deliver. Sex has become metaphor, fetishised, alienated from the rest of the body, made to validate it, since, in the depth of ignorance, we can always be expected to prize carnal knowledge. This singling out of *jouissance* enslaves us to it, while devaluing every other pleasure; it is a further indignity visited on the alienated body, and one then used over and again in contemporary patriarchy to legitimate not only the self but the gendered self specifically.

Subjectivity too has its history, then. It has not always felt like this, to be alive. Sexuality has meant many things in the course of our own century, from Freud to feminism, from eugenics to safe sex. In many of the tapes analysed in this book, some of the micro-history of contemporary subjectivity is traced, and it is important that both speeds of this history are clear in mind, the fast-moving and the slowly evolving: that subjectivity changes minute by minute, but that its major patterns tend to change very slowly. Epochal shifts are cried with every passing fad, but they occur rarely and, when they do, take many years to move through whole populations

and the multiple layers of the mind. Conscious content changes slowly enough: studies of ideological formations made by Gramsci and Adorno in the first half of this century are still recognisable today. How much more slowly do those unconscious fragments of the psyche change, and the overall structure of the mind. Yet change it does: one has only to look into the commentaries of Thomas (1971), Huizinga (1955) or Ginzburg (1980) to see how slowly the mental formation of the European peasantry changed between the fourteenth and the seventeenth centuries, and how unutterably different their emotional, intellectual and general psychic make-up is from our own. It is only at the end of the period that the changes which can be identified in nascent form in the Italian renaissance can be distinguished among the agricultural poor of Northern Europe. Perhaps it was in that long turn of the European subject that the unconscious as we have come to live it was formed.

Comparing Judith Goddard's *Garden of Earthly Delights* with the Bosch triptych from which it makes its initial departure, nothing is clearer than that Goddard's work is of a secular age, while Bosch can still understand his world as populated by demons. Though each of his nightmare creatures derives its attributes from folklore or chapbooks, and so might be said in some way to articulate a symbolic language – as indeed is argued from opposing viewpoints by de Tolnay (1966) and Fränger (1976), the respective champions of Bosch as puritanically orthodox and as heretically sensual – yet it's hard to doubt that Bosch believed firmly in their material existence. We might say that the unconscious was far closer to the conscious mind, or that the meticulous separation of the two in contemporary Western culture was not yet fixed. In Goddard's installation, however, we can neither know that Goddard believes in the existence of the monstrous world she portrays nor believe that she draws upon a common or a hermetic symbolic language.

Where the ambiguity of Bosch's understanding and depiction of sensuality arises from a problem in historical interpretation, in Goddard it is reproduced as a problem of contemporary hermeneutics: what is the meaning of the striptease in the first screen of the triptych, a strip that ends with the wig coming off and a sneer at the camera? We can recognise the iconography of heterosexism, but not the performance. The case is similar of the mother and child walking, in the central panel, through an embattled Trafalgar Square, which was the site in the year of the work's completion of

battles between police and anti-Poll Tax protesters. What relation is there here between a national landscape (including the National Gallery) and a national icon (of mother and child), in a period in which Conservative policies centred on the family as opposed to social provision? Is this about the way the rhetoric of the family comes down to the actuality of women's individual roles as carers? It is a public world to which Goddard draws us, but one which becomes public at the expense of repressing a more intimate set of relationships and understandings. The disturbances of perspective, landscape and iconography all point to an unspoken, unvisualised relation: precisely an unconscious one. The formation of the psychosexual order in which Goddard's mother walks to and fro with her baby in her arms is, then, quite different from that of Bosch's hags and succubi. The moral of this comparison is that that order can then be changed. Even if such change takes historical epochs to complete, there will also be the smaller, narrower shifts and adjustments that can be achieved in a lifetime, and in that process, creating (or depicting) the grounds for further diversification, psychosexual as well as social, takes on the shape of an ecological imperative.

The traumatic formation of modernism, a secular, humanist, liberal and democratic ethos, which seemed to its protagonists and to us so dramatic in its effects, took centuries to work itself through. We should therefore not be too hasty to announce the end of that epoch, when so much remains in balance. Neither should we expect to find the kind of wild veerings in the formation of subjectivity that the more portentous acolytes of postmodernism await. But we should not expect stasis either, especially when analysing the relationships formed around the video media, so central to – or symptomatic of – the emergent formation. The shaping of a contemporary subjectivity is frequently narrated in terms of the development of the mass media, and this book in some ways intimates that the move from mass movie to domestic and, more recently, to personal media relates closely to a – to some degree novel – fragmentation of personality. Perhaps it would be more accurate to see these as elements of an ongoing process, and one in which it is increasingly important to intervene. Max Almy's tape *Leaving the Twentieth Century* gives a material shape to this mediatisation of the psyche, with typical humour, as her protagonist is counted awake by an interior voice which delivers news and

truisms, as if, as the postmodern vaunts its superficiality, the unconscious were made public and were there rationalised for the positive purposes of the administered society. But what Almy here, as in other tapes like *The Thinker*, finds as a saving grace is the potential for overload in a thoroughly managed, efficiency-driven system. It's at this point that it becomes possible to think about the politics of a new sociality based in unstable identities.

In arguing for a crisis, there is the temptation to look for an apocalyptic solution. The Western cultural formation loves an ending, and will sacrifice truth or logic to the pleasures of a satisfactory conclusion anytime; Joyce's great contribution to the history of literature was to invent two brand new endings. In promoting crisis, there is the temptation to expect the revolution not as a beginning, but as an end. But if anti-foundationalist philosophies have taught us anything (and that is a debatable point), it would be that the history of the future cannot be dictated. This does not mean, however, that it cannot occur, but that our responsibility is to create the terms under which some kind of future, preferably a better one, is possible. Like the past summoned up by holistic media forms, that infantile narcissism mobilised in too many computer-generated animations, the future cannot be asked to provide a completion that justifies the present. For us, in our time, for now, crisis will have to be enough.

We blink briefly into existence and blink out again. There is no 'afterwards' for the individual, and our only immortality – since, given the increasing rate of mutation of the human genome with every generation, not even DNA can promise eternity – is the memory that will live after us. But the mounting numbers of the dead mean that an ever-diminishing number can possibly be remembered, and many of them wrongly, hanging around like ghosts to haunt the living. Instead we need to think of the implicit memory of the social world, which follows Freud's rule of the psyche, that nothing is forgotten. Just as every least event is remembered somewhere in the human mind, so the practically infinite flow of human interaction is accumulated in the grounds for the next moment of that flow. All the things we say are not remembered as quotations, but in the way the conversation goes next. Each moment of a conversation is the condition for the next moment, and that is the principle of the interlocking global conversation to which we all contribute. That is the human ecology

to which, then, we owe responsibility for creating the terms under which our speeches and deeds might be recalled.

There is perhaps one other kind of time in which we might find salvation, one which demands a rethinking of the hedonist present invented to provide capital with a moment for consumption and gratification. The aesthetic moment of the epiphany can be upheld, as it is especially in recent rewritings of the Kantian sublime by Lyotard, but far more generally in the culture of living for the moment shared by rock culture and some elements of the New Age. But even that is a fading light, a metaphysical belief in the way a moment can be made to crystallise all the time around it, an extension of the sexual moment evoked in Barthes's aesthetics. But we could also look at the phenomenon described in this philosophical tradition and try to understand it differently: as Benjamin's apocalyptic or messianic time. The moment of beauty, as instantaneous as curds formed in milk at the first splash of bitterness, is immemorial, because it has escaped from history and, from outside, validates it. But in Benjamin's marvellous 'Theses on the Philosophy of History (1969, pp. 253–64), of which only the note on Klee's *Angelus Novus* is well-known, we find a materialist reworking of this conception of the instant. First, we are that future for whom past millions toiled and suffered, and we owe it to them to unearth the joy in our lives that would validate the lack of it in theirs. Second, as each moment is possibly that in which the Messiah is to arrive, each moment can be 'blasted out of the continuum of history', the clock-time on which the administered society so firmly relies. But Benjamin ties these together with the thesis advanced here about a human ecology when he argues – in a passage that rings particularly powerfully as I write this afternoon, the day after another Conservative government is returned to power in the UK – that 'as flowers turn towards the sun, by dint of a secret heliotropism the past strives to turn towards that sun which is rising in the sky of history. A historical materialist must be aware of this most inconspicuous of all transformations' (Benjamin 1969, p. 255).

Benjamin argues thus that we are responsible for the well-being of the dead, since if the enemy wins they defeat those who died in struggle as well as those that survive. So we are responsible for the conditions under which each of our comrades is born, under which they live. We are responsible for the natural environment, but also for the human ecology. We are responsible for the only thing that

can be attained here on earth: the full pleasure of being alive. As long as we deny that pleasure to the majority of the planet's population, ecologically (and aesthetically, as Oscar Wilde would have argued) we deny its fullness to ourselves. Our own wealth strangles us in chains of pollution and dietary addictions. And as we are capable of destroying the planetary gene pool, so we are capable of annihilating the necessary diversity in culture without which there can be no future for our species. The present is itself much in jeopardy: our culture is globalised, but impoverished.

Processes have a kind of continuity over the various scales at which they work: global, national, local, interpersonal and intrapsychic. There seems little question that contemporaneity of lives leads to a certain shared experience and interpretation in a global system, which is, after all, what we now have. Yet there are also claims for cultural difference that need to be recognised, and these at just about every one of these scales. The important point here is that the great historical movements of an age – let's say, for example, the role of the commodity in the global economy – are commonly experienced, but differently, not just at local or individual levels, where we expect difference, but between levels too. At each level, we find a common process re-experienced differently. Thus a fiscal crisis in global capitalism makes itself felt differently not just between nations, but at the level of nationhood. Likewise, the local level experiences such crisis differently again: as loss of jobs, as closure of shops, as falling prices. In groups, we might accept, deny or rejoice over the crisis, finding in it proof of our beliefs concerning politicians, business people, the international Zionist freemason conspiracy or whatever.

Most of all, however, we experience these things differently at the intrapsychic level. There is little doubt that there is a great deal in common between the macro and the micro of social interaction, between the global, local and interpersonal relationships and the ways in which they cope or fail to cope with crisis. But I would argue now that there is a difference not just of scale but of quality as we pass through the scale of conscious (that is Symbolic, meaningful, interpersonal) individual reaction and begin to explore the micro-processes of the human psyche. How do we express those differences as internal differences within the psyche? Can we expect to find a more-or-less familiar cause and effect relationship, or must we look for a differently organised internal dynamic? I believe so, and am

convinced that what we see enacted in the processes of video culture is the politics of just such an internally differentiated personality, and one whose internal processes increasingly take on social lineaments. Narcissism is pre-individual, and therefore pre-gender. If it is at present, in the formation of a new dominant mode of visuality, a liability, it may yet become a tool in the production of a newly social psyche, one in which gender is as radically unfixed as it is in much video work. Though narcissism be appropriated in virtual realities, for example, for a new individualism, it can be reproblematised, made another battlefield, in the cause of a socialised psyche. The gradual processes that have produced a Western culture endowed or burdened with an unconscious, and otherwise riven by splits and instability, provide us with an opportunity to reopen our society just at the moment at which it appears most likely to complete an act of closure.

If, as I argued above, the myth of a unitary and whole body at the origin of our suffering and dispersed one is merely a useful fiction, and the body is irrevocably split both from the mind and from its own organs, while the psyche too undergoes a series of splittings and decentrings; if, then, psyche does not stop at the head but extends through the body in the nervous system and thence out into the world, while the body does not stop at the epidermis but in its feeding and excretion is allied to the world; and if, finally, mind and body alike, though separately, are enmeshed in other minds, other bodies, then we have the ground for an ecological politics of the human world. This is not to argue that there is an inseparable link between psyche and soma, between human and natural; precisely the opposite. In becoming historical beings, we have become so profoundly divided away from the world that we can no longer go back along the route we followed. Our sight is organised into such powerful visualities that we cannot see without them: our other senses are so atrophied that we find them almost an embarrassment (especially smell, but also touch, taste and sound, most of all when they emanates from our own bodies). The politics of crisis involves a materialist grasp of this situation, and seizing the opportunities it presents. Instead of trying to rescue the unconscious in order to put it at the service of rationality – the analytical style Lacan fought against all his life – we should take on the difficult responsibility for multiplying the differences within the psyche, not by throwing ourselves into clinical schizophrenia – precisely the danger of

premature synthesis offered by kitchen-sink psychotropics, all too manipulable within the administered society – but relishing the multiplicity, the variety of our psychic experience, with all its danger and its cruelty.

No medium offers itself more readily for this exploration than video, which begins its work precisely in the heart of the regime of looking. Beginning there, it is possible to begin the dismantling of the individualised, fetishised body that emerges now as the goal, as well as the putative origin, of cultural activity. That body without orifices – without pores or holes where smells and noises emerge – is a visual body, and it is in the audiovisual that it must be made porous again. Video disassembles the ontological pretence of the image (its pretence at presence) by creating a porous and extensible time out of what otherwise is constructed as the irrefragible instant of sight. Mulvey argued (1975) that cinema produced structures of fascination which were founded in the formative moments of individuality in the mirror stage. But it could be argued that this is also the moment at which the psyche experiences the birth of the Other, giving cinema a positive social role in articulating the nascent self's traumatic relationship with society. But when video lures vision into the interior of the screen, as in George Barber's recent tapes (*Curtain Trip, Desperately Seeking Dave*), it constructs fascinations on the basis of self-absorbed narcissism that, however, by drawing the spectator out along the line of sight, can begin the process of reconnecting the internal with the external world from which it has been estranged in regression, and which it has been encouraged to forget.

My first book led me to the conclusion that video has a uniquely democratic mission because it is so intrinsically indefinable: so proteiform, so multifarious. The work of writing this text has led me to a further discovery, or at least towards thinking something that I, a reader of this book, hadn't thought before. That is that video media need to be thought in terms of relationships first, and of representations only second. Representation, the core of orthodox British media studies, is a special case in video media, unlike the photochemical, lens-based media – film and photography – in which it plays a more central role.

It is not that there is no representation, or that there has been an irrevocable historical shift away from it, leaving it an impossible dream, but that it is no longer the sole or the central object of study

in the analysis of audiovisual media. This complex is what we have grown to call representation, and it has been the core of those analyses that centre on reading the meanings off from audiovisual texts, especially those focussing on ideological readings. Ironically, such readings, of course, are targeted not at representation but at misrepresentation, a far more common factor in photomechanical media. Such texts – the *locus classicus* is in film studies – are said to pose as accurate descriptions of reality, and the critique has always been (a) that they are not, but are class/gender based accounts of partial elements of reality and (b) that an accurate summation of the Real is impossible because audio-visual language and reality are not of the same kind. But here I argue that (b) is incorrect: the world and speech about the world are not of a kind, but they are not utterly dissociated. Their separation is historical, social; it can be reworked. The formal properties of language share the morphology of the real: the two, while not identical, share some of the same shapes (for example a tape occupies a measurable extent of time in the real world), and some of the same processes (for example, the physics of colour and of sound). The material aesthetics of electronic media leads us away from the prison of representation – the enounced, and the subject of the enounced – and into the realm of relations between enunciations, and the subjects of enunciations: what cultural studies isolates as the moment of reception.

This shift is brought about in one of the more local determinants on the genesis of this book: a distrust of the literary appropriation of film and media studies in the UK. An exclusive reliance on textual practices, marginalising cultural activity more generally, allows such a strategically important figure as the British Film Institute's Paul Willemen to descry 'an almost terroristic imposition of the crudest types of populism' and 'malevolently paranoid anti-intellectualism' (Willemen 1992, p. 16) on the part of video practitioners and those who, like Valerie Walkerdine, Channel 4's *The Media Show* and myself, have supported them. In opposition, he cites 'a fundamentally cinematic mode of attention' (p. 26) to the textual qualities of works. What I want to argue here is that this misses the point. Videography does require a detailed attention to textuality: but it also requires attention to production and post-production, to the terms of exhibition, distribution, broadcasting, reception and consumption, to the activities of publicists and journalists, curators and activists, funders and audiences. By focussing narrowly on

textual properties, in the literary critical style of the academy, Willemen misses the opportunity to understand the broader parameters of critique offered by a cultural analysis of the conditions of enunciation and the active processes of communication in which the text plays an important but neither isolated nor unique role.

To come at the problem in a more global way: if technology is a relationship between people that appears to them as a thing, and video is a relationship between technologies, then video is the relationship between relationships; it is not so much an interpretation as a mood (subjunctive?) in which relationships are affected, so that relationships, hermeneutic or no, are central to understanding it, not representation. For example, there is the much-observed phenomenon of electronic banking. The cash nexus, in which our social, political and psychosexual status are all closely bound, is precisely a formative technology that appears to us as something beyond our control: video art gives form to the electronic nexus – the invisibilisation of cash – in work like Joanna Moss's frozen finance screens or the numerical sequencing of Stefan Dowsing's meditative installation work *Faces of Light* (1991). Interrupting the flow, fragmenting, destabilising by giving a shape that can be manipulated: these are enabling devices, new relationships that put power in question. Perhaps it is possible to begin to imagine, in the field of the relationship of relationships, a socialised unconscious that shares the fluidity of dialogue, rather than the overconcretised, overindividualised unconscious of more traditional psychoanalysis.

Not that this quality of video – a relation of relationships – is necessarily positive. The postmodern is a middle-brow culture, not a popular one. The real postmodern texts don't hang in galleries or get shown on prime time television: *Starlight Express* and *Cats*, for example. The abolition of history is all too clear in *Miss Saigon* and *Evita*. The triumphant suburban culture (of which the New Age [cf. A. Ross 1991b] is a modulated expression) is the culture of repressive tolerance, of endless mediocrity masquerading as individuality. Enzensberger's *Mediocrity and Delusion* (1992) accuses German culture of catering only to the median within allowable deviation tolerances. As a relater of relationships, the TV in particular has become a standardiser, relating all to a golden mean, and reducing as much as possible the use of the media as terrains of struggle. The purpose, then, of video art in video culture

is to attack and destroy mediocrity; not in the name of the popular or the highbrow, but in the name of real diversity, real difference.

The word is losing its valency. The philosophers increasingly turn from the 'end of philosophy' towards the rhetorical analysis of language, admitting a kind of defeat before the recalcitrance of phenomenological 'Being' (resulting, one guesses, from a failure to take materialist philosophy seriously) and moving towards another kind of literary study. Armed with an ideological critique of 'totality', this school of thought has created a total critique of thought, a disabling myth of language's inability to escape from the simultaneous necessity and impossibility of representation. So media students say that audio and video are 'structured like a language' at the very moment that that structure is unpinned as the central one in the Western culture. And therefore video finds itself undertaking the critical work, the negative work, which once was the prerogative of philosophy, that most verbal of forms, taking over that function in the spirit of the betrayed legacy of Hegel. As language is pursued into tail-chasing rhetoric, video, freed of representational burden, becomes philosophical. And indeed, it now need no longer limit its themes to the relation to reality – the epistemological – but can entertain other issues, as, I hope, picked out here.

We have this sense of video as a 'philosophical' exploration of relationships: unpicking and reworking the technologies through which individuals relate or fail to relate to one another; unpacking the relationships between one mode of technological relationship and another, and between each of them and the wider world. But where is the actual tape that does this? Taking an ecological standpoint means both giving the meticulous attention to the fabric of each work that each demands, but also trying to think of the whole field of video practices. Each work needs considering as a tile in the mosaic; the tile may have its values, some of them intrinsic to the tile. But many of them – perhaps the most important at this point in history, when keeping any kind of culture alive during the invention of the new form is paramount – derive from the relationship to all the other tiles. You can judge the cultural work in a tile by its orientation *vis-à-vis* the others, by how it contributes to or conflicts with prevailing patterns. In this multidimensional matrix, the alignment is perhaps more like the magnetic alignment of oxide particles on tape. There is no homology between an individual tape

and the whole field, no holographic relationship in which all video is visible in a single piece. Profusion and openness, process and struggle: these qualities mark responsible work in the electronic ecology.

The truth status of this? Frederic Jameson (1991, p. 385) quotes approvingly Adorno's dialectical formula: that something may be the case without necessarily being true. I rather feel that my 'discovery' of video's special vocation to embody relationships is 'true', correct even though it may not be the case. Were it the case that there existed an absolute Truth, and that the historical mission of video was to give real form to that absolute, then the absolute to which it would tend would be that of giving form to relationships, both between people, and between people and reality. In the absence of such historical absolutes, it still seems that writing about video – videography – is rendered more thinkable by the device of forming a mythical whole, a network that can be considered as possessing historical agency. The concept of agency is a strange one: we think that it is the case that individual people do not make history occur (for example, that Napoleon didn't conquer Europe alone). And in place of individuals, there has evolved a habit of speaking about other forces – notably Hegel's world spirit – as if they were the agents which made history move. This habit of speech is so widespead and deep-seated that it is difficult to avoid writing as if capitalism or video were conscious creatures capable of acting historically.

Yet it is also clear that history does occur: things do change. One of the flaws of the historical agency theory is that it tends to encourage you to sit back and wait for the necessary truth of history to emerge. These are not days in which I would like to do that. Adorno's comments can be adapted for our times if we take it as a principle that, where the facts don't match the implicit or inherent truth of the medium, then it may be necessary to produce those 'facts' in such a way as to influence the construction of the truth. This is the way in which this book has been composed: not by falsifying information, but by creating a new 'fact' in the video culture. This may seem like irresponsibility from the standpoint of authoritative scholarship; in the video culture, it seems like a necessary genesis of responsibility not to some metaphysics of absolute Truth, but as commitment to the possibility of a future culture.

When it is suggested that a concept like 'freedom' not only drives history, but has achieved its goal, as Francis Fukuyama (1990) has claimed, the effect is to deliver us over to the manipulations of the market. The market is the opposite, conceptually and practically, of an ecology. An ecology is characterised by diversity, cooperation and mutuality. A market is characterised by standardisation, competition and mutual destruction. The worst pun of the nine-teenth century, which turned Darwin's insight into the need for evolving species to 'fit' into a niche in their environments into 'survival of the fittest', still informs the market ideology. Yet that ideology has clearly not succeeded even by its own definitions. Ageing fascist calls (such as that the highest duty of the state is to control the supply of money) are still powerful as the concentration of wealth in ever fewer hands continues apace. As it does, it infects every aspect of our world, and nowhere more so than the emergent media.

Where we look for diversity we find industrialised commodities, and relationships to them anchored around the repressive institutions of the family, the village, the temple, the firm or the state. Where we seek out cooperation, we are split off from one another by the industrial division of labour, by fiscal constraints and by the apparent necessity to conform to competition. And so we get a destructive, homogenising and enclosed environment instead of an open one. The kind of fragile ecology which video workers around the world have begun to establish is based in a perception that the environment is composed of activities which would be impossible unless the environment for them existed. There is no practice without the culture, but the culture is itself composed of these practices. The mutuality of this little ecology, threatened in every way, is a gem of hope at the bottom of the Pandora's box of the 1990s.

In an orgy of faith, we are called to believe in the free market, despite its manifest incompetence to secure a decent life for all, even for most: an orgy of faith without charity or hope. And in orgies of charity, we mistake generosity in the pocket for change in the heart: self-indulgent charity, barren, lacking hope or belief. This book is written because the idiot dancers of the New Age and the *idiots savants* of the New Right, offspring of disillusionment and suburbia, alike seek simple, clear solutions for the world and, despite the evidence, insist that they have found them. This kind of simplicity

isn't charming: it is stupid and brutal, the mission statement of the inflamed fundamentalist, ready to preside over a thousand deaths to save one soul. In a culture that has mislaid the faculty of hope, the video media emerge. No medium comes into existence without struggle, and the terms of the struggle for video media are the terms of a world driven by blind belief in avarice and a culture based on the present to the exclusion of history or the future: a present without change. The world into which video is born is the one which Wittgenstein crushingly defines as 'all that is the case' (1961, p. 5), echoing the deafening, unarguable chorus from Aeschylus: 'Things are as they are.' Video's function, working at the micro-level of history, is to bring alteration to this stasis.

Against it are arrayed the armaments and lures, the sticks and carrots, of a world order that hates, above all things, change. For every avenue of thought, invention, practice that has been proved wrong but has been stuck to with the obdurate ignorance of the powerful, another and more promising one has been scored off the maps of the possible. In the interests of the management of desire, the options that might have been explored, that might have led to other cultural and social formations, are meticulously and repetitively cut off. After Auschwitz and Hiroshima (crimes not of humanity, or of the USA and Germany, but crimes thinkable only in the context of advanced capitalism and the military-industrial complex), after war, it is hard to believe that any good can come of the current system. But if we have to become aware that atavism and entropy can be produced from the past, we also need to know that so may real achievement: the rise of the British welfare state, the making, against all odds, of a living culture which, like rock 'n' roll, still continues to renew itself despite its intensive commodification. History has not ended, will not end, partly because capital is fated, in the pursuit of growth, to produce new inventions, any one of which may contain the seeds that will overthrow it, and partly because the great contradictions of wealth and poverty are that last instance whose hour does necessarily come. The global structure of capital is too unstable to survive.

Writing these closing pages in the wake of British elections that returned a deeply reactionary government to power, it may be that I'm whistling in the dark here, to keep my spirits up. These are dark times, and must be faced. In an ecological critique, there should be room for an understanding of the politics and economics of the

provenance of these machines in the offshore/migrant labour of the electronic hardware business, and the repetitive stress injuries, the fading eyesight, the abbreviated working life expectancy. Attention should be paid to 60mHz radiation. There should be far greater attention to the exclusion of the majority of the world's population from the emergent ecology, and without them we minimise diversity, impoverish the culture, and threaten its ability to grow. The problem with the ecological model of humanity is that we don't have an ecology, since we exclude so many from it. An ecology would require the largest numbers of people making things: but they need to eat first. Perhaps the video media can have some part in that struggle. Nowadays, such hope is not a luxury.

Chronology

What follows is a skeletal outline of the development of the technologies, practices, legislation and discourses which have framed the development of video recording. Its purpose is to help the reader gain some sense of the historical developments within which video has grown. It is not intended to give the impression that a handful of great men have been responsible for the discovery of essential principles of nature, or that progress is the major principle of history. This list of firsts must be understood against the background of the development of corporate and transnational capitalism, against the increasing concentration of ownership in the electronic media industries, the development of an international information and image economy, and the growing gap between rich and poor nations. My major sources are Armes (1988), Welsh (1991), Geddes (1972), Hartney (1984), and London (1985a), the reader is referred to Armes in particular for suggestions on how this listing might be turned into useful knowledge. Further information on the technological aspects of video can be found in Money (1981), and on business aspects in Wade (1985). An excellent sense of both the technology and the business of computing can be found in Kidder (1981). For updates on technology and business, the reader is referred to *Scientific American* and *Screen Digest*.

1802	Thomas Wedgewood produces photograms by placing objects on photosensitive surfaces
1827	Niepce fixes on a pewter plate an eight-hour exposure of the view from his window
1839	Daguerrotype process made public in Paris
1844	Samuel Morse demonstrates the electric telegraph
1849	First European commercial telegraph opened; Reuters news agency founded
1863	The Electric Telegraph Act (UK) establishes the principle of state's right to regulate scarce channels
1875	Introduction of the mechanical calculator
1876	Alexander Graham Bell applies for basic telephone patents
1878	Thomas Alva Edison patents the mechanical phonograph; introduction of the shift-key typewriter
1889	George Eastman launches nitrocellulose film for use in patent Kodak cameras, developed later for use in moving images
1893	Edison and his chief engineer W.K.L. Dickson complete a working kinetoscope (peep-show) using celluloid film, opening the first commercial parlour in the following year

1895	28 December: Louis and Auguste Lumière give the first public demonstration of a projected cinematograph
1896	Guglielmo Marconi patents wireless telegraphy
1911	Official Secrets Act places major restrictions on UK media after spy scare: still in force
1914	All amateur radio broadcasting banned in Britain until 1919
1919	Marconi assets seized in the USA and assimilated into the Radio Corporation of America cartel (including GE, Westinghouse and AT&T), which introduces the concept of 'toll broadcasting', (paid advertising on air)
1922	Formation of the British Broadcasting Company (made a Corporation in 1927)
1925	March: John Logie Baird demonstrates mechanical television in Selfridge's, Oxford Street, London; launch of the electrical gramophone for replay of electrically recorded discs; first Geneva Conference on international allocation of airwaves.
1926	*Don Juan* premièred by Warner Bros, first feature film with recorded sound, *The Jazz Singer* following in 1927
1927	The USA's Radio Act introduces the principle of the state licensing (not selling) airwaves to broadcasters
1933	EMI demonstrate the Emitron electronic camera, incorporating Zworykin's iconoscope, officially adopted by the BBC in 1937
1936	2 November: BBC commence first regular broadcasting service from the Alexandra Palace, London; Alan Turing publishes on the *Entscheidungsproblem*, including notes on the Universal Turing Machine, first theoretical design for a computer
1937	First commercial marketing of the Magnetophon, first recording device to use oxidised tape, for office use
1939	TV broadcasting halted in UK (until 1945)
1947	Bing Crosby takes delivery of the first Ampex reel-to-reel audio tape recorder of broadcast quality
1948	Invention of the transistor, the first step in the development of the microchip; introduction of black-and-white Polaroid film; 45 r.p.m. and LP records introduced
1949	ENIAC computer comes on-line at the University of Pennsylvania
1951	USA adopts NTSC colour system for broadcast; all major US film studios have by now moved from optical to magnetic sound recording; Remington Rand introduce first commercial mainframe computer, UNIVAC
1954	Commencement of Eurovision networking
1955	Commercial TV broadcasting commences in Britain: licences will double in number from 4 million to 8 million by 1958
1957	Ampex Corporation introduce first industrial videotape recorders; Sputnik launched
1958	Commercial launch of stereophonic records; Nagra portable reel-to-reel sound recording deck introduced; Eclair and Arriflex introduce lightweight 16mm cameras; Wolf Vostell exhibits *TV Dé/Collage*, installation including 3 minutes erased from a television programme

1960 John Whitney founds Motion Graphics Inc, producing moving images on home-built mechanical analogue computer; he becomes IBM's first artist in residence in 1966

1962 Launch of Telstar, first telecommunications satellite; MIT put *Spacewar* on the market, the 'first' computer game

1963 Nam June Paik's first one-man show at the Galerie Montparnass in Wupperthal, including treated televisions: 'the first video sculptures'; Vostell shows *Television Dé/Collage* at Smolin Gallery, NY (first US installation including a TV monitor)

1964 Pirate radio broadcasting commences offshore in the English Channel

1965 Sony Portapak introduced; October: Paik imports one of the first portapaks into the US: his first tape (of Pope Paul VI's visit to New York) shown that night at the Café A Go Go; Intelsat launch first commercial telecommunications satellite; introduction of audio-tape cassette

1966 *International Times* (*IT*) begins publication in UK; Dolby noise reduction introduced on audio cassettes

1967 BBC adopts PAL colour system; WGBH in Boston, Mass., inaugurates artist in residence programme; Marine Broadcasting (Offences) Act makes pirate radio illegal in UK

1968 First Portapak imported into the UK by John Hopkins; first tape is about squatters' rights in Elgin Avenue, London. Hopkins and Cliff Evans begin a series of experimental works at the New Arts Lab, Drury Lane, London; Ant Farm founded in San Francisco; *Cybernetic Serendipity: The Computer and the Arts* show, originated at the ICA, London, tours to the USA; *The Machine as Seen at the End of the Mechanical Age* show at MoMA, NY, first national gallery showing of video art in USA

1969 Intel introduce first microchip; *TV As a Creative Medium* at Howard Wise Gallery, NY, first all-video gallery show in USA; Raindance Corporation and Videofreex founded; MIT open Centre for Advanced Visual Studies ('The Media Lab')

1970 Gene Youngblood publishes *Expanded Cinema; Electronic Arts Intermix* founded in New York; *Radical Software* commences publication (till 1974); Video Inn (Vancouver, BC) open series of Matrix conferences and launch *Video Exchange Directory*

1971 BBC Scotland broadcast 'Seven TV Pieces' by David Hall, the first UK broadcast of electronic media arts; Videofreex start low-power broadcasting in upstate New York; publication of Michael Shamberg and Raindance Corporation's *Guerrilla Television*; US Federal Communications Commission require cable operators to provide at least one channel of locally originated material; Intel develop commercial microprocessors; The Electronic Kitchen (later simply The Kitchen) founded in New York; Open University founded; *Spacewar* and *Pong* launched as first video arcade games; *Oz* trial widely seen as the end of the underground press in Britain (the magazine closes in 1973)

1972 Phillips market the first three-quarter inch video cassette recorder;
 BBC introduce digital sound in television broadcasting; Time-base
 corrector introduced, allowing professional standards on low-band
 equipment; Greenwich Cablevision, UK's first cable station; First
 Annual National Video Festival, Minneapolis, USA; TVTV brings
 together independent videomakers for coverage of Democrat and
 Republican conventions, first use of half-inch tape in US broad-
 casting; Sound Broadcasting Act legislates for commercial local
 radio in UK; first domestic video games machines released
1973 First inclusion of video art in the Whitney Biennial of American
 Art, NY
1975 May: Serpentine Video Show, London; first meeting of British video
 art producers; Video Art at the Institute of Contemporary Art of the
 University of Pennsylvania; Institut National de l'Audiovisuel
 (INA) founded in Paris, France
1976 Formation of LVA (London Video Arts; later London Video
 Access); Video Show at the Tate Gallery, London, first recognition
 of video art by a national collection in the UK; 'Video Art', special
 edition of *Studio International*; Sony and Phillips independently
 introduce laser video disc; Apple market first fully-asembled
 personal computer; Beryl Korot and Ira Schneider publish *Video
 Art: An Anthology*, first collection of criticism and artists' statements
1977 Send/Receive Satellite Network links NY and San Francisco for live
 video/performances; *The New Television: A Public/Private Art*
 manifesto, USA; *Star Wars* released, first all-Dolby mastered
 soundtrack in cinema
1978 First LVA evening at the AIR Gallery, London
1979 Decca launch first digital audio recordings; *Video from Tokyo to
 Kukui and Kyoto*, first major international show of Japanese video,
 curated by MoMA tours USA, Japan and Europe; Atari/Warner
 introduce *Space Invaders*: sales of video arcade games will rise from
 $50 to $800m. in the next three years
1980 Sony launch the Walkman personal stereo
1981 First World Wide Video Festival at The Hague, Holland; First
 National Video Festival, Bracknell, England, run annually to 1988;
 The Broadcasting Act (1981) founds Channel 4, with a specific remit
 to encourage 'innovation in form and content'; Sony introduce
 Compact Discs (CDs); First National Latin Film and Video festival,
 El Museo del Barrio, NY; formation of Paper Tiger Television
1982 The Workshop Declaration signed by Channel 4 and the
 technicians' union ACTT, allowing collective work practices for
 broadcast; foundation of SIGGRAPH, annual showcase and
 discussion forum on computer media, Boston, Mass.
1983 Channel 4 makes first investments in access and workshop
 production; birth of scratch video
1984 First Bonn Videonale; Bruno de Florence launches the Video
 Lounge at The Fridge, Brixton; pirate TV stations operate in South
 London and Birmingham; sales of VCRs in UK top 40% of

households; the Video Recordings Act introduces censorship of videos after a year of moral panics; *The Luminous Image*, major retrospective of video arts, Stedelijk Museum, Amsterdam; *Video: A Retrospective* at Long Beach Museum of Art, LA, with important catalogue; *Video: A History* at MoMA, NY; *Good Morning Mr Orwell*, live satellite art event produced by Nam June Paik for WNET/13, NY and FR3, Paris

1985　Sony introduce domestic chip-based video camcorders

1986　500 000th CD player sold in Britain

1988　The Arts for Television, international touring exhibition curated at the Stedelijk Museum, Amsterdam

1989　First of biennial Video Positive festivals, Liverpool, England; *Video Skulptur: Retrospektiv und Aktuell*, major exhibition at Kölnischer Kunstverein, Cologne, Germany.

1990　*Signs of the Times*, touring retrospective of British film and video installation curated at MOMA, Oxford

List of Videos and Distributors

LIST OF VIDEOS AND FILMS CITED

Alchemy (Simon Biggs, 1991, UK) Installation. Dist. LVA
AMY! (Laura Mulvey and Peter Wollen, 1980, UK) 16mm. Dist. BFI
Anicca (Daniel Dion, 1990, Can:) Installation
Art of Memory (Woody Vasulka, 1987, US) Video. Dist. LVA
L'Assassinat du Duc de Guise (Comédie Française, 1908, Fr.) Film
Autumn (Catherine Elwes, 1991, UK) Video. Dist. LVA
Belshazzar's Feast/The Writing on Your Wall (Susan Hiller, 1983–4, UK) Installation. Collection of the Tate Gallery, London
Blade Runner (Ridley Scott, 1982, US) 70mm
The Colour Myths (The Inevitability of Colour; Echo's Revenge, The Object of Desire) (Terry Flaxton, 1991–, UK) Video. Dist. LVA
The Conquest of Form (William Latham, 1990, UK) Computer sculpture
The Cook, The Thief, His Wife and Her Lover (Peter Greenaway, 1990, UK) 35mm
Cornered (Adrian Piper, 1990, US) Installation
Couch (Andy Warhol, 1963, US) 16mm
Curtain Trip (George Barber, 1991, UK) Video.
Der Golem (Simon Biggs, 1988, UK) Installation. Dist. LVA
Descry (Judith Goddard, 1992, UK) Installation
Desperately Seeking Dave (George Barber, 1990, UK) Video. Dist. FVU
Eat (Andy Warhol, 1963, US) 16mm
Empire (Andy Warhol, 1964, US) 16mm
Escalator (Tina Keane, 1988, UK) Installation
The Evolution of Form (1) (William Latham, 1989, UK) Computer sculpture. Dist. FVU
The Evolution of Form (2) (William Latham, 1991, UK) Video wall
Faces of Light (Stefan Dowsing, 1991, UK) Installation
The Flood (Jaap Drupsteen, 1985, Holland) Video
France/Tour/Détour/Deux/Enfants (Jean-Luc Godard and Anne-Marie Miéville, 1978, Fr) Video. Dist. ICA
Fusion and the Electrical Prowess (Lei Cox, 1990, UK) Video. Dist. LVA
Fujiyama Pyramid Project (Peter Callas, 1990, Aus) Installation. Dist. LVA
Le Gai Savoir (Jean-Luc Godard, 1968, Fr) 35mm
The Garden of Earthly Delights (Judith Goddard, 1989, UK) Installation. Dist. LVA

Hotel (Ann Wilson and Marty St James, 1988, UK) Installation and performance, AIR Gallery, London

Kiss (Andy Warhol, 1963, US) 16mm

Knick Knack (John Lasseter/Pixar, 1991, US) Computer animation

Leaving the Twentieth Century (Max Almy, 1982, US) Video

Lei Can Fly (Lei Cox, 1988, UK) Video. Dist. LVA

Luxo Jnr. (John Lasseter/Pixar, 1986, US) Computer animation

Magnification Maximus (Lei Cox, 1991, UK) Installation. Dist. LVA

Memories of Medieval Manhattan (Brian Eno, 1988, UK) Video

Merce by Merce by Paik (Merce Cunningham and Nam June Paik, 1975, US) Video

Modern Times (Charles Chaplin, 1936, US) 35mm

Mseleni Tales (Lynne Fredlund, 1989/90, UK) 16mm. Dist. Africa Sound + Image

Neo-Geo: An American Purchase (Peter Callas, 1989, Aus.) Video. Dist. LVA

A New Life (Simon Biggs, 1989, UK) Video. Dist. LVA

Night's High Noon: An Anti-Terrain (Peter Callas, 1988, Aus.) Video. Dist. LVA

NLV 1 (*Strange Attractor*) (Clive Gillman, 1989, UK) Video. Dist. LVA

NLV 6 (*Sublime*) (Clive Gillman, 1990, UK) Video. Dist. LVA

One From the Heart (Francis Ford Coppola, 1983, US) HDTV

Penthesilea (Laura Mulvey and Peter Wollen, 1973, UK) 16mm

Portrait of Duncan Goodhew (Anne Wilson and Marty St James, 1990, UK) Installation

Portrait of Shobana Jeyasingh (Anne Wilson and Marty St James, 1990, UK) Installation

The Process of Evolution (William Latham, 1991, UK) Computer sculpture

Prospero's Books (Peter Greenaway, 1991, UK) 35mm

Riddles of the Sphynx (Laura Mulvey and Peter Wollen, 1975, UK) 16mm

Seal (Gareth Roberts, Big TV, Michael Geoghegan, Don Searll, 1992, UK) Dist. ZTT/Warner Music Vision.

Seven TV Pieces (David Hall, 1971, UK) Broadcast video. Dist. LVA

A Situation Envisaged: The Rite II (David Hall, 1988, UK) Installation

Sparkle and Fire (Maria Vedder, 1990, Ger:) Installation. Dist. LVA Installation

Spring (Catherine Elwes, 1988, UK) Video. Dist. LVA

Star Trek: The Movie (Robert Wise, 1979, US) 70mm

Star Wars (George Lucas, 1977, US) 70mm

Streamline (Chris Meigh-Andrews, 1991, UK) Installation

S.T.R.E.S.S. (Southgate Video Group and Simon Robertshaw, 1990, UK)

The Temptation of Saint Anthony (Simon Biggs, 1990, UK) Video. Dist. LVA

Terminator 2 (Andrew Cameron, 1991, US) 70mm

The Thinker (Max Almy, 1989, US) Video. Dist. LVA

Tin Toy (John Lasseter/Pixar, 1988, US) Computer animation

Top Gun (Tony Scott, 1986, US) 70mm

La Tortue qui chante (Hantz Koffi, 1987, Togo) Video

TRON (Steven Lisberger, 1982, US) 70mm
TV (Kurt Kren, 1966, Ger.) 16mm. Dist. LFMC
2001: A Space Odyssey (Stanley Kubrick, 1968, US) 35mm
Video-Buddha (Nam June Paik, 1974–88, US) Installation
Visual Shuffle (John Sanborn and Mary Perillo, 1986, US) Video. Dist.
 LVA
Why Do Things Get In A Muddle? (Gary Hill, 1984, US) Video
Winter (Catherine Elwes, 1988, UK) Video. Dist. LVA
(Wishing) Well (Catherine Elwes, 1991, UK) Installation. Dist. LVA
Zygosis (Gorilla Tapes, 1992, UK) Video/16mm. Dist. BFI

DISTRIBUTORS' ADDRESSES

LVA (London Video Arts)
3rd Floor
5–7 Buck Street
Camden
London NW1 8NJ
England

BFI (British Film Institute)
21 Stephen Street
London W1P 1PL
England

ICA (Institute of Contemporary Arts)
The Mall
London SW1Y 5AH
England

Moviola
Bluecoat Chambers
School Lane
Liverpool L1 3BX
England

Metro Pictures
79 Wardour Street
London W1V 3TH
England

Cine Nova
113 Roman Road
Bethnal Green
London E2 0HU
England

Africa Sound + Image
232 Cowley Road
Oxford OX4 1UH
England

FVU – Film and Video Umbrella
6a Orde Hall Street
London WC1N 3JW
England

ReVision
28/30 The Square
St Anne's
Lytham St Annes
FY8 1RF
England

EVS (for European Distributors)
PO Box 98
CH–1255 Veyrier
Switzerland

V Tape
183 Bathurst Street
Toronto
Canada M5T 2R7

Video Out
1102 Homer Street
Vancouver, BC
Canada V6B 2X6

Art Metropole
788 King Street West
Toronto
Ontario
Canada M5V 1N6

Electronic Arts Intermix
10 Waverly Place
New York NY 10003
USA

The Kitchen/Video Distribution
512 W 19th St
New York NY 10012
USA

Museum of Modern Art Circulating Video Library
11 W 53rd Street
New York NY 10019
USA

Video Data Bank
School of the Art Institute of Chicago
Columbus Drive at Jackson Blvd
Chicago IL 60603
USA

Electronic Media Arts Australia
PO Box 661
Globe NSW 2037
Australia

Bibliography

Adorno, Theodor W. (1989), 'Perennial Fashion – Jazz', trans. Samuel and Shierry Weber, in Bronner and Kellner (eds) (1989).

Allen, Robert C. (1987), *Channels of Discourse: Television and Contemporary Criticism*, Routledge, London.

Althusser, Louis (1965), *Pour Marx (For Marx)*, François Maspéro, Paris.

Altman, Rick (1986), 'Television Sound' in Tania Modleski (ed.) (1986), *Studies in Entertainment: Critical Approaches to Mass Culture*, Indiana University Press, Bloomington.

Anderson, Laurie (1982), 'Example 22' on *Big Science*, Warner Bros Records, K57002.

Angus, Ian and Sut Jhally (eds) (1989), *Cultural Politics in Contemporary America*, Routledge, London.

Araeen, Rasheed (1989), *The Other Story: Afro-Asian Artists in Post-War Britain*, South Bank Centre, London.

Arato, Andrew and Eike Gebhardt (eds) (1978), *The Essential Frankfurt School Reader*, Blackwell, Oxford.

Aristotle (1965), *On the Art of Poetry* in *Classical Literary Criticism*, trans T. S. Dorsch, Penguin, Harmondsworth.

Armes, Roy (1987), *Third World Film Making and the West*, California University Press, Berkeley.

Armes, Roy (1988), *On Video*, Routledge, London.

Arts Council (1978), *Perspectives on British Avant-Garde Cinema*, Arts Council of Great Britain/Hayward Gallery, London.

Arts Council (1979), *Film as Film*, Arts Council of Great Britain, London.

Attali, Jacques (1985), *Noise: The Political Economy of Music*, trans Brian Massumi, Manchester University Press, Manchester.

Batchelor, David and Charles Harrison (1983), *Surrealism*, Open University Course A315, Block XI, Open University Press, Milton Keynes.

Baudelaire, Charles (1968), *L'Art Romantique (Romantic Art)*, Gallimard, Paris.

Baudrillard, Jean (1972), *Pour une critique de l'économie politique du signe*, Gallimard, Paris.

Baudry, Jean-Louis (1976), 'The Apparatus: Metapsychological Approaches to the Impression of Reality in the Cinema', trans. Jean Andrews and Bertrand Augst, *Camera Obscura*, no. 1, Fall.

Baudry, Jean-Louis (1985), 'Ideological Effects of the Basic Cinematographic Apparatus', trans. Alan Williams, in Bill Nichols (ed.) *Movies and Methods Volume II*, California University Press, Berkeley.

Bazin, André (1958), 'The Ontology of the Photographic Image', in *What is Cinema? Volume One*, University of California Press, Berkeley.

Bell, Clive (1982), 'The Aesthetic Dimension', in Frascina and Harrison (eds) (1982).

Bell, Daniel (1962), *The End of Ideology*, Penguin, Harmondsworth.

Benjamin, Andrew and Peter Osborne (eds) (1991), *Thinking Art: Beyond Traditional Aesthetics* (ICA Documents 10), Institute of Contemporary Arts, London.

Benjamin, Walter (1969), *Illuminations*, ed. Hannah Arendt, trans. Harry Zohn, Schocken, New York.

Benjamin, Walter (1973), *Understanding Brecht*, trans. Anna Bostock, New Left Books, London.

Benjamin, Walter (1979), *One-Way Street and Other Writings*, trans. Edmund Jephcott and Kingsley Shorter, New Left Books, London.

Berger, John (1965), *The Success and Failure of Picasso*, Penguin, Harmondsworth.

Berghaus, Günter (1988), '"Girlkultur" – Feminism, Americanism and Popular Entertainment in Weimar Germany', *Journal of Design History*, vol. 1, nos. 3/4.

Bhaskar, Roy (1986), *Scientific Realism and Human Emancipation*, Verso, London.

Biggs, Lewis (ed.) (1990), *New North: New Art from the North of Britain*, Tate Gallery, Liverpool.

Biggs, Simon (1989), 'Connecting Hysteria: Towards an Imaginary Ecology', in *Mediamatic*, vol. 4, nos. 1/2, Fall.

Bishton, Derek, Andy Cameron and Tim Druckery (eds) (1991), *Digital Dialogues: Photography in the Age of Cyberspace*, *Ten:8 Photo Paperback*, vol. 2, no. 2, Autumn.

Bohm, David (1980), *Wholeness and the Implicate Order*, Ark, London.

Bordwell, David and Kristin Thompson (1990), *Film Art: An Introduction*, 3rd edn, McGraw Hill, London.

Brakhage, Stan (1963), *Metaphors on Vision*, special issue of *Film Culture*, no. 30, Fall.

Brakhage, Stan (1989), *Film at Wit's End,* Documentext/Macpherson, Kingston NY.

Brett, Guy (1990), *Transcontinental: Nine Latin American Artists*, Verso, London.

Brett, Guy and Sean Cubitt (1991), *Camino Way: Las Pinturas Aeropostales – The Airmail Paintings de/of Eugenio Dittborn*, Pinturas Aeropostales & Books S.A., Santiago de Chile.

Bronner, Stephen Eric and Douglas MacKay Kellner (eds) (1989), *Critical Theory and Society: A Reader*, Routledge, London.

Brophy, Philip (1991), 'The Architecsonic Object', in Philip Hayward (ed.) *Culture, Technology and Creativity*, John Libbey, London.

Brunsdon, Charlotte (1990), 'Problems with Quality', *Screen*, vol. 31, no. 1, Spring.

Brunsdon, Charotte and David Morley (1978), *Everyday Television: 'Nationwide'*, BFI, London.

Bryson, Norman (1983), *Vision and Painting: The Logic of the Gaze*, Macmillan, London.

Bryson, Norman, Michael Anne Holly and Keith Moxey (eds) (1991), *Visual Theory: Painting and Interpretation*, Polity Press, Cambridge.

Buck-Morss, Susan (1977) *The Origin of Negative Dioletics*, MIT Press, Cambridge, Mass.

Burch, Noel (1974), 'Propositions', *After Image* no. 5.

Bürger, Peter (1984), *The Theory of the Avant-Garde*, trans. Michael Shaw, Manchester University Press, Manchester,.

Burgin, Victor (1986), *The End of Art Theory: Criticism and Postmodernity*, Macmillan, London.

Burgin, Victor (1991), 'Realising the Reverie', in Bishton, Cameron and Druckery (eds) (1991).

Cartwright, Lisa (1984), 'The Front Line and the Rear Guard', *Screen*, vol. 25, no. 6, November/December.

CAYC (eds) (1976), *Japan Video Festival: 33 Artists at CAYC*, Centre of Art and Communication, Buenos Aires.

Chipp, Herschel B. (1968), *Theories of Modern Art: A Source Book by Artists and Critics*, University of California Press, Berkeley.

Clark, T. J. (1984), *The Painting of Modern Life: Paris in the Art of Manet and his Followers*, Thames & Hudson, London.

Clark, VeVe A., Millicent Hodson and Catrina Neiman (1984), *The Legend of Maya Deren: A Documentary Biography and Collected Works*, special issue of *Film Culture*, nos. 72–5, Anthology Film Archives/Film Culture, New York.

Collier, Caroline, Andrew Nairne and David Ward (1990), *The British Art Show 1990*, South Bank Arts Centre, London.

Cook, Pam (1984), '*The Golddiggers*: Interview with Sally Potter', *Framework*, no. 24, Spring.

Copjec, Joan (1982), 'The Anxiety of the Influencing Machine', *October*, no. 23, Winter.

Crary, Jonathan (1988), 'Modernizing Vision', in Foster (ed.) (1988).

Cubitt, Sean (1988), 'Anxiety in Public Houses: Speculations on the Semiotics of Design Consciousness', *Journal of Design History*, vol. 1, no. 2.

Cubitt, Sean (1990/1), 'Retrato Hablado: The Airmail Paintings of Eugenio Dittborn', *Third Text*, 13, Winter.

Cubitt, Sean (1991), *Timeshift: On Video Culture*, Routledge, London.

Curtis, Dave (1971), *Experimental Film*, Studio Vista, London.

Curtis, Dave and Deke Dusinberre (eds) (1978), *A Perspective on British Avant-Garde Film*, Arts Council of Great Britain, London.

D'Agostino, Peter (ed.) (1985), *Transmission: Theory and Practice for a New Television Aesthetics*, Tanam, New York.

Damisch, Hubert (1979), 'The Duchamp Defense', trans. Rosalind Krauss, *October*, no. 10, Fall.

de Certeau, Michel (1984), *The Practice of Everyday Life*, trans. Steven Rendall, University of California Press, Berkeley.

de Lauretis, Teresa (1984), *Alice Doesn't: Feminism, Semiotics, Cinema*, Macmillan, London.
de Lauretis, Teresa (1987), *Technologies of Gender: Essays on Theory, Film and Fiction*, Indiana University Press, Bloomington.
de Lauretis, Teresa (1990), 'Guerrilla in the Midst:Women's Cinema in the 80s', *Screen*, vol. 31 no. 1, Spring.
de Lauretis, Teresa and Stephen Heath (eds) (1980), *The Cinematic Apparatus*, Macmillan, London.
Deleuze, Gilles and Félix Guattari (1975), *L'Anti-Oedipe (Capitalisme et Schizophrénie I (The Anti-Oedipus [Capitalism and Schizophrenia I])*, Editions de Minuit, Paris.
de Tolnay, Charles (1966), *Hieronymous Bosch*, London.
Dews, Peter (1987), *Logics of Disintegration: Post-Structural Thought and the Claims of Critical Theory*, Verso, London.
Dieckmann, Katherine (1985), 'Electra Myths: Video, Modernism, Postmodernism', *Art Journal*, vol. 45 no. 3, Fall.
Doane, Mary Ann (1981), 'Women's Stake: Filming the Female Body', *October*, no. 17.
Drummond, Phillip (1977), 'Textual Space *Un Chien Andalou*, *Screen* vol. 18 no. 3, Autumn.
Duchamp, Marcel ([1934] 1960), *The Bride Stripped Bare by her Bachelors Even* (a typographic version by Richard Hamilton of Marcel Duchamp's Green Box Trans. by George Heard Hamilton), Hansjorg Mayer, Stuttgart.
Duchamp, Marcel (1971), *Dialogues with Marcel Duchamp*, Thames & Hudson, London.
Duchamp, Marcel (1975), *Marchand du sel/Salt Seller: The Essential Writings of Marcel Duchamp*, ed. and trans. Michel Sanouillet and Elmer Peterson, Thames & Hudson, London.
Duncan, Carol ([1973] 1982) 'Virility and Domination in Early Twentieth Century Vanguard Painting', in Norma Broude and Mary D. Garrard (eds) *Feminism and Art History: Questioning the Litany*, Harper & Row, New York.
Dunford, Mike (1976), 'Experimental/avant-garde/revolutionary/film practice', *Afterimage*, no. 6, Summer.
Dusinberre, Deke (1977a), 'Consistent Oxymoron – Peter Gidal's Rhetorical Strategy', *Screen*, vol. 18 no. 2, Summer.
Dusinberre, Deke (1977b), 'English Avant-Garde Cinema 1966–1974' M. Phil thesis, University College, University of London.
Dwoskin, Steve (1975), *Film Is: The International Free Cinema*, Peter Owen, London.
Eagleton, Terry (1989), *The Ideology of the Aesthetic*, Blackwell, Oxford.
Eaton, Mick (1978), 'The Avant-Garde and Narrative', *Screen* vol. 19 no. 2, Summer.
Elwes, Catherine (1991), '(Wishing) Well', in Houghton (ed.) (1991).
Enzensberger, Hans Magnus (1992), *Mediocrity and Delusion*, trans. Martin Chalmers, Verso, London.

Featherstone, Mike (ed.) (1990), *Global Culture: Nationalism, Globalization and Modernity*, Sage, London.

Fisher, Tony (1990), 'Isaac Julien: Looking for Langston: Montage of a Dream Deferred', *Third Text* no. 12, Autumn.

Fiske, John (1987) *Television Culture*, Methuen, London.

Fiske, John (1989a) *Reading the Popular*, Unwin Hyman, London.

Fiske, John (1989b) *Understanding Popular Culture*, Unwin Hyman, London.

Foster, Hal (ed.) (1988), *Vision and Visuality*, Dia Art Foundation, *Discussions in Contemporary Culture Number 2*, Bay Press, Seattle.

Foucault, Michel (1970), *The Order of Things: An Archaeology of the Human Sciences* (no translator credited), Tavistock, London.

Foucault, Michel (1972), *The Archaeology of Knowledge and the Discourse on Language*, trans. Alan Sheridan, Harper Collophon, New York.

Fränger, Wilhelm (1976), *The Millennium of Hieronymous Bosch: Outlines of a New Interpretation*, Hacker Art Books, New York.

Frascina, Francis (ed.) (1985), *Pollock and After: The Critical Debate*, Harper & Row, London.

Frascina, Francis and Charles Harrison (eds) (1982) *Modern Art and Modernism: A Critical Anthology*, Harper & Row, London.

Frascina, Francis and Charles Harrison (1983) *Abstract Expressionism and Jackson Pollock*, Open University Course A315, Block XIII, Open University Press, Mlton Keynes.

Fraser, Nancy and Linda Nicholson (1988), 'Social Criticism Without Philosophy: An Encounter Between Feminism and Postmodernism', *Theory, Culture and Society*, vol. 5 nos. 2–3, June.

Freud, Sigmund (1977), 'Fetishism', *The Pelican Freud Library, Volume 7: On Sexuality – Three Esays on the Theory of Sexuality and Other Works*, Penguin, Harmondsworth.

Fukuyama, Francis (1990), 'The End of History', *The Independent*, 20 September; first published in *The National Interest*, Summer.

Gabriel, Tehome (1982), *Third Cinema in the Third World: The Aesthetics of Liberation*, UMI Research Press, Ann Arbor.

Gadamer, Hans-Georg (1976), *Hegel's Dialectic: Five Hermeneutical Studies*, ed. and trans. P Christopher Smith, Yale University Press, New Haven.

Gadamer, Hans-Georg (1986), *The Relevance of the Beautiful and Other Essays*, ed Robert Bernasconi, trans. Nicholas Walker, Cambridge University Press, Cambridge.

Gale, Peggy (ed.) (1976), *Video By Artists*, Art Metropole, Toronto.

Gauthier, Xavière (1971), *Surréalisme et sexualité*, (*Surrealism and Sexuality*) Gallimard, Paris.

Geddes, Keith (1972) *Broadcasting in Britain 1922–1972: A Brief Acount of its Engineering Aspects*, The Science Museum/HMSO, London.

Gidal, Peter (1974), 'Definition and Theory of the Current Avant-Garde', *Studio International*, 187.963, February.

Gidal, Peter (1975), 'Theory and Definition of Structural-Materialist Film', *Studio International*, 190.978, November/December.

Gidal, Peter (ed.) (1976), *Structural Film Anthology*, BFI, London.

Gidal, Peter (1979), 'The Anti-Narrative', *Screen*, vol. 20 no. 2, Summer.

Gidal, Peter (1984), 'Against Sexual Representation in Film', *Screen*, vol. 25 no. 6, Nov–Dec.

Gidal, Peter (1989), *Materialist Film*, Routledge, London.

Gillespie, Marie (1989), 'Technology and Tradition', *Cultural Studies*, vol. 3 no. 2.

Ginzburg, Carlo (1980), *The Cheese and the Worms: The Cosmos of a Sixteenth Century Miller*, trans. John and Anne Tedeschi, Routledge & Kegan Paul, London.

Goodwin, Andrew (1992), *Dancing in the Distraction Factory: Music Television and Popular Culture*, University of Minnesota Press.

Gorbman, Claudia (1987), *Unheard Melodies: Narrative Film Music*, BFI, London.

Graham, Dan (1979), *Video – Achitecture – Television: Writings on Video and Video Works*, ed. Benjamin D. Buchloh, Press of the Nova Scotia College of Art and Design/New York University Press, Halifax and New York.

Gramsci, Antonio (1971), *Selections from the Prison Notebooks*, ed. and trans. Quintin Hoare and Geoffrey Nowell-Smith, International Publishers, New York.

Gray, Ann (1987), 'Behind Closed Doors: Women and Video Recorders in the Home', in Helen Baehr and Gillian Dyer (eds) *Boxed In: Women On and In Television*, Pandora, London.

Greenberg, Clement (1982a), '"American-Type" Painting' in Frascina and Harrison (eds).

Greenberg, Clement (1982b), 'Modernist Painting' in Frascina and Harrison (eds).

Greenberg, Clement (1986a), *Clement Greenberg: The Collected Essays and Criticism*, Volume One, *Perceptions and Judgements 1939-44*, ed. J O'Brien, Chicago University Press, Chicago.

Greenberg, Clement (1986b), *Clement Greenberg: The Collected Essays and Criticism*, Volume Two, *Arrogant Purpose 1945-49*, ed. J O'Brien, Chicago University Press, Chicago.

Griffiths, Paul (1978), *Modern Music: A Concise History from Debussy to Boulez*, Thames & Hudson, London.

Grossberg, Lawrence (1989), 'MTV: Swinging on a Postmodern Star', in Angus and Jhally (eds) (1989).

Habermas, Jurgen (1987), *The Philosophical Discourse of Modernity: Twelve Lectures*, trans. Frederick G. Lawrence, Polity Press, Cambridge.

Hamlyn, Nicky (1990), 'Exploring Sexuality Anew: Erotic Films by European Women Film-Makers', *Performance* no. 61, September.

Hammond, Paul (1978), *The Shadow and its Shadow*, BFI, London.

Harraway, Donna J. (1991), *Simians, Cyborgs and Women: The Reinvention of Nature*, Free Association Press, London.

Harrison, Charles (1981), *English Art and Modernism 1900-1939*, London.

Harrison, Charles and Fred Orton (eds) (1984), *Modernism, Criticism, Realism: Alternative Contexts for Art*, Harper & Row, London.

Hartney, Mick (1984), 'An Incomplete and Highly Contentious Summary of the Early Chronology of Video Art (1959–1976); With Tentative Steps in the Direction of a De-Definition', *London Video Arts: 1984 Catalogue*, LVA, London.

Harvey, Sylvia (1978), *May '68 and Film Culture*, BFI, London.

Haworth-Booth, Mark (1989), *Photography Now*, Victoria and Albert Museum, London.

Heath, Stephen (1979), 'Afterword', *Screen* vol. 20 no. 2, Summer.

Heath, Stephen (1981), *Questions of Cinema*, Macmillan, London.

Held, David (1980), *Introduction to Critical Theory*, Macmillan, London.

Hewison, Robert (1990), *Future Tense: A New Art for the Nineties*, Methuen, London.

Horkheimer, Max and Theodor Adorno (1973), *The Dialectic of Enlightenment*, trans. John Cumming, Allen Lane, London.

Houghton, Nick (ed.) (1991), *Video Positive One 99 One*, Moviola, Liverpool.

Huizinga, J. (1955), *The Waning of the Middle Ages: A Study of the Forms of Life, Thought and Art in France and the Netherlands in the Fourteenth and Fifteenth Centuries*, trans. F. Hopman, Penguin, Harmondsworth.

Huyssen, Andreas (1986), *After the Great Divide: Modernism, Mass Culture, Postmodernism*, Indiana University Press, Bloomington.

Inter Nationes (eds) (1986), *In Memoriam Joseph Beuys: Obituaries, Essays, Speeches*, Inter Nationes, Bonn.

Irrigaray, Luce (1977), *Ce sex qui non est pas un* (*This sex which is not one*), Seuil, Paris.

Iles, Chrissie (ed.) (1990), *Signs of the Times: A Decade of Video, Film and Tape-Slide Installation in Britain, 1980–1990*, Museum of Modern Art, Oxford.

Jameson, Fredric (1981), *The Political Unconscious: Narrative as Socially Symbolic Act*, Methuen, London.

Jameson, Fredric (1991), *Postmodernism, or, The Cultural Logic of Late Capitalism*, Verso, London.

Jay, Martin (1973), *The Dialectical Imagination*, Little, Brown, Boston.

Kant, Immanuel (1952), *The Critique of Judgement*, trans. James Creed Meredith, Oxford University Press, Oxford.

Kassabian, Anahid (1991), 'Communication and Competence: How Film Music Works', paper given at the First Screen Conference, University of Strathclyde, Glasgow.

Kidder, Tracey (1981), *The Soul of a New Machine*, Penguin, Harmondsworth.

King, Anthony D. (ed.) (1991) *Culture, Globalisation and the World-System*, Macmillan, London.

Kracauer, Siegfried (1989), 'The Mass Ornament', trans. Barbara Correll and Jack Zipes, in Bronner and Kellner (eds) (1989).

Krauss, Rosalind E. (1986), *The Originality of the Avant-Garde and Other Modernist Myths*, MIT Press, Cambridge, Mass..

Kristeva, Julia (1974), *La révolution du langage poétique: L'avant-garde à la fin du XIXe siècle: Lautréamont et Mallarmé* (*The Revolution of Poetic*

Language: The Avant-garde at the End of the 19th Century: Lautréamont and Mallarmé), Seuil, Paris.

Kristeva, Julia (1980), *Pouvoirs de l'horreur: Essai sur l'abjection*, (*Powers of Horror: An Essay on Abjection*), Seuil, Paris.

Kroker, Arthur and Marilouise (eds) (1988), *Body Invaders: Sexuality and the Postmodern Condition*, Macmillan, London.

Kuntz, Martin (ed.) (1990), *William Wegman: Paintings, Drawings, Photographs, Videotapes*, Harry N. Abrams Inc., New York.

Labrioux, Yves (1985), *Ian Hamilton Finlay: A Visual Primer*, Reaktion Books, Edinburgh.

Lacan, Jacques (1991), *Le Séminaire, livre VIII: Le transfert* (*The Seminar, Book VIII: The Transference*), Seuil, Paris.

Le Grice, Malcolm (1977), *Abstract Film and Beyond*, Studio Vista, London.

Le Grice, Malcolm (1979/80), 'Towards Temporal Economy', *Screen*, vol. 20, nos. 3/4, Winter.

Le Grice, Malcolm (1981), 'Problematising the Spectator Relationship in Film', *Undercut* no. 1, March/April.

Le Grice, Malcolm (1983), 'Some Recent Thoughts on Film', *Millenium Film Journal*, no. 13, Winter.

Levidow, Les and Kevin Robins (eds) (1989), *Cyborg Worlds: The Military Information Society*, Free Association Books, London.

Lingwood, James (ed.) (1986), *Staging the Self: Self-Portrait Photography 1840s to 1980s*, Plymouth Arts Centre/National Portrait Gallery, Plymouth and London.

London, Barbara (1985a), 'Video: A Brief History and Selected Chronology', in D'Agostino (ed.) (1985).

London, Barbara (1985b), 'Video: A Selected Chronology', *Art Journal* vol. 45, no. 3, Fall.

Lovelock, J. E (1979), *Gaia: A New Look at Life on Earth*, Oxford University Press, Oxford.

Lyotard, Jean-François (1984), *The Postmodern Condition*, Manchester University Press, Manchester.

MacCabe, Colin (1980), *Godard: Images, Sounds, Politics*, BFI/Macmillan, London.

Mao Tse-Tung (1967), 'On Correct Thinking', in *Four Essays on Philosophy*, Foreign Language Press, Peking.

Maravall, José Antonio (1986), *Culture of the Baroque: Analysis of a Historical Structure*, trans. Terry Cochran, Manchester University Press, Manchester.

Marx, Karl (1976), *Capital*, volume 1, trans. Rodney Livingstone, New Left Books/Penguin, London.

Meehan, Eileen R. (1990), 'Why We Don't Count: The Commodity Audience', in Mellencamp (ed.) (1990b).

Meigh-Andrews, Chris (1991), *Streamline*, Moviola, Liverpool.

Mekas, Jonas (1972), *Movie Journal: The Rise of a New American Cinema 1959-1971*, Collier Books, New York.

Mellencamp, Patricia (1990a), *Indiscretions: Avant-Garde Film, Video and Feminism*, Indiana University Press, Bloomington.

Mellencamp, Patricia (ed.) (1990b), *Logics of Television: Essays in Cultural Criticism*, Indiana University Press, Bloomington.

Merleau-Ponty, Maurice (1968), *The Visible and the Invisible*, trans. Alphonso Lingis, Northwestern University Press, Evanston.

Metz, Christian (1982), *Psychoanalysis and Cinema: The Imaginary Signifier*, Macmillan, London.

Michelson, Annette (1966), 'Film and the Radical Aspiration', *Film Culture* no. 42, Fall; reprinted in Sitney (1970).

Michelson, Annette (1972a), 'Screen/Surface: The Politics of Illusionism', *Artforum*, September.

Michelson, Annette (1972b), 'The Man with a Movie Camera: From Magician to Epistemologist', *Artforum*, March.

Michelson, Annette (1974), 'Paul Sharits and the Critique of Illusionism', in *Projected Images*, Walker Art Center, Minneapolis.

Michelson, Annette, Rosalind Krauss, Douglas Crimp and Joan Copjec (eds) (1987) *October: The First Decade 1976–1986*, MIT Press, Cambridge, Mass.

Middleton, Richard (1990), *Studying Popular Music*, Open University Press, Milton Keynes.

Money, Steve (1981), *Video*, Newnes Technical Books, Sevenoaks, Kent.

Montrelay, Michele (1977), *L'Ombre et le nom*, Editions de Minuit, Paris.

Morley, David (1980a), 'Texts, Readers, Subjects', in Stuart Hall *et al.* (eds) *Culture, Media, Language*, Hutchison, London.

Morley, David (1980b), *The 'Nationwide' Audience*, BFI, London.

Morley, David (1981), '"The Nationwide Audience" – A Critical Postscript', *Screen Education* no. 39, Summer.

Morley, David (1987), *Family Television: Cultural Power and Domestic Leisure*, Routledge, London.

Morley, David (1991), 'Where the Global Meets the Local: Notes From the Sitting Room', *Screen*, vol. 32 no. 1, Spring.

Morley, David and Kevin Robins (1989), 'Spaces of Identity: Communications Technologies and the Reconfiguration of Europe', *Screen*, vol. 30 no. 4, Autumn.

Morris, Meaghan (1988a), *The Pirate's Fiancée: Feminism, Reading, Postmodernism*, Verso, London.

Morris, Meaghan (1988b), 'Things to do with Shopping Centres', in Sheridan (ed.) (1989).

Morse, Margaret (1983), 'Sport on Television: Replay and Display', in E. Ann Kaplan (ed.) *Regarding Television*, American Film Institute/University Publications of America, Frederick, MD.

Morse, Margaret (1985), 'Talk, Talk, Talk – The Space of Discourse on Television', *Screen*, vol. 26, no. 2, March–April.

Morse, Margaret (1990), 'An Ontology of Everyday Distraction: The Freeway, the Mall and Television', in Mellencamp (ed.) (1990b).

Moure, Gloria (1988), *Marcel Duchamp*, Thames & Hudson, London.

Mulvey, Laura (1975), 'Visual Pleasure and Narrative Cinema', *Screen*, vol. 16, no. 3, Autumn.

Norris, Christopher (1983), *The Deconstructive Turn: Essays in the Rhetoric of Philosophy*, Methuen, London.

Norris, Christopher (1990), *What's Wrong with Postmodernism: Critical Theory and the Ends of Philosophy*, Harvester Wheatsheaf, London.

O'Pray, Mike (1982), 'Movies, Mania and Masculinity', *Screen*, vol. 25 no. 5, November/December.

O'Pray, Mike (1989) 'Warhol's Early films: Realism and Psychoanalysis in Michael O'Pray (ed.) *Andy Warhol Film Factory*, BFI, London.

Ovid (1939) 'The Story of Echo and Narcissus', in 'The Metamorphoses', trans. Arthur Golding, in J. C and M. J. Thornton (eds), *Ovid: Selected Works*, Everyman, London.

Paz, Octavio (1978), *Marcel Duchamp: Appearance Stripped Bare,* trans. Rachel Phillips and Donald Gardner, Viking Press, New York.

Pelzer, Birgit (1979), 'Vision in Process', *October*, no. 10, Fall.

Penley, Constance (1977), 'The Avant Garde and its Imaginary', *Camera Obscura*, no. 2, Fall.

Penley, Constance (1978), 'The Avant Garde: Histories and Theories', *Screen*, vol. 19, no. 3, Autumn.

Penley, Constance (1989), *The Future of an Illusion: Avant Garde Film and Feminism*, BFI, London.

Penley, Constance and Andrew Ross (eds) (1991), *Technoculture*, University of Minnesota Press, Minneapolis.

Penrose, Roger (1989), *The Emperor's New Mind: Concerning Computers, Minds and the Laws of Physics*, Vintage, London.

Phillipi, Desa (1990), 'The Witness Beside Herself', *Third Text*, no. 12, Autumn.

Pines, Jim and Paul Willemen (eds) (1989) *Questions of Third Cinema*, BFI, London.

Piper, Keith and Marlene Smith (1987) *The Image Employed: The Use of Narrative in Black Art*, Cornerhouse, Manchester.

Polan, Dana (1985), *Image-Making and Image-Breaking: Studies in the Political Language of Film and the Avant Garde*, UMI Research Press, Ann Arbor.

Polan, Dana (1987), 'Powers of Vision, Visions of Power', *Camera Obscura,* no. 18.

Pollock, Griselda (1988), *Vision and Difference: Femininity, Feminism and Histories of Art*, Routledge, London.

Rainer, Yvonne (1979), 'Working Title: Journeys from Berlin/1971', *October*, no. 9, Summer.

Rainer, Yvonne (1983), 'More Kicking and Screaming from the Narrative Front/Backwater', *Wide Angle*, vol. 7, no. 1–2.

Reed, Lou and John Cale (1991), *Songs for Drella*, Sire Records, 7599 – 26140-4/WX 345C.

Renan, Sheldon (1968), *An Introduction to the American Underground Film*, Studio Vista, London.

Richard, Nelly (1986), *Margins and Institutions: Art in Chile since 1973*, special issue of *Art & Text*, no. 21, May–July, Art & Text in association with The Experimental Art Foundation, Sydney.

Ricoeur, Paul (1970), *Freud and Philosophy: An Essay on Interpretation*, trans. D. Savage, Yale University Press, New Haven.

Ricoeur, Paul (1991), *A Ricoeur Reader: Reflection and Imagination*, ed. Mario J. Valdés, Harvester Wheatsheaf, Hemel Hempstead.

Ritchin, Fred (1990), *In Our Own Image: The Coming Revolution in Photography*, Aperture Foundation, New York.

Roberts, John (1990a), *Postmodernism, Politics and Art*, Manchester University Press, Manchester.

Roberts, John (1990b), 'The Temporal Arts: Prospects and Problems into the Nineties', in Isles (ed.) 1990.

Rodowick, D. N. (1988), *The Crisis of Political Modernism: Criticism and Ideology in Contemporary Film Theory*, University of Illinois Press, Urbana.

Rorty, Richard (1980), *Philosophy and the Mirror of Nature*, Blackwell, Oxford.

Rorty, Richard (1984), 'The Historiography of Philosophy: Four Genres', in Richard Rorty, J. B. Schneewind and Quentin Skinner (eds), *Philosophy in History*, Cambridge University Press, Cambridge.

Rose, Gillian (1978), *The Melancholy Science: Introduction to the Thought of Theodor W. Adorno*, Macmillan, London.

Rose, Jacqueline (1986), *Sexuality in the Field of Vision*, Verso, London.

Rosen, Philip (ed.) (1986), *Narrative, Apparatus, Ideolgy*, Columbia University Press, New York.

Rosen, Robert (1985), 'Ernie Kovacs: Video Artist', in D'Agostino (ed.) (1985), pp.143–50.

Ross, Andrew (1991a), 'Hacking Away at the Counterculture', in Penley and Ross (eds) (1991).

Ross, Andrew (1991b), *Strange Weather: Culture, Science and Technology in the Age of Limits*, Verso, London.

Ross, David A. (1985), 'Nam June Paik's Videotapes', in D'Agostino (ed.) (1985), pp. 151-64.

Rubin, William (ed.) (1984), *Primitivism in 20th Century Art* (2 vols), Museum of Modern Art, New York.

Said, Edward (1976), *Orientalism*, Penguin, Harmondsworth.

Schneider, Cynthia and Brian Wallis (eds) (1988), *Global Television*, special issue of *Wedge*, nos. 9/10, Wege Press, New York.

Schor, Naomi (1987), *Reading in Detail: Aesthetics and the Feminine*, Methuen, London.

Scientific American (1991), *Communications, Computers and Networks: How to Work, Play and Thrive in Cyberspace*, vol. 265, no. 3, September.

Seiter, Ellen, Hans Borchers, Gabrielle Kreutzner and Eva-Maria Warth (eds) (1989), *Remote Control: Television, Audiences and Cultural Power*, Routledge, London.

Serra, Richad and Clara Weyergraf (1979), 'Richard Serra's Films: An Interview', *October*, no. 10, Fall.

Sheridan, Susan (ed.) (1989), *Grafts: Feminist Cultural Criticism*, Verso, London.

Silverman, Kaja (1988), *The Accoustic Mirror: The Female Voice in Psychoanalysis and Cinema*, Indiana University Press, Bloomington.

Sitney, P. Adams (1970), *Film Culture*, Secker & Warburg, London.

Sitney, P. Adams (1974), *Visionary Film*, Oxford University Press, New York.

Solanas, Fernando and Octavio Gettino (1976), 'Towards a Third Cinema', in Bill Nichols (ed.) *Movies and Methods*, Vol. 1, University of California Press, Berkeley.

Spigel, Lynn (1988), 'Installing the Television Set: Popular Discourses on Television and Domestic Space, 1948–1955', in *Camera Obscura*, no. 16, January.

Spivak, Gayatri Chakravorty (1985), 'Displacement and the Discourse of Woman', in Mark Krupnick (ed.) *Displacement: Derrida and After*, Midland/Indiana University Press, Bloomington.

Spivak, Gayatri Chakravorty (1988), *In Other Worlds: Essays in Cultural Politics*, Routledge, London.

Stern, Lesley (1989), 'Acting Out of Character: The Performance of Femininity', in Sheridan (ed.) (1989).

Stoneman, Rod (1979/80), 'Film-Related Practice and the Avant Garde', *Screen* vol. 20, nos. 3/4.

Straayer, Chris (1990), 'The She-Man: Postmodern Bi-sexed Performance in Film and Video', *Screen*, vol. 31 no. 3, Winter.

Tagg, Philip (1989), 'An Anthropolgy of Stereotypes in TV Music?', *Svensk tidskrift för musikforskning*, pp. 19–42.

Theweleit, Klaus (1987), *Male Fantasies: Volume One – Women, Floods, Bodies, History*, trans. Stephen Conway, Polity Press, Cambridge.

Thomas, Keith (1971), *Religion and the Decline of Magic: Studies in Popular Beliefs in Sixteenth and Seventeenth Century England*, Weidenfeld and Nicolson, London.

Tisdall, Caroline (1979), *Joseph Beuys*, Thames & Hudson, London.

Turkle, Sherry (1984), *The Second Self: Computers and the Human Spirit*, Granada, London.

Tyler, Parker (1971), *Underground Film*, Secker & Warburg, London.

Ulmer, Gregory (1989), *Teletheory: Grammatology in the Age of Video*, Routledge, London.

van Leeuwen, Theo (1988), *Music and Ideology: Notes Towards a Sociosemiotics of Mass Media Music*, Sydney Association for Studies in Culture and Society Working Papers, Series Two:1.

Virilio, Paul (1990), 'Cataract Surgery: Cinema in the Year 2000', in Annette Kuhn (ed.) *Alien Zone: Cultural Theory and Contemporary Science Fiction Cinema*, Verso, London.

Vološinov V. N. (1976), *Freudianism: A Critical Sketch*, trans. I. R. Titunik, Indiana University Press, Bloomington.

Wade, Graham (1985), *Film, Video and Television: Market Forces, Fragmentation and Technological Advance*, Comedia, London.

Wallis, Brian (ed.) (1987), *Blasted Allegories: An Anthology of Writings by Contemporary Artists*, New Museum of Contemporary Art, New York/ MIT Press, Cambridge, Mass.

Wallis, Roger and Stanley Baran (1990), *The Known World of Broadcast News: International News and The Electronic Media*, Comedia/Routledge, London.

Walsh, Martin (1981), *The Brechtian Aspect of Radical Cinema*, ed. Keith M. Griffiths, BFI, London.

Warner, Marina (1985), *Monuments and Maidens: The Allegory of the Female Form*, Picador, London.

Watney, Simon (1980), *English Post-Impressionists*, Methuen, London.

Wees, William C. (1974), *Vorticism and the English Avant Garde*, Toronto University Press, Toronto.

Welsh, Jeremy (1991), 'Video Art Chronology: UK', in Houghton (ed.) (1991).

Willemen, Paul (1984), 'An Avant-Garde for the Eighties', in *Framework*, no. 24, Spring.

Willemen, Paul (1988), 'Questions of Third Cinema', in Jim Pines, and Paul Willemen (eds) (1989).

Willemen, Paul (1992), '*Bangkok-Bahrein* to *Berlin-Jerusalem*: Amos Gitai's Editing', *Screen*, vol. 32, no. 1, Spring.

Willett, John (1978), *The New Sobriety: Art and Politics in the Weimar Period 1917–33*, Thames & Hudson, London.

Williams, Linda (1976), 'The Prologue to *Un Chien Andalou*: A Surrealist Metaphor', *Screen*, vol. 17, no. 4, Winter.

Williams, Linda (1981), *Figures of Desire: A Theory and Analysis of Surrealist Film*, University of Illinois Press, Urbana.

Wittgenstein, Ludwig (1961), *Tractatus Logico-Philosophicus*, trans. D. F. Pears and B. F. McGuinness, Routledge & Kegan Paul, London.

Wittgenstein, Ludwig (1972), *Philosophical Investigations* trans. G. E. M. Anscombe, Blackwell, Oxford.

Wittkower, R. and B. A. R. Carter (1953), 'The Perspective of Piero della Francesca's "Flagellation"', *Journal of the Warburg and Courtauld Institutes*, vol. 16, no. 3–4.

Wolff, Janet (1981), *The Social Production of Art*, Macmillan, London.

Wolff, Janet (1983), *Aesthetics and the Sociology of Art*, George Allen & Unwin, London.

Wolff, Janet (1985) 'The Invisible Flâneuse', *Theory, Culture and Society*, vol. 2, no. 3.

Wollen, Peter (1982), *Readings and Writings: Semiotic Counter-Strategies*, Verso, London.

Wombell, Paul (ed.) (1991), *Photovideo: Photography in the Age of the Computer*, Rivers Oram Press, London.

Youngblood, Gene (1970), *Expanded Cinema*, Studio Vista, London.

Ziff, Trisha and Daniel Martinez (1991) 'Culture Wars', in Bishton, Cameron and Drickery (eds) 1991.

Index

Abstract Film and Beyond (Le Grice) 79

Adorno, Theodor W. 25, 29, 31, 32, 36, 39, 40, 45, 50, 61, 62, 71, 89, 92, 99, 115–16, 120, 196, 206

Aeschylus 208

Africa Word + Image 143

AIDS 192–3

Allen, Woody 73

Almy, Max 22, 197–8

Althusser, Louis 93, 108

Altman, Rick 122, 123

Amy! (Mulvey and Wollen) 80

André, Carl 26

Ang, Len 94

anti-raster 167

apparatus theory 74–8, 98, 164–5

Aristotle 141

Armes, Roy xv, 174, 210

Art of Memory (Vasulka) 145–51

art film 73

Artists' Congress 29

Assassination of the Duc de Guise, The (Comédie Française) 72

Attali, Jacques 113

Attenborough, David 124

autonomy 21–2, 24–5, 27, 43

Autumn (Elwes) 19–20

avant garde 28, 30, 35, 39

avant-garde film 74, 78ff

Bacon, Francis 132

Baird, John Logie 87

Band Aid 102

Barber, George 202

Barthes, Roland 199

Baselitz, George 158

Batchelor, David 47

Battcock, Gregory 104

Baudelaire, Charles 49

Baudrillard, Jean 9, 26, 107, 109, 181–4

Baudry, Jean-Louis 77, 84, 92

Bauhaus 23, 58–9, 99

Bazin, André 85

Bell, Clive 23, 32, 34

Bell, Daniel 95

Belshazzar's Feast/The Writing on Your Wall (Hiller) 176–178

Benjamin, Walter 2, 39, 40–1, 48–9, 50, 54–6, 62, 65–6, 70–1, 92, 97, 99–100, 145, 199

Berg, Alban 29, 115

Berger, John 24

Berghaus, Günter 6

Berkeley, Busby 60

Beuys, Joseph 41, 47, 50–3, 54, 55, 113

Bhagavad Gita 145

Biggs, Simon 113, 181

Big TV 111

Birnbaum, Dara 22

Blade Runner (Scott) 180, 188

Bleasdale, Alan 107

Bleibtrau, John 100

Bosch, Hieronymous 196–7

bourgeois/bourgeoisie 24, 28, 56

Brakhage, Stan 74

Brecht, Bertolt 28, 33, 55, 99

Breton, André 100

Brett, Guy 133

Brophy, Philip 118

Bruce, Lenny 147

Brunsdon, Charlotte 91, 97–8

Buñuel, Luis 79

Burger, Peter 39–41, 47

Burgin, Victor 50

Burroughs, William S. 194